PORSCHE

· T · H · E ·

Enduring Legend

Text and photography by

NICKY WRIGHT

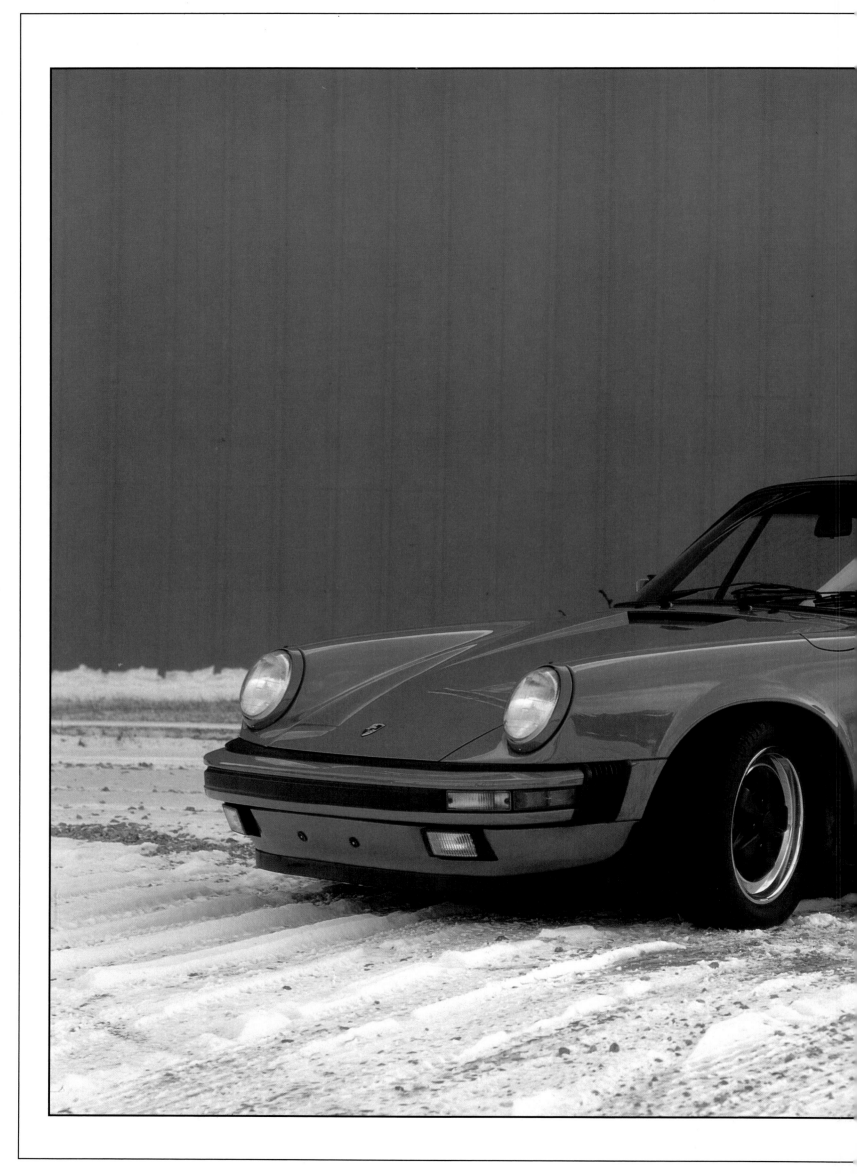

PORSCHE

·T·H·E·

Enduring Legend

GALLERY BOOKS
An Imprint of W. H. Smith Publishers Inc.
112 Madison Avenue
New York City 10016

DEDICATION

I respectfully dedicate this book to C.A.S. and David Edelstein –
without your help it would not have happened.

ACKNOWLEDGEMENT

The author gratefully acknowledges the invaluable assistance
provided by the following individuals and organizations
throughout the preparation of this book:

C.A.S.; David Edelstein; Dennis Machell; Alan Seymour; Langeland,
Fort Wayne, Indiana/Todd Fleck; Larry Nicklin; Tom Nicklin;
National Motor Museum, Beaulieu, U.K./Philip Scott and Tom; Fuji
Films (the best in the business); Pentax Cameras (all pictures shot
on Pentax 6x7 and 645 cameras; Jack' Camera Shop, Muncie,
Indiana (detail shots taken on Nikon); Milland Place Hotel,
Milland, U.K.; Donna Begley; Roy and Barb Hathaway; and last but
not least my wife, Becky, who spent a lifetime typing and proofing
the manuscript and generally keeping me together.

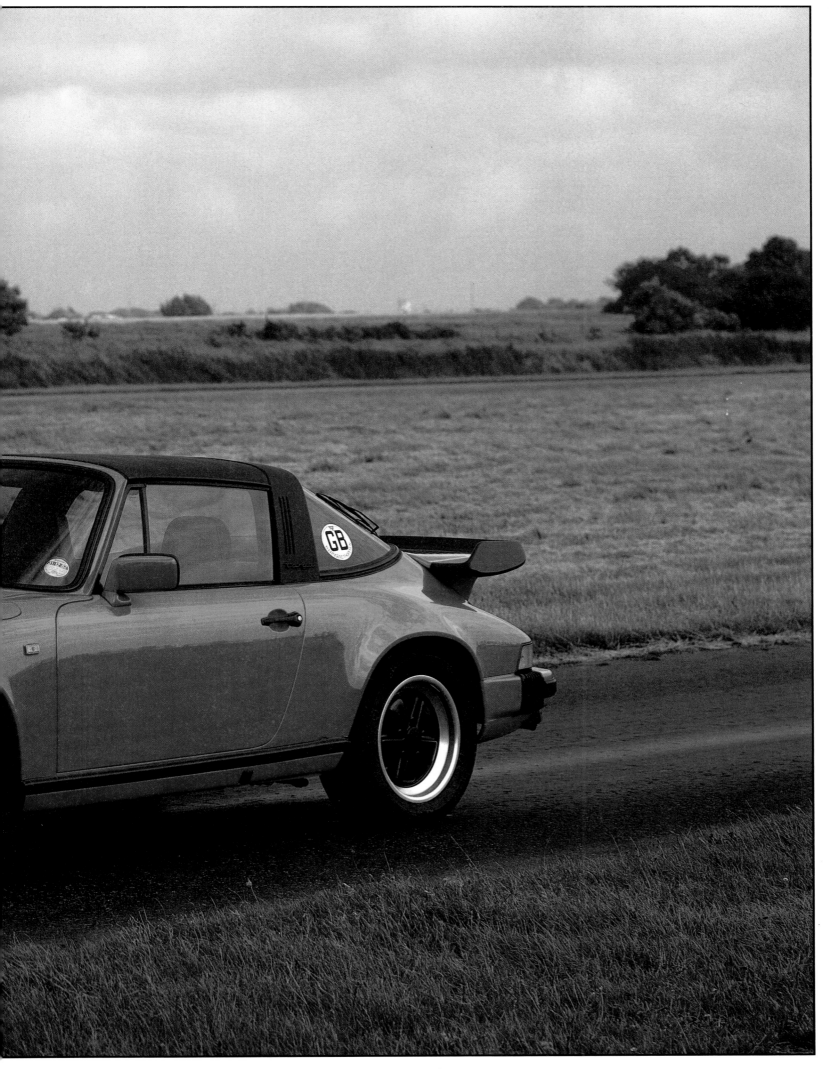

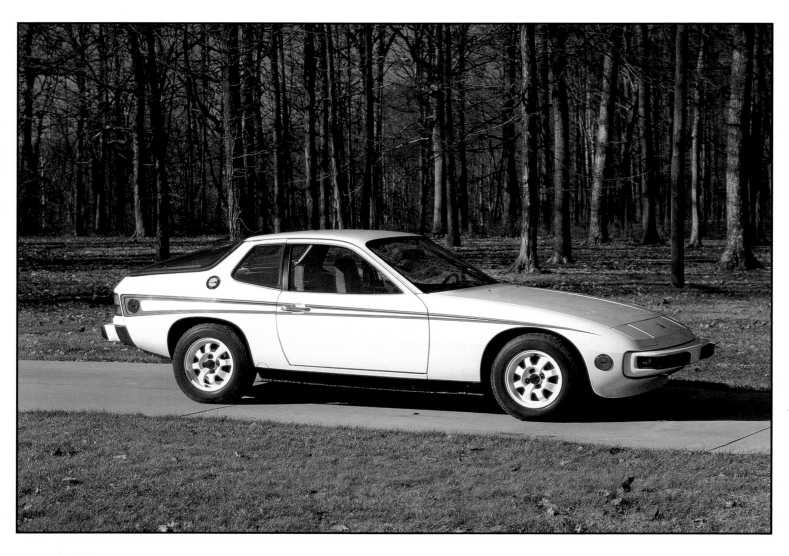

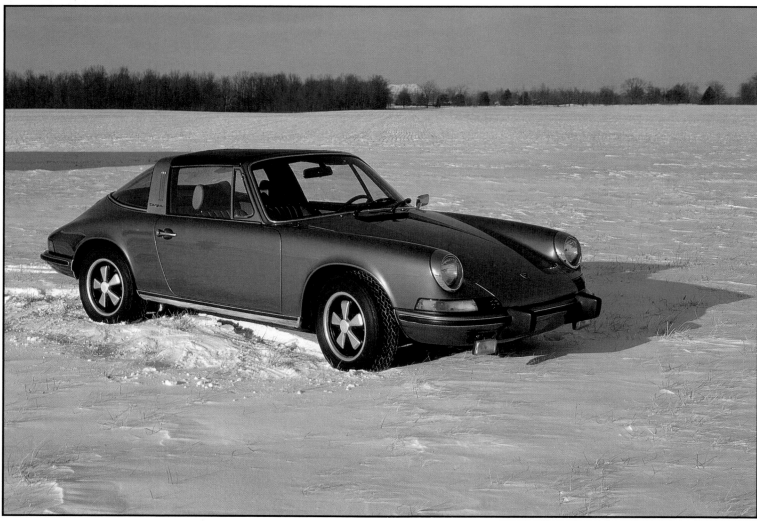

INTRODUCTION

Gmund. Small, out of the way. Primitive even. So out of the way that not even the railway ran there. South of Katschberg, this little Austrian village hardly seemed the sort of place to find an automotive design office.

Nor was Gmund thought of as the place to design cars by the highly skilled engineers ordered there by Berlin, following the evacuation of Porsche's factory at Stuttgart. The engineers looked at the cows grazing upon the grass flourishing around the deserted army barracks which was to be Porsche Konstruktionsburo's home for the next five years. As Ferdinand Porsche and his companions reviewed the chilled, windswept scene it is likely that not one of them, not even Professor Ferdinand Porsche himself, realized the significance Gmund would eventually bring to the world of motoring.

Ferdinand Porsche was born in the Austrian village of Maffersdorf on 3 September 1875 (now part of Czechoslovakia, the name has been changed to Liberec). Bright and full of promise, young Ferdinand became heir apparent to the family business of metalsmithing when his elder brother, Anton Jr., was killed in an accident.

Much to his father's chagrin, Ferdinand did not care for metalsmithing; he showed a talent for mechanical things. Being the sensible folk they were, the Porsches sent him to the Imperial Technical School in Reichenberg. There he discovered electricity, and by 1893 had designed and installed a complete electrical system in the family home – including door chimes!

Jakob Lohner was the coachbuilder. His clients included the Hapsburgs as well as many other titled and wealthy persons. He gave Ferdinand Porsche the job to design an electric engine to drive his new horseless carriages. Not for him gasoline engines. Far too crude for the rich and famous!

Porsche tackled the assignment with the searching technical genius that was to become his forte, resulting in two electric motors installed in the front wheel hubs. No transmission, no drive shaft; instead the world's first front wheel drive vehicle.

This was in 1900; in 1905 Porsche was, at the age of 30, technical director of the mighty Austro-Daimler car company. Soon he was designing gasoline engines and racing cars. Porsche drove some of the cars and won quite a few events.

Despite his restless inventive genius thirsting to conquer more goals, Porsche found time to fall in love and to marry. His wife bore him two children; a daughter, Louise, and in 1909 a son called Ferdinand. From the beginning Porsche's son was nicknamed Ferry, and it stuck. Although it was not known then, Ferry Porsche had his destiny mapped out for him; forty-one years on he would be the thrust behind Porsche cars.

During the First World War, Ferdinand Porsche took to designing aircraft engines and was named managing director of Austro-Daimler in 1916. Meanwhile the war ground inexorably on, dissipating wealth and manhood until its end, in a railway carriage, in 1918.

The war left Germany and its allies destitute, a position soon felt by luxury car makers such as Austro-Daimler. There was a wind of change in the air; war had triggered a long needed social revolution. The workers were demanding fair play and automobiles, too.

Some, unlike Austro-Daimler, saw the need for smaller cars which Mr. Everyman could afford. Porsche was one of them and resolved that by hook or by crook he would one day build them. An opportunity presented itself in 1921 when a wealthy Austrian film maker, Count Sascha Kolowrat, asked Porsche to design a 61 cid car. The result was the "Sascha", an open two seater with a SOHV four-cylinder engine providing power to attain 90 mph.

The Saschas were raced with great success – they finished 1 and 2 in their class at the Targa Florio. A year later, struggling Austro-Daimler cut off further funds to develop the Sascha, much to the consternation of Ferdinand Porsche, who threw his gold cigarette lighter at the board of directors and resigned on the spot.

Crossing the border into Germany, Porsche soon joined Daimler – not the same company as Austro-Daimler, by the way – as technical director and was given a place on the board. The time was 1923 and Porsche found a company whose ideas were far more liberal than the one he had left behind.

Three years after he joined, Daimler became Daimler-Benz. Two and a half years after that Porsche moved on, this time to Steyr; but not before he had contributed a great deal. He developed a new supercharged 2.0 liter engine which Daimler had been working on, turning it into a successful racing unit. It came home 1-2-3 in its class at the 1924 Targa Florio earning Porsche the grateful appreciation of the University of Stuttgart who rewarded him with an honorary doctorate.

By the late twenties Porsche designed 6.0 liter supercharged six cylinder engines for the K and S series Mercedes. By the time the Mercedes SSKL came along in 1931, the engine had grown to 7 liters, developed 300 bhp at 3200 rpm and could reach 145 mph. During its span the SSKL was invincible, the "power of the hour" – with apologies to Duesenberg – on road and track.

At the beginning of 1929, Steyr Motor Company of Austria offered Porsche a place on the board and the post of chief engineer. Hardly had he taken up his position when Steyr merged with Austro-Daimler. This placed Porsche in an impossible position and resulted in his leaving the new company and led him to form his own design consultancy business, with his old friend and gifted engineer, Karl Rabe. Hardly had he opened his office in Stuttgart when he was contracted to design a new mid-priced car for Wanderer of Chemnitz.

In 1931 Porsche Konstruktionsburo of Stuttgart was registered and Porsche began work on his idea for a small, fuel efficient car anyone could afford. He planned an air-cooled, rear-mounted engine which would be horizontally opposed, have four cylinders and be built of light alloy to obviate weight bias. Unit construction, suspension consisting of swing axles and torsion bars (Porsche invented torsion-bar suspension, incidentally): this was to be the Volksauto.

Almost a decade separates the two 911 Targas; the first (facing page bottom) is a 1973 model, while that shown previous pages dates from 1982. With its Volkswagen and Audi ties, the 924 was considered to be of doubtful parentage by some Porsche enthusiasts. Despite its difficult birth, the model has stood the test of time. Shown facing page top with its red, blue and black stripes and white wheels is the 1977 "Championship Edition" of the 924, which was limited to a production run of 2,000.

Everything appeared to be going Porsche's way when Dr Fritz Neumeyer, of Zundapp Motorcycle Company, said he would back the Volksauto if Porsche developed it for his company.

Motorbike sales had taken a dive during the Depression, hence Neumeyer's interest in a small car. Work began on prototypes, but there was friction between Neumeyer and Porsche; Zundapp's head wanted a water cooled five-cylinder engine; Porsche a flat four air cooled one. Porsche gave in and three prototypes were built, and while tests were being run, Neumeyer had second thoughts. The outlay for the project seemed too high and anyway, motorcycle sales were picking up again.

Early in 1932 Dr Porsche received a visit from three Russian engineers. After being shown a variety of engines and tractor designs (which Karl Rabe assumed to be their main interest) the men left.

Shortly after, Ferdinand Porsche received an invitation to an expenses-paid visit to Russia in order to be shown Russian engineering technology. It was an impressive tour: he was shown everything from aircraft factories to foundries; he traveled from the Caucasus to the Urals; to Kiev and Odessa; and on his return to Moscow he was offered a comprehensive contract which would make Porsche virtually a czar of engineering. Whatever he wanted would be put at his disposal – a blank check would be submitted in his name at the Bank of Moscow. Such was their faith in Porsche and their determination to advance Russian technology.

Porsche realized this was the offer of a lifetime; no more worries, no problems, everything he wanted. Except one thing: Freedom. The only stipulation the Russians made was that Porsche would have to seek permission to cross over the border to the outside world. This meant he would be a prisoner in his own engineering paradise. This decided Porsche that all the uncertainties and problems of the free world were to be preferred to this. He took his leave and returned to Stuttgart, where NSU were waiting with a contract for a small car. This time there was no interference; Porsche had his way and developed a rear, air cooled 1.4 liter engine with four horizontally opposed cylinders and overhead valves. In fact, just like the Volkswagen yet to come.

By early 1934 three prototypes had been built, when NSU found its motorcycle sales booming. Porsche must have had a feeling of *déja vu*; like Zundapp before, NSU pulled out of the car contract. "Motorcycles are selling so well, we can't keep up," said NSU officials. "So we haven't time to develop a car."

Fortunately for Porsche his torsion bar suspension system aroused great interest the world over. Soon his system was being sold to numerous car makers, including Alfa Romeo, Citroen, Morris and Volvo. American companies did not use it until 1955 when Porsche's patent had expired; Packard was first, then Chrysler in 1957. Word spreads when you are good at whatever you choose to do and in Porsche's case this was no exception.

Germany had experienced a traumatic few years since the end of the war. Unemployment was rife, inflation so bad that in the morning 1,000 marks would buy a car; in the evening maybe a postage stamp! The new Chancellor of Germany intended to change that and replace it with full employment, have economic stability, and build the best roads in the world. Adolf Hitler sent for Dr Porsche.

Porsche had little interest in the politics of Nazi Germany; his life was that of the engineer whose concern was exclusively that of his profession and his immediate interest of the "people's car". His reply on the 17 January 1934 to Hitler's request resulted in a meeting with him at the Hotel Kaiserdorf in Berlin.

Hitler informed him that in the development of a people's car, costs were not of crucial importance – but it must be priced below RM 1,000. Porsche explained that the limit could not be less than RM 1,500, to which an aide replied to the effect that Hitler would enable the discrepancy to be met.

Work started in earnest on the people's car, already called the Volkswagen by Hitler in a speech at Berlin's Motor Show. Daimler-Benz was contracted to build 30 prototypes which were tested in 1935 by fifty-five soldiers, for security, Porsche was told. Porsche continued to remain aloof from any political implications that might have been drawn

More prototypes were built as Germany's government got more involved in the project. A large factory was built at Wolfsburg to assemble the Volkswagens and Porsche was well on the way to becoming a legend. Then, on 3 September 1939 Germany became embroiled in war; German tanks rumbled up the new autobahns on an invasion course of Europe. Car production shut down; Volkswagens would have to wait another day, another time. The Wolfsburg factory turned to military vehicles instead.

Naturally Porsche worked throughout the war years; but before discussing what he built for Hitler's armies, let us turn the clock back for a brief précis of some of his other memorable achievements.

In 1932 an already ailing Germany was severely affected by the big depression raging across the world. Many industries went to the wall, particularly car companies. Several found a solution in a merger; at least they might stand a chance of survival. So Audi, Wanderer, Horch and DKW formed Auto Union.

While mergers and dissolutions were going on all round, Porsche busied himself with a V16 engine design discussed with Karl Rabe and other members of his team. Ideas were thrashed out and on 15 November 1932 Rabe produced a sheet of calculations based upon what had been discussed. Items of interest included a 4.4 liter displacement engine, cylinders inclined at an angle of 45 degrees and having the ability to reach 180 mph.

The newly formed conglomerate Auto Union soon came to Porsche with a commission for a new competition car. Would Porsche be able to take on the task? "It is already done; it is here, in my pocket." And so Auto Union had a successful racing car which carried the new company's name past the winner's flag on numerous occasions. In its last year, displacement had risen to 6.3 liters and horsepower was a massive 545. However, with Mercedes winning the races that Auto Union did not, Germany dominated road and track; and it took the war to break its hold.

Accompanied by G. H. Kaes, his extremely efficient secretary, Porsche embarked on a trip to America in 1936, ostensibly to view the American motor industry and its workings. In 1937 he went again, bought a Packard to drive about America in, was fêted by Detroit's top industrialists, including Henry Ford, who told him small cars such as the proposed Volkswagen would not work in America. But then, conservative Henry Ford was applying well-worn ideas instead of trying something new. His philosophy almost killed his company.

Facing page: the classic lines of the 1989 Porsche 911 Carrera (top) contrast with the muscular and rather more modern styling of the 944 of the same year.

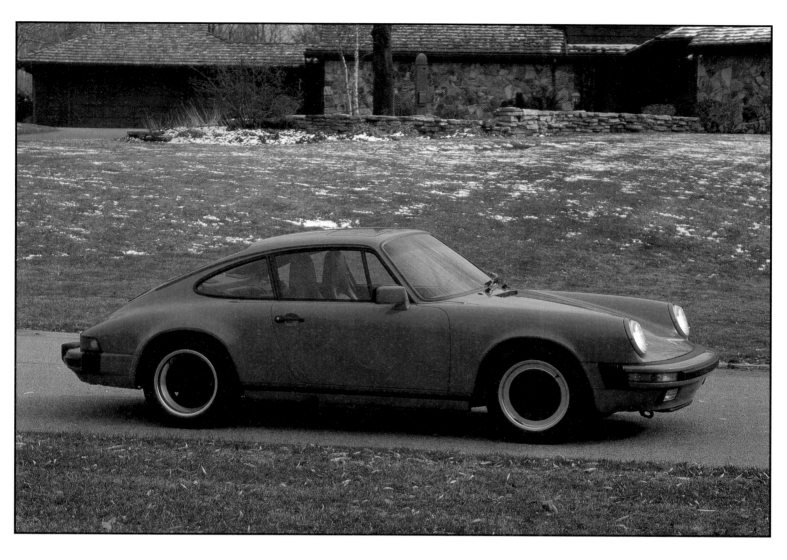

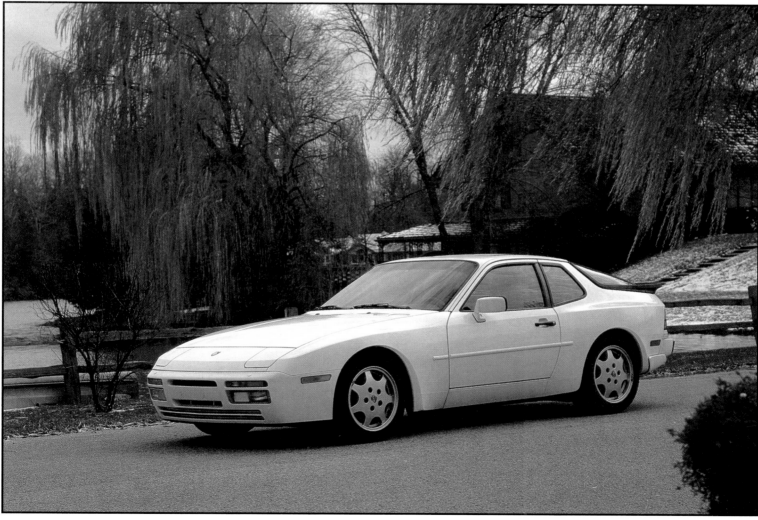

Porsche had traveled to America on the German liner *Bremen*. Preparing to return to Europe, he heard the newest and largest liner in the world, the *Queen Mary*, would be leaving two days before the *Bremen*. Porsche told his secretary to switch his passage from the *Bremen* to the *Queen Mary*. Changing tickets from one carrier to another is never easy at the best of times, and in 1937 for a German citizen to change from a domestic liner to a non-aryan one was tantamount to treachery. Tongue in cheek, secretary Kaes went to the shipping office and asked for a dollar refund on the tickets. The response was predictable:

Impossible! Out of the question! Does not Herr Doctor Porsche understand the strict regulations regarding foreign currency? The good Dr has used up his quota."

It was then suggested that Berlin might waive the rules in Porsche's favor because he was a world-famous figure. Berlin was approached: No, came back the answer. Porsche was livid, adamant in his determination to cross on the *Queen Mary* and see her engines. Then Kaes had an idea. He hurried to Cunard's office, explained the situation, said how keen Dr Porsche was to see the great ship but was unable to obtain the necessary currency with which to buy a ticket.

Good humor is a British forte. So is compassion. Smilingly the British official asked to be excused. Shortly he returned; Porsche and his secretary would be guests of Cunard, they would have first class accommodation and Dr Porsche would be given a sum of British currency to spend on the voyage. Fortunately for Porsche, the Captain reveled in having the rich and famous on board and Porsche fitted that category. So Porsche got his passage, saw the engines, asked many questions including one relating to the ship's angle in a bad storm. "What", he asked, "is the angle at which the Q. M. keels over and cannot straighten up again?" The engineer replied the bridge would have to touch the water. Satisfied, Porsche made a few notes – shortly after, the ship battled its way through a severe Atlantic storm and Porsche was ready, camera in hand, to photograph the *Queen Mary's* angle of inclination during a wind force of ten.

Docking at Southampton, newspaper reporters queried whether anyone had taken pictures during the storm. They were led to Porsche; the next day the national newspapers carried photographs of the storm on their front pages.

During the war years Porsche was contracted to design both military and agricultural equipment. His Wolfsburg factory was turned over to making stoves, farm tractors and the amazing Kubelwagen. This was Porsche's answer to the Jeep. It was really a reworked VW with a military body. Tough as old boots the Kubelwagen could go anywhere, climb any hill, charge over the roughest terrain. This was followed by an amphibious version called the Schimmwagen which had four wheel drive and a detachable propeller.

Porsche may well not have been political but his machinery of war certainly helped delay its inevitable outcome. One weapon he devised was the infamous Tiger tank. It led the blitzkreig against France, Belgium and the Netherlands, and had the Germans not run out of gasoline, the Tiger might have won the Battle of the Bulge. Another famous Porsche designed tank was the Ferdinand.

He had also been working on a tank colossus, the "Mouse". This would have weighed 180 tons, had armor thick enough to have rendered it almost invulnerable and would have had a very large gun. Fortunately the tide of war had turned against Hitler, Wolfsburg and the rest of Germany's armaments factories were destroyed, so the "Mouse" never saw production.

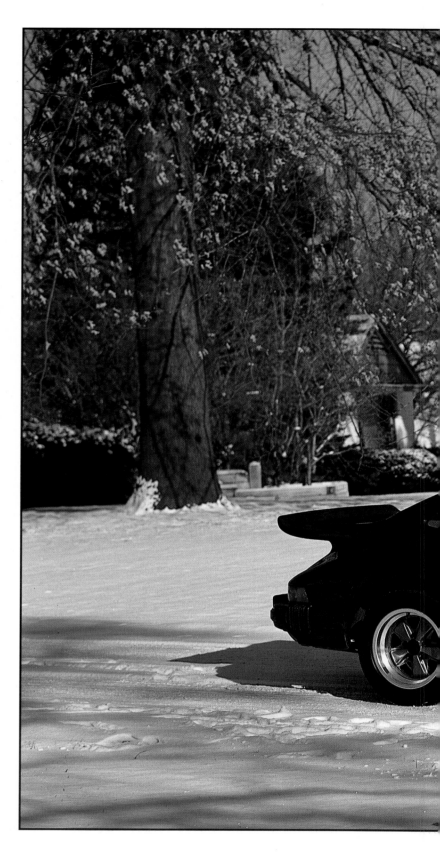

Which brings us full circle, to the deserted, windswept ex-army barracks in Gmund. The cows paid little heed to the half-dozen or so men staring at the abandoned building that had been decreed Dr Ferdinand Porsche's new design center.

Arrested by the Allies, Dr Porsche had escaped trial only through the intervention of Albrecht Speer, Hitler's chief architect. Speer told the authorities that Porsche had never been a Nazi, nor involved in politics. Later, in November 1945, the French invited Porsche, his son Ferry and son-in-law Dr Piech to Baden-Baden to discuss ideas for a French people's car. Discussions started amicably enough but the French, wanting revenge against any German, became increasingly difficult to deal with and threw the three of

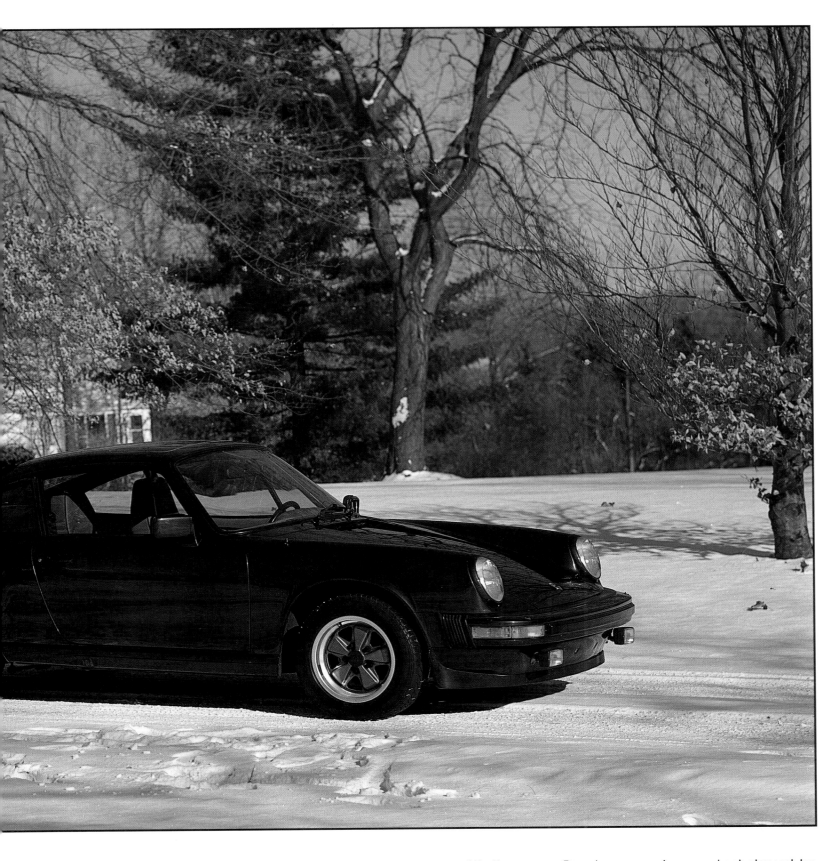

them in prison.

Ferry Porsche was freed earlier than his father and went to assist Karl Rabe at Gmund. Rabe had started repairing ex-Wermacht VW jeeps in an effort to keep going until Porsche returned. This did not supply enough work, so the Gmund factory built agricultural spares and began designing farm tractors. All rather far from the first of a long line of Porsche sports cars – or so it seemed. In fact, they first appeared in 1948.

And with the arrival of that first Porsche 356/2 another star shone in that automotive firmament reserved for the select few recognized as instant classics. It sprang from the restless, inventive mind of Dr Ferdinand Porsche whose achievements spanned the globe. Like other pioneering spirits the young Porsche was not a good scholar yet he had an innate talent no school could have taught. School can refine perhaps, but it cannot teach what is not already there.

As you read this book, you will notice Dr Ferdinand Porsche leaves the stage quite early on. It is his son Ferry who takes up the reins and brings to fruition his father's dreams.

For Dr Ferdinand Porsche was quite a man.

Above: the 1980 911 Weissach Edition. Essentially a dress-up kit, the Weissach was a marketing ploy intended to help boost sales.

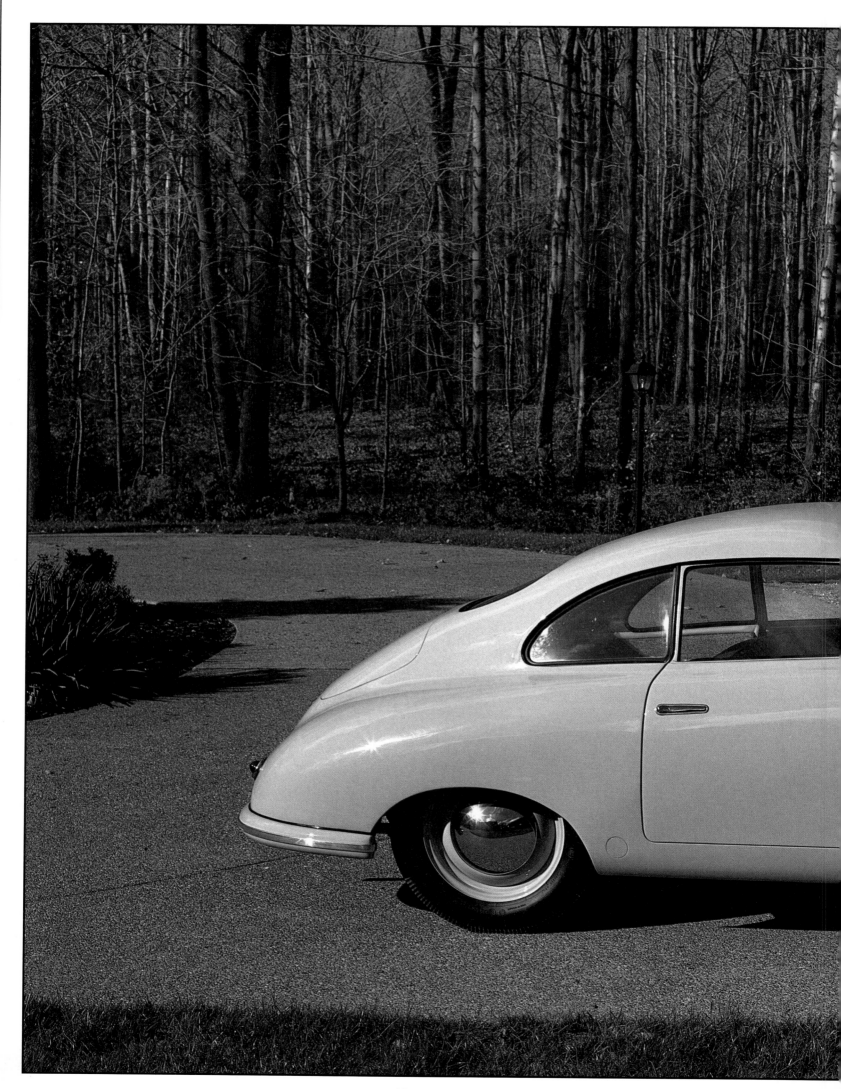

1948 PORSCHE 356/2

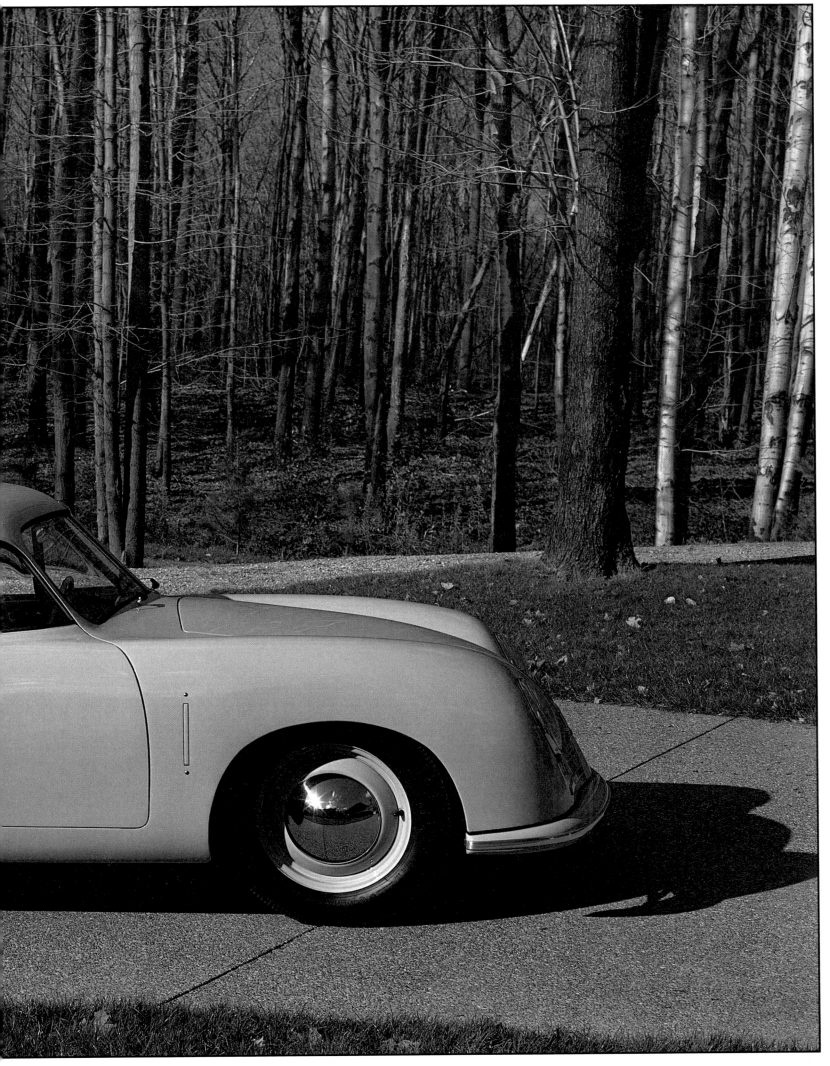

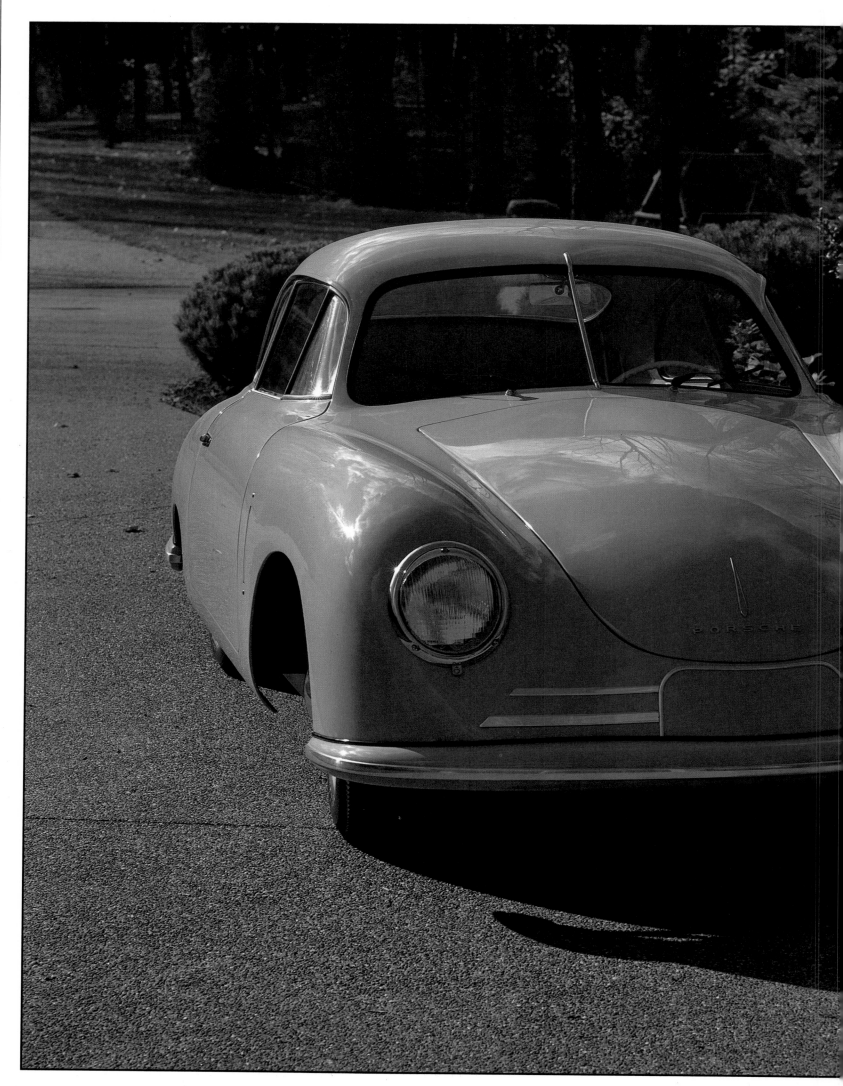

IN THE BEGINNING - THE 356

Erwin Komenda stepped back to review his rendering and liked what he saw. So too, did Karl Rabe and Ferry Porsche. Outside, the wind blew cold across the fields of Gmund, sending an icy chill through the deserted barracks compound that would soon become part of a legend.

The French had seen no reason to keep Ferry Porsche in prison; rather, he might serve their aims better outside. So they released him in the middle of 1946. His father, Dr Ferdinand Porsche, was in a different category and could remain in the unheated dungeon until the million franc ransom was extracted.

Once free, Ferry Porsche lost no time in trying to procure the funds to get his illustrious father released. All Porsche knew was automobile engineering, and the little factory at Gmund would be hard put to raise a million francs on repairing old VW jeeps and sales of tractor spares. With winter coming, Ferry wanted his 71-year-old father to be free from suffering the dark Dijon prison.

Commendatore Piero Dusio was managing director of the Cisitalia Company in Turin, the producer of the little Cisitalia sports cars. They were selling well and the racing versions had successfully put the company's name on the map. Now, once a successful racing driver himself, Commendatore Piero Dusio decided his company should build grand prix cars that would be designed by Porsche.

This was indeed good fortune for Ferry Porsche. The contract to design the Cisitalia Formula One car eventually enabled him to pay for his father's release, which took place in August 1947. Tried *in absentia*, Dr Porsche was acquitted of the trumped-up charges leveled against him – but the French forgot to return the million francs bail.

The months in prison had taken their toll. He did not have the inexhaustible stamina he once possessed, nor the drive that could keep him up all night. But his interest never waned; on his release he studied the designs his son, Ferry, and chief engineer, Karl Rabe, had made for Piero Dusio's Cisitalia GP car. The twelve-cylinder flat opposed, supercharged engine and four wheel drive impressed him, and he said he would not have designed the car differently.

When Dusio launched himself into the world of Grand Prix racing, however, he obviously did so with little idea of what it would cost in time and money.

His plans to build six GP cars came to nought for he had not foreseen the work involved in testing and building just one of these radical new cars, nor the enormous expense that mounted ever higher. This and other problems found Cisitalia's financial position in a perilous state. To save himself and his company, Dusio entered into a contract with General Peron of Argentina to provide that South American country with the means to produce its own line of sports cars and agricultural machinery. It was not before time; Cisitalia decamped to South America with promises from Peron that all debts left behind would be settled.

Although these events did not seriously concern Gmund, there was disappointment over a lost contract and the chance to see the Rabe/Porsche-designed GP car in action. Even the legendary Nuvolari had expressed interest in driving it. This was not to be, as the car never ever saw a Grand Prix race.

Between 1947 and 1948 the little makeshift factory at Gmund, Austria, busied itself experimenting and testing the Porsche 356/1. Various modifications led to the first production Porsche, the 356/2. Only four were built in 1948, and this (previous pages and left) is one of them.

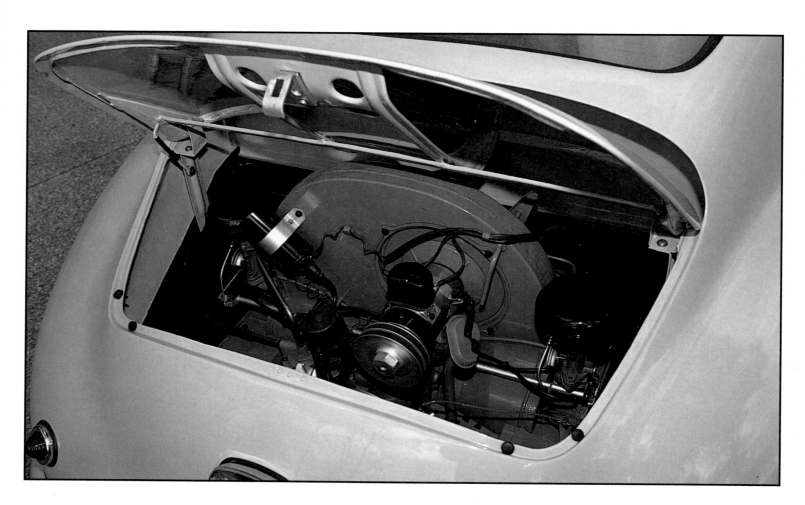

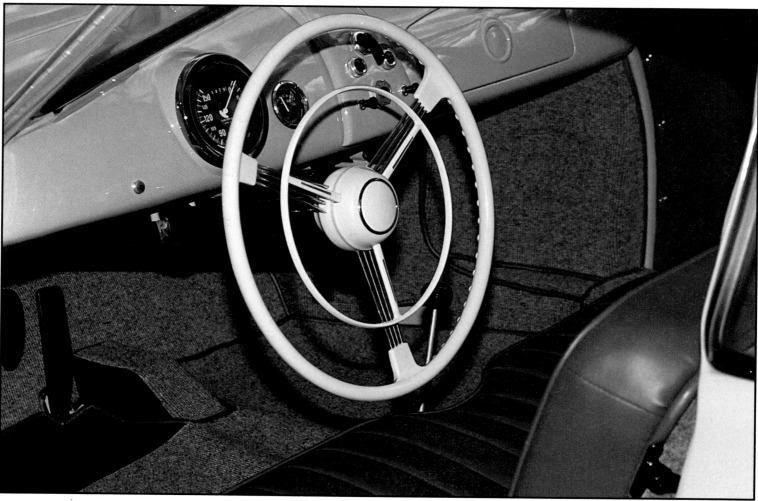

The rear-mounted engine (top) of the 356 is essentially that of the VW with modified cylinder heads. Horsepower was an anemic 40, and top speed a shade over 90 mph. Compared to today's luxo-sporty cars the interior (above) was sparse. A tachometer was not fitted as standard until 1952. The bulbous rear (facing page top) was a Porsche trademark for many years. Decoration (facing page bottom) was scant compared to American cars of the period. Only 51 356/2 models were built between 1948 and 1951.

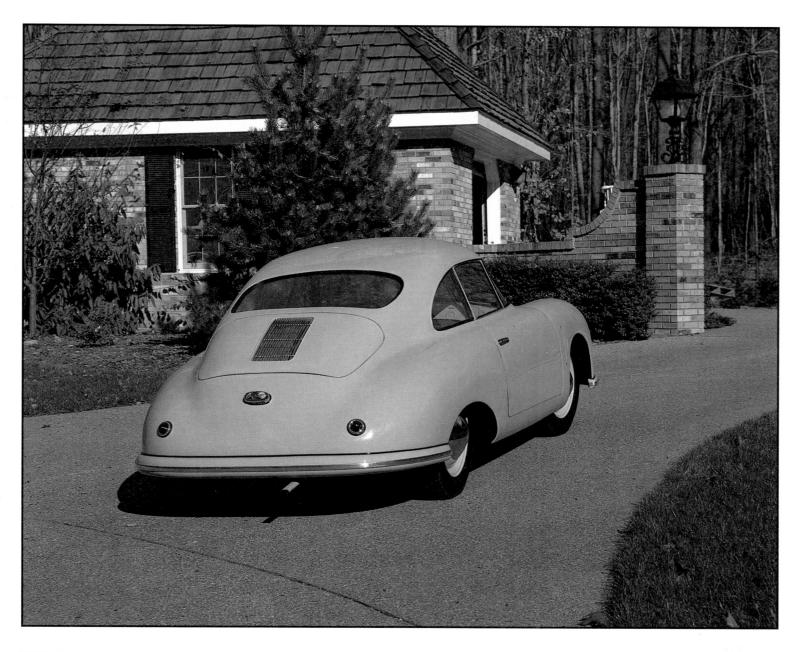

SPECIFICATIONS
1948 TYPE 356 PROTOTYPE

Engine: Four-cylinder horizontally opposed with Porsche-modified cylinder heads. Bore and Stroke: 75 x 64mm (2.853 x 2.52 in.), 1131cc (169.0 cid). Bhp: 40 (DIN), 46 (SAE) at 4000 rpm. Compression ratio: 6.5:1. Overhead valves, four plain bearings, single Solex Type 26VFJ carburetor.
Chassis: Trailing-arm front suspension, swing-axle rear suspension, VW brakes and worm-gear steering, VW 9-inch drum brakes (cable actuated), single dry-disc clutch, VW non-synchromesh gearbox. Final drive ratio: 4.43:1.
Measurements: Weight (lbs): 1324 (unladen). Tire size: 5.00 x 16. Track: 53.4″ front, 53.5″ rear. Wheelbase: 84.6″. Overall length: 152.4″. Overall width: 65.7″. Overall height: 49.8″. Maximum speed: 90 mph. Fuel consumption: 35 mpg.

SPECIFICATIONS
1949 EARLY PRODUCTION TYPE 356 1100

Engine: As per 1948 prototype except twin carburetors.
Chassis: As per 1948 prototype.
Measurements: Weight (lbs): 1332 (unladen). Tire size: 5.00 x 16. Track: 50.8″ front, 49.2″ rear. Wheelbase: 82.7″. Overall length: 152.3″. Overall width: 65.5″. Overall height: 51.2″. Maximum speed: 90 mph. Fuel consumption: 33.6 mpg.

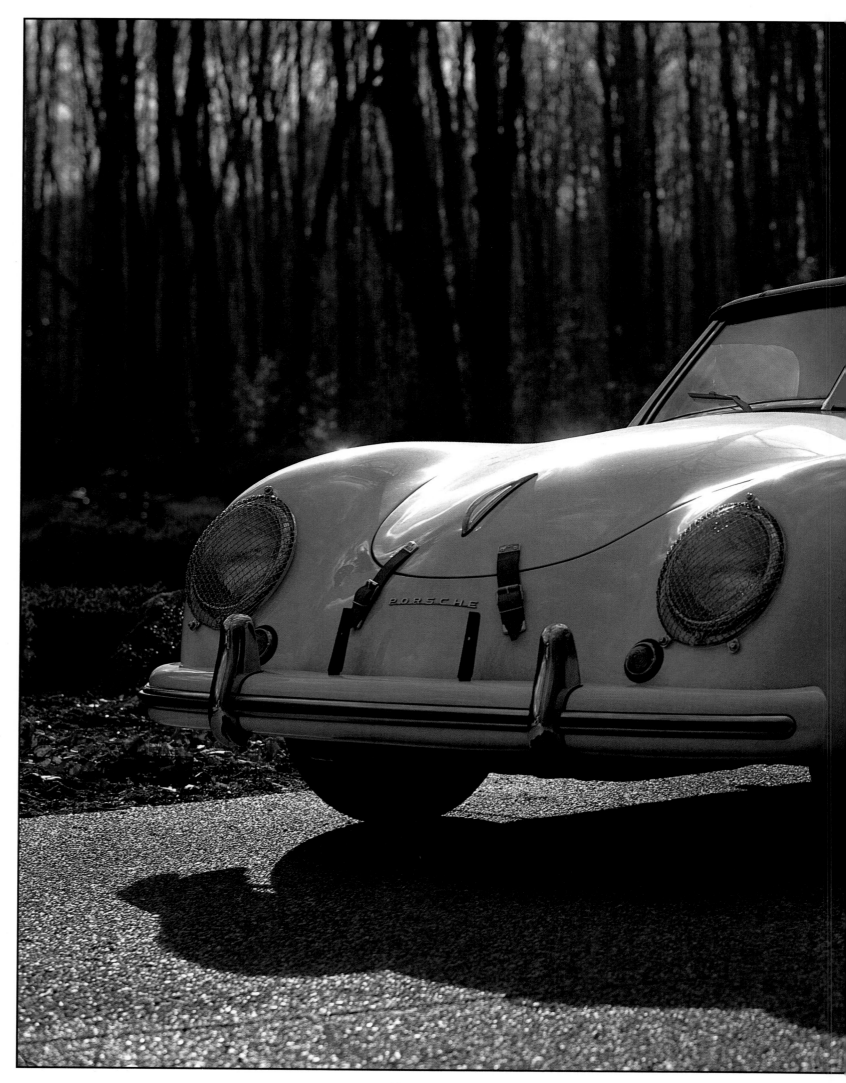

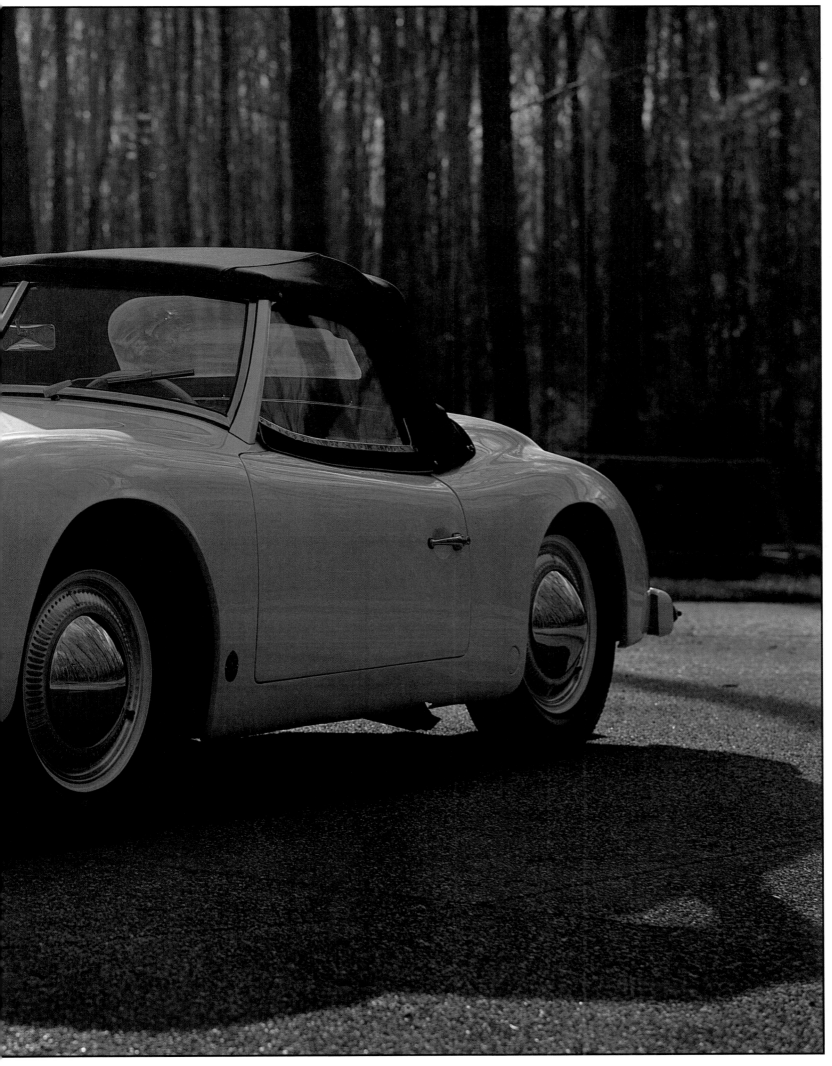

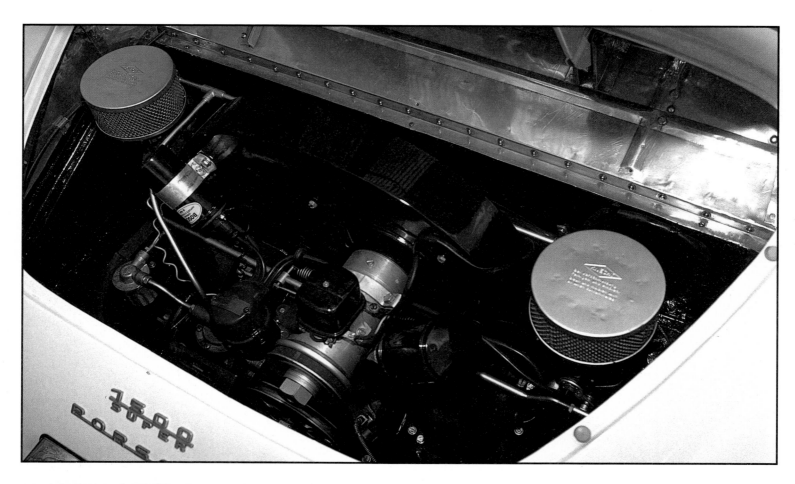

SPECIFICATIONS
1952-55 TYPE 356 1500S

Engine: Porsche Type 528 (528/2 from November 1954), four-cylinder flat-opposed. Bore and Stroke: 80 x 74mm (3.14 x 2.91 in.), 1488cc (90.8 cid). Bhp: 70 (DIN), 82 (SAE) at 5000 rpm. Compression ratio: 8.2:1. Overhead valves, four roller-type bearings, twin Solex Type 40PBI carburetors (Type 40PBIC from May 1954).
Chassis: As per 1953-55 1300S.
Measurements: As per 1953-55 1300S except Maximum speed: 105 mph. Fuel consumption: 21 mpg.

Austrian-born Max Hoffmann, a New York dealer in imported cars, was the man behind the Porsche's introduction into America. He exerted considerable influence on Porsche during the early days and persuaded the company to produce the 1952 1500 Super America (these and previous pages). Hoffmann wanted a lightweight machine suitable for racing, and the factory duly complied. Bodywork was all aluminum and built by Glaser, a distinguished coachbuilder. The Super America's engine developed 70 bhp (DIN), and displacement was 90.8 cubic inches (1488cc). As can be seen, the finish was typically Spartan.

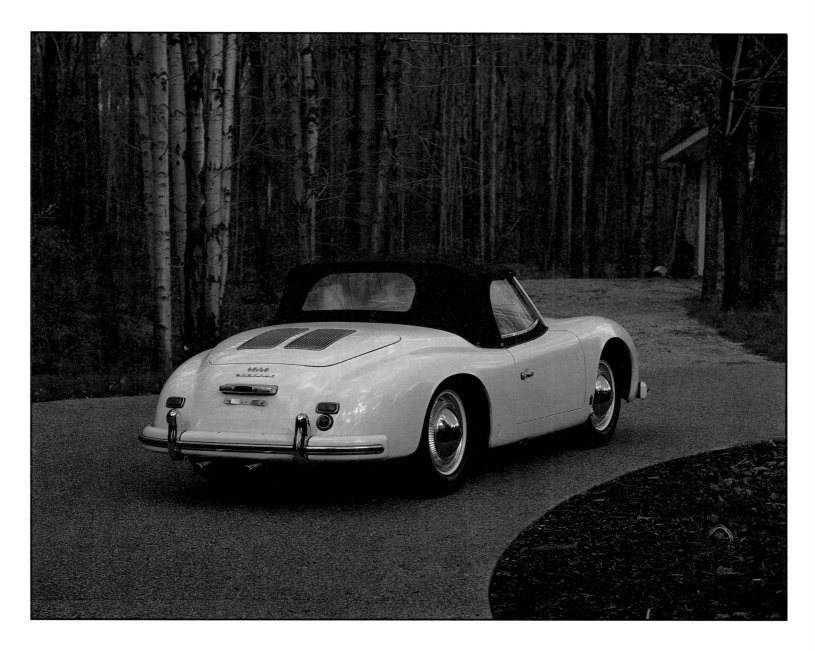

Over the years various people tried to resurrect the Cisitalia without much success. The Germans are very thorough, leaving nothing to chance – in the end one has a perfect piece of machinery but machinery somewhat over-engineered – a look at any modern German automobile will attest to this. When Porsche designed the Cisitalia it needed experts to work on it, to get the best out of it. Unfortunately, the Argentinians were not used to such complex pieces of hardware and after aiming at the Argentine speed record (140 mph in 1953) which ended in dismal failure, the Cisitalia remained at the back of a garage in Buenos Aires and was left to deteriorate.

It was rescued in time when Porsche was designing a museum to be opened on the Stuttgart factory grounds late in 1959. Ferry Porsche remembered the Cisitalia, and considering the car worthy of a place in the museum, he located it and made arrangements to ship it back to Germany. On the day the museum was opened visitors were awed by the sight of this grand car that, in the right hands, could have accomplished so much.

A dozen years earlier at about the time the Ferry Porsche/Karl Rabe duo were roughing out the Cisitalia, another project sat on the drawing boards. Looking at Erwin Komenda's rendering again, Ferry Porsche instinctively knew this was how the car, type number 356, should look.

The general idea for type 356 had actually been laid down before the war. Dr Porsche had envisaged a VW type sports car with a 1.5 liter air cooled engine placed at the rear. This did not happen because the Nazis did not want it to happen – they wanted the Volkswagen, but that too did not materialize. Put on the back burner, the sporting VW would have to wait another day. Now, in 1947, with the Porsches, father, son and daughter (Dr Porsche's daughter Louise helped keep Gmund going during the bad times) together again, it seemed there might be a market for an advanced new sports car.

By the spring of 1948 the reinforced tubular chassis was ready to receive the engine which, in true VW fashion, was placed ahead of the rear axle. This first unit was a 1131 cc standard VW engine developing 40 bhp. This was 15 hp more than the stock VW engine, the rise in power accomplished by modifying the cylinder heads with larger valves and ports. Suspension also came courtesy VW. The rear swing axle suspension was reversed to allow the transverse torsion bar to be located at the rear; the trailing arms then became leading arms. Up front the suspension was stock.

Wheelbase was 85 inches, the weight a miniscule 1300 lb – they wanted to see how light they could satisfactorily make the car. Then the Porsche was test driven on a 32 per cent grade that was part of Katschberg Pass. Up hill, down dale, through the Pass, the Porsche Type 356 prototype took everything in its stride.

Replete with its smooth, almost sensuous body the 356/1 (meaning the first prototype) was nothing short of radical at a time when most manufacturers were still bolting on

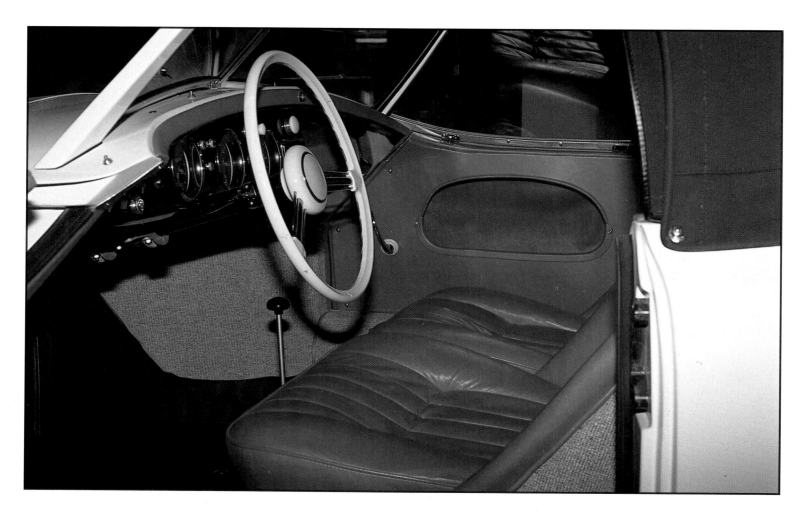

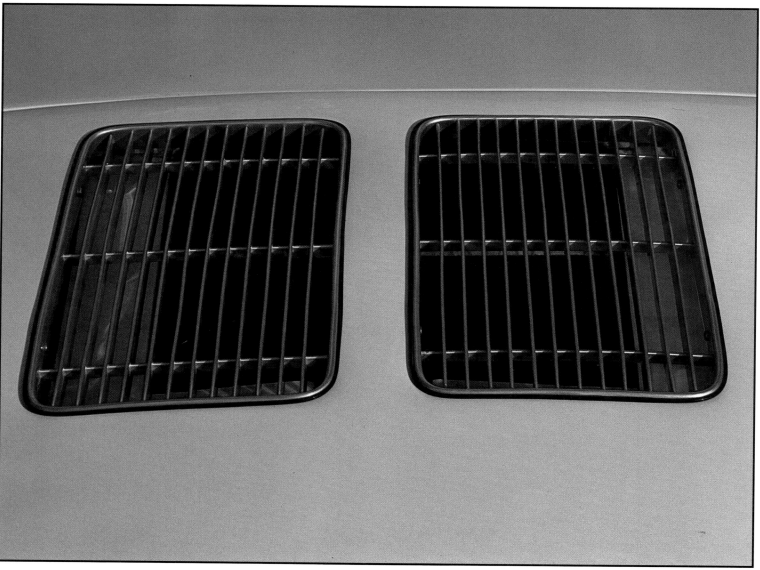

The dashboard (facing page top) on the Super America was sportier than on the 356/2 with more instruments, and bucket seats were definitely race orientated. Facing page bottom: twin grills allowed for efficient cooling of the engine, which was described as the 1500 Super (top). Above: Glaser's tell-tale emblem appeared on the right front fender, and the straps (right) were a sure way of preventing the front from popping open.

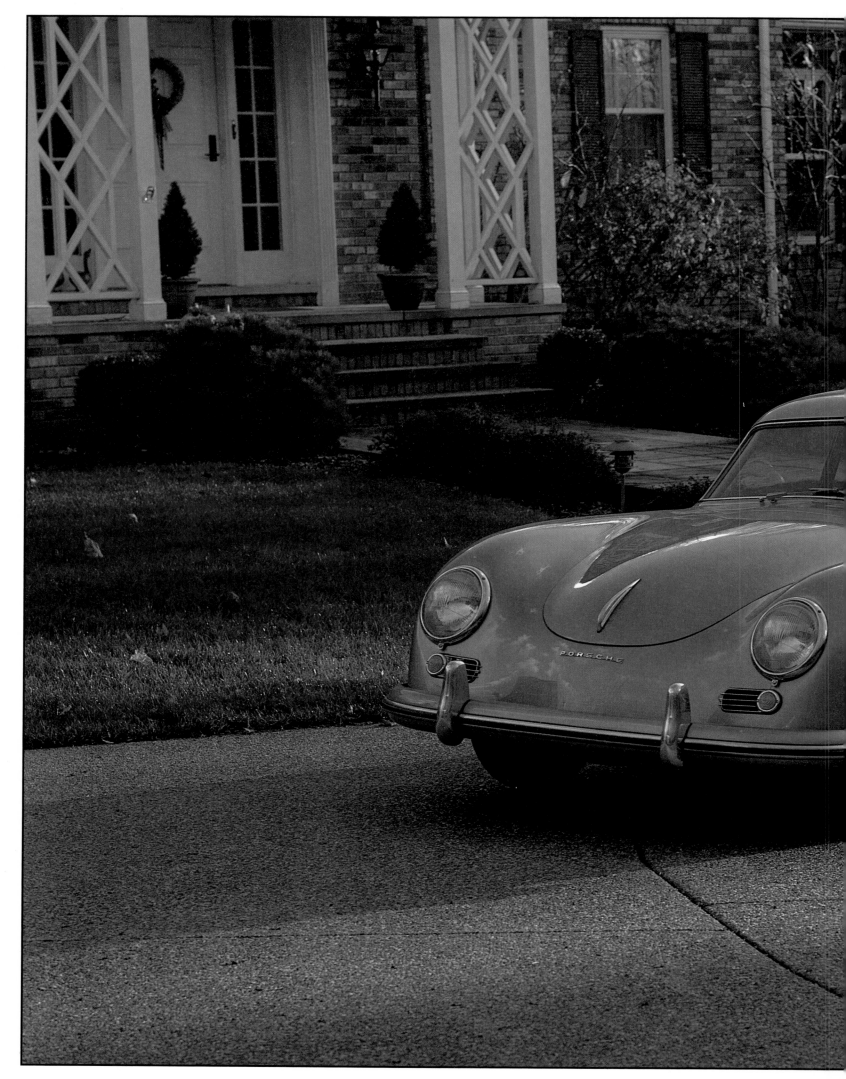

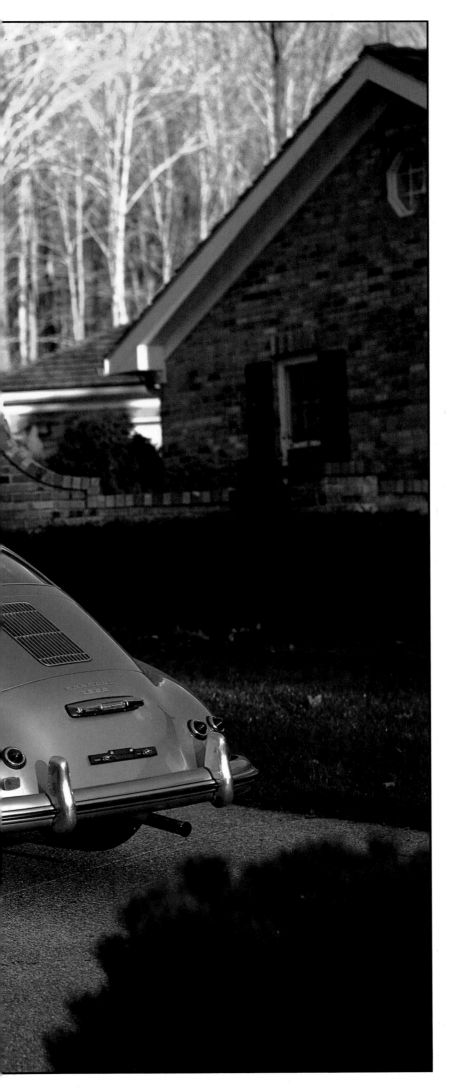

SPECIFICATIONS
1954-55 TYPE 356 1500A

Engine: Porsche Type 546/2, four-cylinder flat-opposed. Bore and Stroke: 80 x 74mm (3.14 x 2.91 in.), 1488cc (90.8 cid). Bhp: 55 (DIN), 64 (SAE) at 4400 rpm Compression ratio: 6.5:1. Overhead valves, four plain bearings, twin Solex Type 32PBI carburetors.
Chassis: As per 1954-55 1300A.
Measurements: As per 1954-55 1300A except Maximum speed: 96 mph. Fuel consumption: 29 mpg.

SPECIFICATIONS
1954-55 TYPE 356 1500S/A

Engine: Porsche Type 528/2, four-cylinder flat-opposed. Bore and Stroke: 80 x 74mm (3.14 x 2.91 in.), 1488cc (90.8 cid). Bhp: 70 (DIN), 82 (SAE) at 4400 rpm. Compression ratio: 6.5:1. Overhead valves, four roller-type bearings, twin Solex Type 40PBIC carburetors.
Chassis: As per 1954-55 1300 A.
Measurements: As per 1954-55 1300A except Maximum speed: 105 mph. Fuel consumption: 21 mpg.

four separate fenders. Much of the design of the car resulted from the experience Dr Porsche and his fellow engineers gained from working on the Auto Union racing car.

A Swiss journal, the *Automobil Revue*, gave the first report on the two seater convertible. By the time the magazine got its hands on it the car had been sold to a Zurich businessman. He allowed *Automobil Revue* to test the car and the tester gave it top marks all round, so eliciting orders from Sweden, Holland and even Portugal where, due to the red tape regarding import licenses, the Portuguese became prepared to trade Porsches for sardines if needs be!

Import licenses were not the easiest items to obtain in a Europe desperately trying to rebuild itself after the war. Certainly automobile purchases would have been regarded as a frivolous, self centered act at a time when most people considered their country came first. There was no problem with Switzerland or Sweden, both neutral during the war but Holland refused to issue the necessary licenses. Especially to Austria, whose wartime allegiance fell on the wrong side of the fence during the war.

Not that the Gmund plant would have been able to fulfill the orders; lack of facilities and the absence of a railway would not allow full scale production. After another Porsche prototype was built, this time a coupé-designed 356/2, production of sorts began in the winter of 1948/1949.

The prototype coupé was developed in parallel with the convertible but it was quite different in concept. It had a different frame, the body was changed (the coupé looked fleshier than ever) and the engine position was set farther back, behind the rear wheel centerline. As for the rear suspension, this was reversed back to the way it was located in a VW.

Designed to carry either coupé or cabriolet bodies, the 356/2 was selected as the production prototype over the 356/1 roadster, which was much modified to meet production specifications.

As much of the Porsche 356 relied on Volkswagen parts, a new contract was obviously necessary with the Wolfsburg

It had been intended to produce only 500 Type 356s (previous pages and left), but by March 1954 car number 5,000 rolled out of the factory – a glowing testament to the popularity of the model. The rounded aerodynamic shape was destined to stay with Porsche, albeit in various forms, to the present day. Apart from the twin tail-lights either side, the rear has changed remarkably little since 1948.

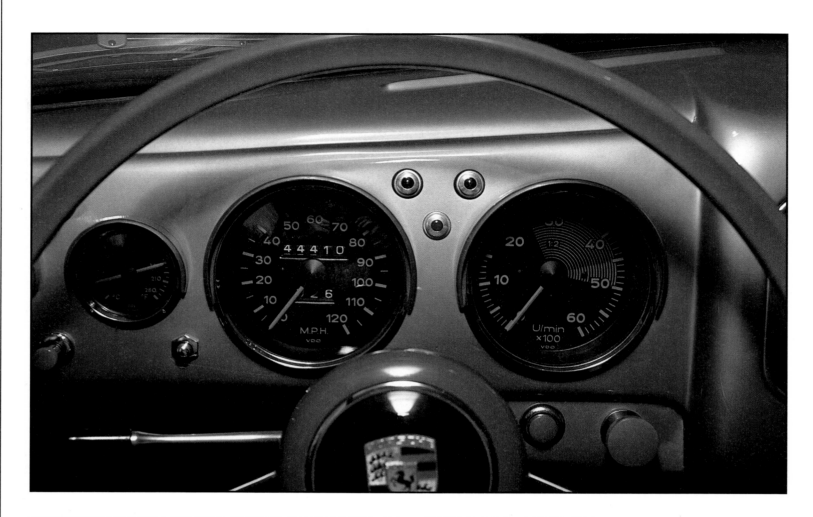

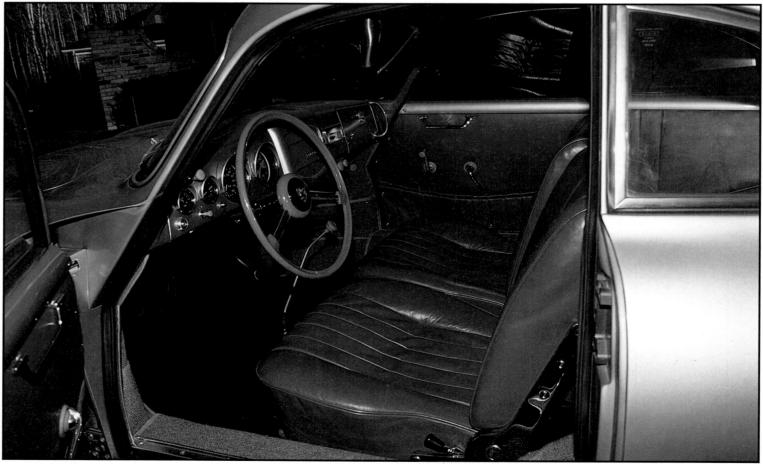

The 120 mph speedometer and 6,000 rpm tachometer (top) on the 356 were typically sporty, with white numbering on a black dial offering excellent legibility. The interior (above) displays good taste and high quality finish. Facing page top: the 1500cc horizontally-opposed flat four features twin Solex carburetors, with cooling via a single grill (facing page bottom left). The grills under the headlights (facing page bottom right) are decorative horn covers.

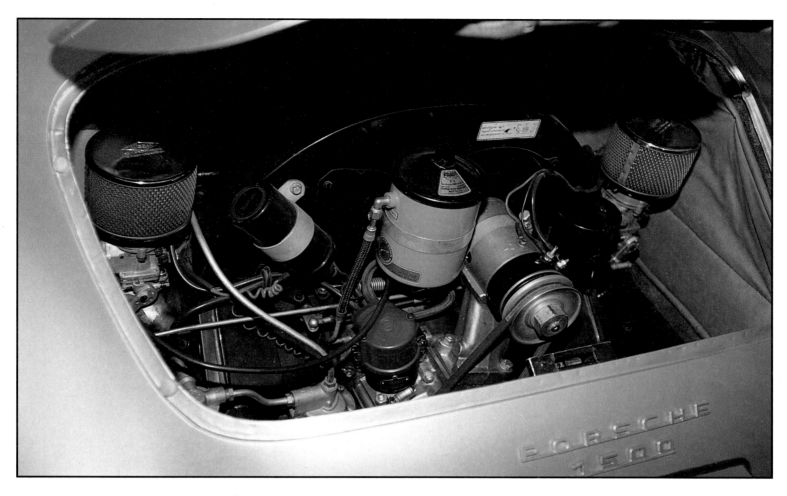

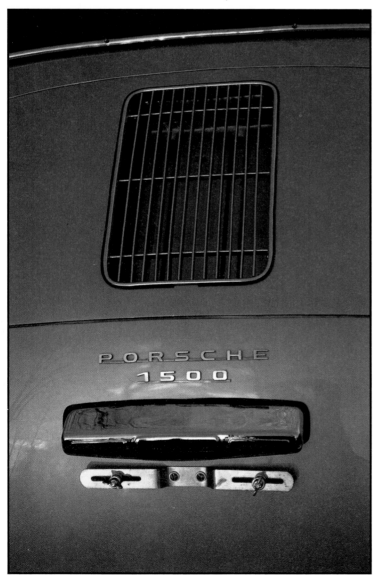

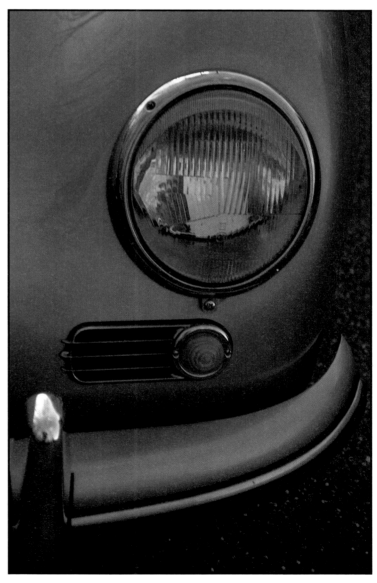

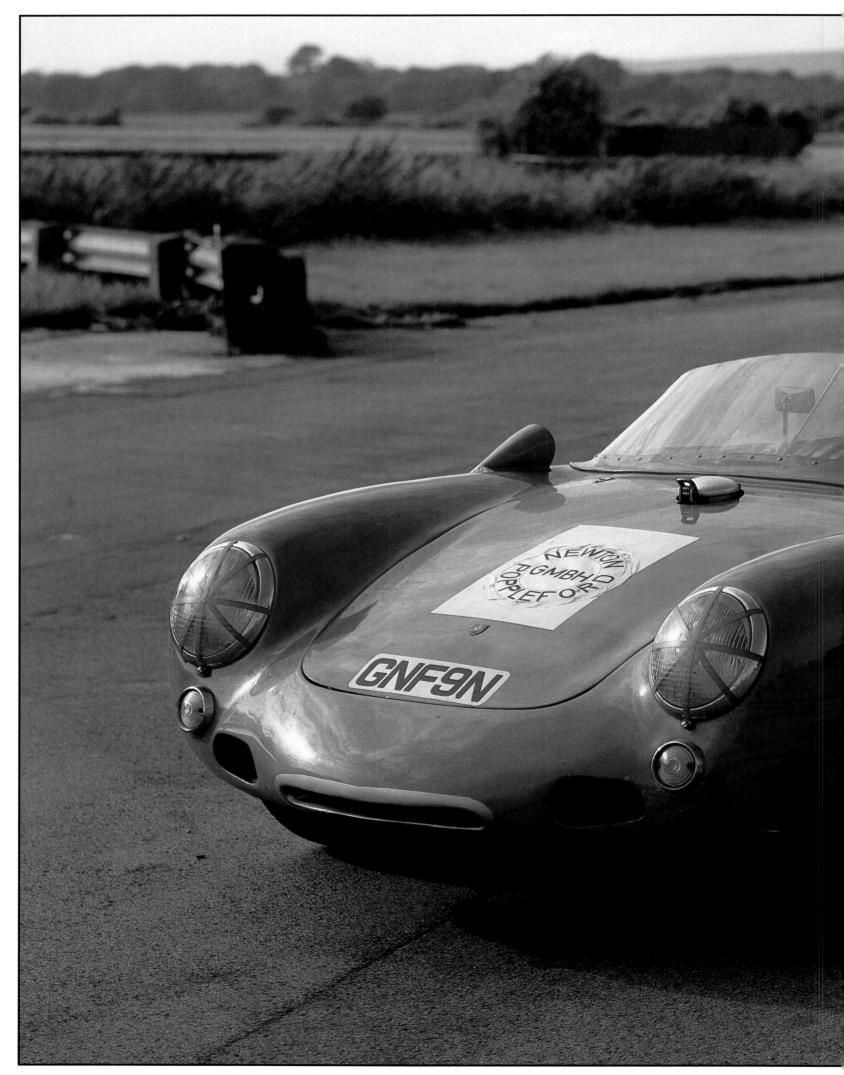

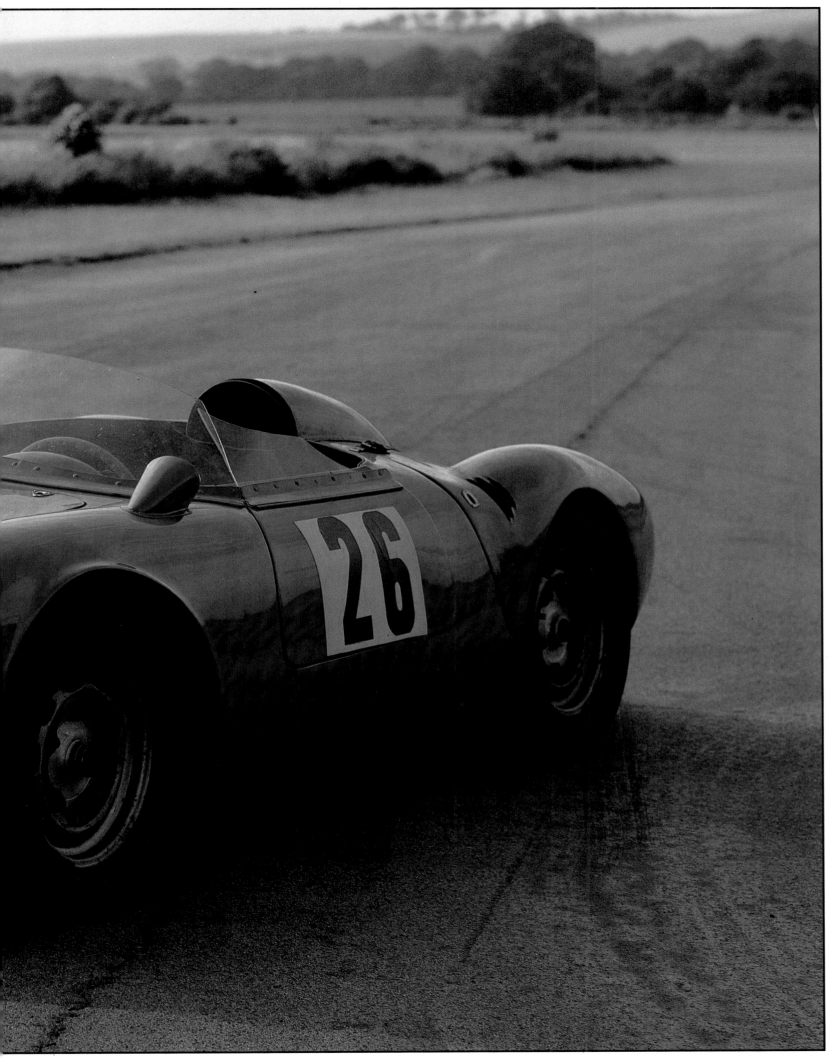

PORSCHE SPYDER SPECIFICATIONS

year	model	bore x stroke	cc	CR (:1)	bhp @ rpm	gears	WB (in.)	length (in.)	width (in.)	height (in.)	weight (lbs.)
1953	550/528	74.0 x 80.0	1488	9.0	79 @ 5200	4	82.8	141.8	61.0	40.0	1512
1953	550/547	66.0 x 85.0	1498	9.0	110 @ 7000	4	82.8	141.8	61.0	40.0	1500
1954	550/547	66.0 x 85.0	1498	9.0	110 @ 7000	4	82.8	140.0	60.0	40.0	1500
1955	550S	66.0 x 85.0	1498	8.8	110 @ 6200	4	82.8	140.0	60.0	40.0	1440
1956	550/1500RS	66.0 x 85.0	1498	9.8	135 @ 7200	5	82.8	149.5	63.8	36.0	1301
1957	718/1500RSK	66.0 x 85.0	1498	9.8	142 @ 7500	5	82.8	149.8	58.3	34.6	1146
1958-59	718/1600RSK	66.0 x 87.5	1598	9.8	165 @ 8000	5	82.8	149.8	58.3	34.6	1148
1960	718/RS60	66.0 x 87.5	1598	9.8	165 @ 8000	5	82.8	149.8	57.8	34.9	1058
1961	718/RS61	66.0 x 85.0	1498	9.8	150 @ 7800	5	82.8	149.8	57.8	34.9	1058
1961	718/RS61	66.0 x 87.5	1598	9.8	165 @ 8000	5	82.8	149.8	57.8	34.9	1058

BHP is DIN measurement

factory. Remember, before the war the plant was set up as a separate entity; it was Porsche's design but he did not own the company. After the war the British, having turned down the offer of owning VW, had installed Heinz Nordhoff to head the company which the British considered stood no chance. The official who declined taking VW for Britain must have felt very foolish by 1950 when Germany and Austria were overrun with "Beetles". Within fifteen years the Volkswagen was the most popular small car in the world.

On 17 September 1948 Nordhoff and Ferry Porsche negotiated a new agreement whereby VW would pay Porsche a royalty for each Volkswagen leaving the plant; that Volkswagen parts would always be available for use in any Porsche sports car and Porsche would also have joint use of Volkswagen's dealerships across the globe. In return, Porsche agreed not to design any small car competitive to VW for any other company and would allow VW to use any Porsche patents in its designs, free of charge. Furthermore, Porsche engineers would be on hand to serve Volkswagen as consultants should the need ever arise.

A contract was drawn up, duly signed, and Porsche was in business. Not quite, though. There was the frustration of trying to produce cars in volume which had proved to be impossible in small, out of the way Gmund. At the time, each car was completely hand assembled, the bodies beaten and shaped out of aluminum over wooden dies. This was done by one man, a panel beater whom Dr Porsche had known when he worked at Austro-Daimler. He was excellent; one of the best in the trade. However, there was one minor snag – drink.

The panel-beater was too fond of alcohol. When he worked he worked hard; if it was necessary to work all night to meet orders, he would. The entire production staff of 300 relied on his hammering and shaping of the bodies to be mated to the finished chassis. All would be well. The cars would roll on to the next-to-last stages of upholstering and wiring before final assembly. Then the craving for a drink would be irresistible, and when that happened, everything stopped. Perhaps for a couple of hours, maybe a couple of days, it all depended on how much of the "ole devil drink" he desired. Normally it was enough to render him incapable of anything but sleep for quite a while.

Bearing this in mind and remembering that these cars were completely hand built it is surprising that Gmund turned out five finished cars a month. Orders were becoming more frequent and pressure to turn the cars out on schedule was increasing. Porsche needed to return to their factory at Zuffenhausen, Stuttgart. In an effort to persuade them to allow Porsche to return, an approach was made to the mayor of Stuttgart, who in turn approached the Allied Occupation Forces, the ruling body for that area.

While the military government was sympathetic, its hands were tied. The US army used the factory as a parts depot and repair shop for military vehicles and no amount of pleading would make the GIs give it up at short notice. If Ferry Porsche and his father could wait, maybe a year, the unit would then be transferred elsewhere. Then Porsche could have his factory back.

Late in 1949 preparations began for the move back to Germany. Staff from Porsche's Gmund offices were sent to Stuttgart to lay down the framework for the move to take place on 1 September 1950. Just as everything was being finalized, an unseen hitch occurred, for, on 12 June 1950 Communist North Korea invaded the South.

It was fortunate that discussions and eventual agreement had taken place with Reutter Karosserie, a prominent coachbuilder whose premises were almost next door to what would shortly become Porsche's factory again. The agreement was for Reutter to build five hundred 356 bodies initially, more if all went well. At this point, body materials switched to steel as Reutters had little knowledge of alloy construction.

World politics are complicated and the North-South Korea conflict paid no attention to the needs of a struggling motorcar company in Europe. Because America and other UN countries became involved in the war with the North Koreans (then, shortly after, with the Chinese) the US military authorities in Germany destroyed the Porsches' hopes: they would be unable to hand back the factory in its entirety at that time. Long-drawn-out negotiations began with the American command until finally agreement was reached, this time a guaranteed US pull-out from the place. While all this talk went on, Porsche "borrowed" space from Reutters to make complete cars. Production started up in later summer 1950, and about ten cars a month started to leave Reutters.

In the bleak years at Gmund only 50 cars were built, but today what remains of those aluminum-bodied 356/2 coupés, convertibles and cabriolets (the latter being mostly fitted with coachwork by Beatler of Switzerland) is history indeed. Their monetary worth at the present time must be considerable.

Previous and facing page: the 1955 version of Porsche's first true racing car, the Type 550 Spyder. Engineer Ernst Fuhrmann modified the existing pushrod engine with four camshafts placed on top of the cylinder barrels to serve the widely spaced valves. A stopgap Type 550 powered by a tweaked pushrod engine won races and fared well across Europe in 1953. The four-cam engine was ready by August 1953 and distinguished itself the following spring with a class win in the Mille Miglia. Many international successes followed, and the car shown here no doubt appeared at the Goodwood track, the location for these photographs.

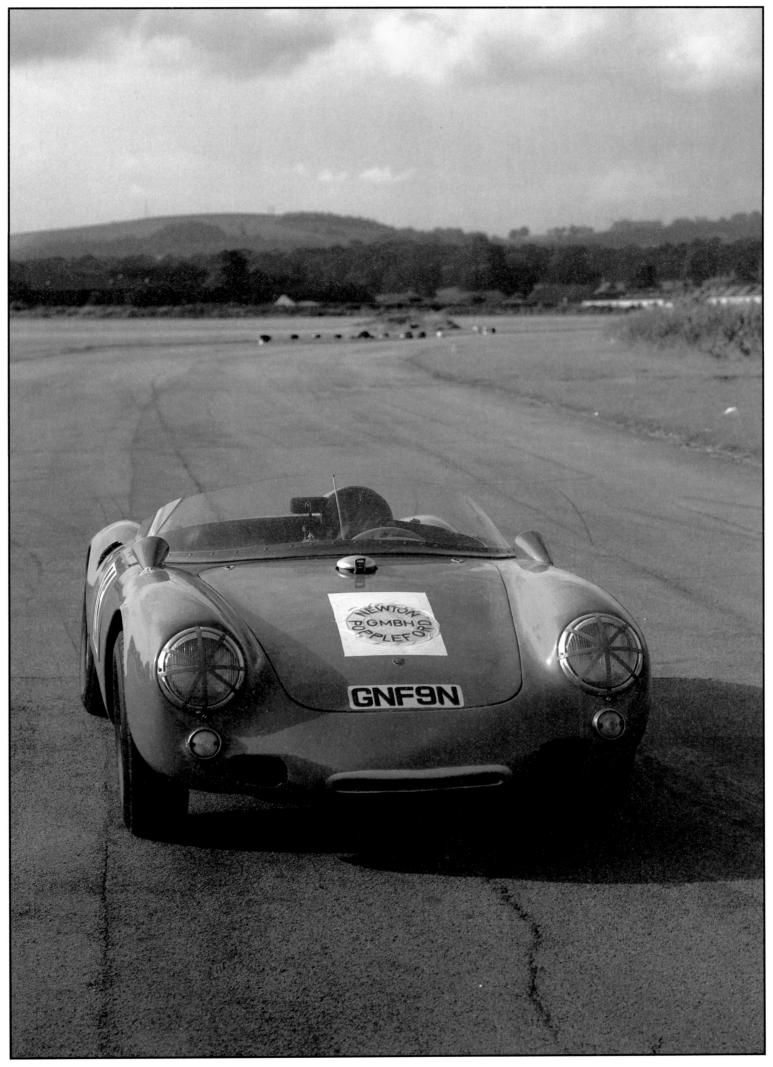

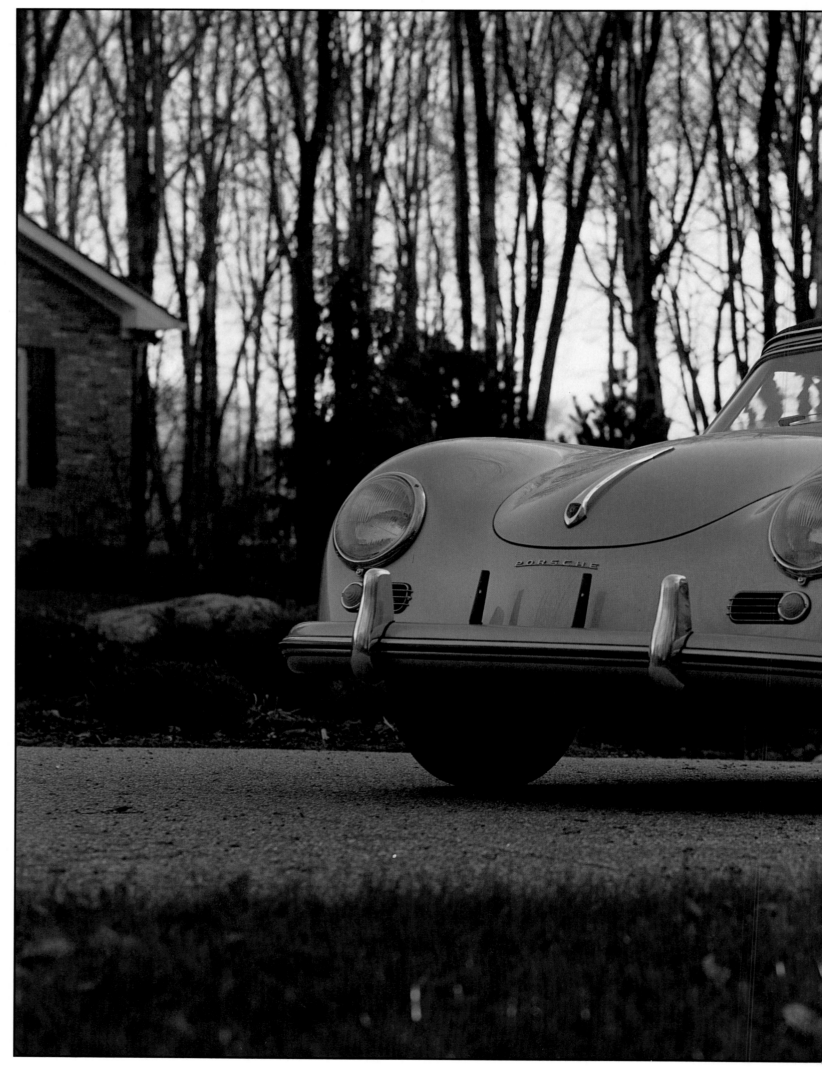

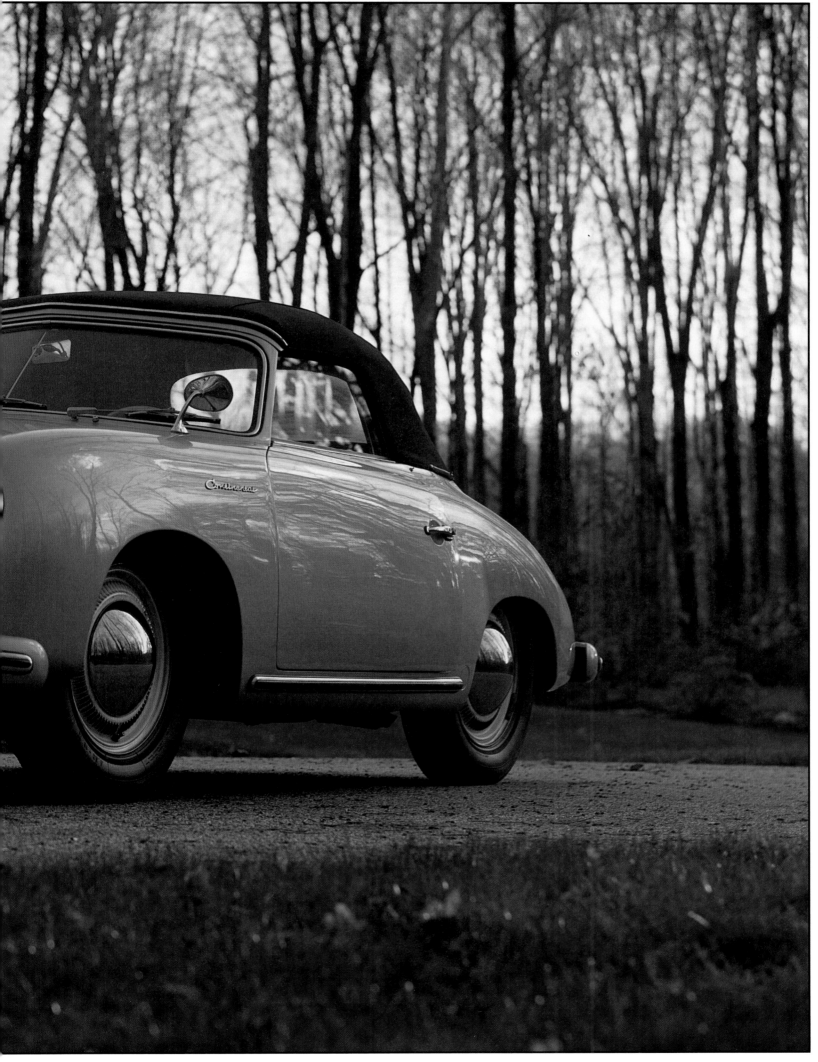

Dr Ferdinand Porsche, though somewhat weakened by his immediate postwar experiences, still took an active part in the running of the company, even if his son, Ferry, now did the lion's share. He had returned to live in his beloved home at Zell am See, not too far from Stuttgart, an estate that has remained in the family to this day. On the 3 September 1950 Dr Porsche celebrated his 75th birthday and on that day an unprecedented event took place when, from all over Germany, Porsche owners turned out to pay their respects, their cars lined up in front of Castle Solitude, near Stuttgart. As Dr Porsche moved amongst the owners, shaking them by the hand, pausing to say a few words, it was seen he was much moved by this almost unique demonstration of respect and loyalty, a bond cemented that day among Porsche owners and continued ever since.

Starting up production in Stuttgart took a considerable amount of money, much more than Volkswagen's royalty payments, then virtually the only income Porsche had. Realizing how desperate the situation was, Ferry Porsche's old friend and company business manager, Alfred Prinzing, undertook a sales campaign in a Porsche coupé across Germany. He visited VW dealerships, regaled the owners with drives in the 356/2, and returned triumphant with thirty-seven orders worth 200,000 marks in his pocket. Added to the VW payments this enabled Porsche to get under way. It was around April 1950 that the first all-steel, German made Porsche rolled out of Reutter's doors.

Due to the unexpected popularity of the Porsche, production soared to forty, sixty, eighty cars a month. Much of this popularity stemmed from Erwin Komenda's memorable design which he further improved for the German-made models. The divided windshield was enlarged, the front quarter-light windows were removed but the glass area narrowed due to a higher waist-line, and wheel arches were given a more rounded look.

While the 550 was chalking up a name for itself, Max Hoffmann suggested that all Porsche cars destined for the U.S. market be called "Continental." This was accepted as sound advice, and all Porsches sent to the United States had the name in gold affixed to their sides. Previous pages and right: the 1955 Porsche 356/1500 Continental.

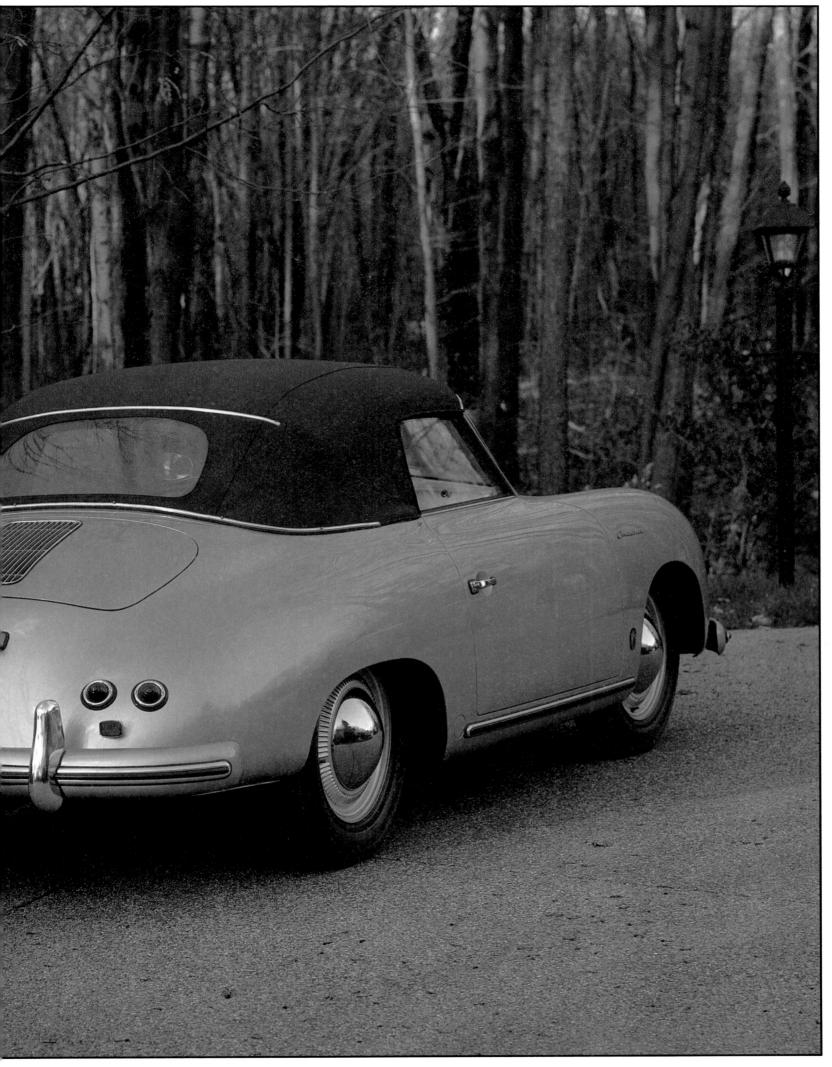

Following VW's lead (they were more or less obliged to in the early days), Porsche adopted hydraulic shock absorbers. Instrumentation remained sparse but at least an oil pressure gauge was added. This, then, was the Porsche 356 which remained in production, albeit with constant improvements and modifications, for thirteen years and 78,000 units.

In April 1951, in time for the Frankfurt Motor Show, Porsche introduced a revised engine, the Type 369 bored out to 3.14 x 2.52 inches to allow for a displacement of 78.5 ci (1286 cc). This, allied to aluminum cylinders (they were cast iron before) and the car realized a claimed 44 bhp – or 4 more than with the 1100 engine. Top speed went up by two or three miles an hour to, 92-94 depending of course on wind direction.

In the autumn of 1951 tragedy befell the Porsche family when Dr Ferdinand Porsche suffered a stroke. This was a blow from which the great pioneer did not recover, and on 30 January he passed away.

He had lived long enough to witness the fruition of his long-held vision of his own people's car. On a drive to Wolfsburg for part of his 75th birthday celebration Dr Porsche saw many dozens of VW "Beetles" driving along the roads, and this proof of the realization of his early dream moved him to tears. He had assisted at the birth of a dream that carried his name to every corner of the world. With other great pioneers of motoring, his immortality lives as an artist at his craft with the mind of a creative genius for whom no mechanical problem was impossible.

Now Ferry Porsche had absolute control of the company he had helped found. By 28 August 1951 the 1,000th Porsche left Reutter's works. Some were still built at Gmund until March, when all production finally switched to Germany. It was also in 1951 that Porsche decided sporting events would be worth the effort; private individuals had raced their own cars, but the Porsches entered for the 1951 classic Le Mans 24 hour race were works cars.

Only one, a silver-grey Gmund-built car, actually participated. It had the 66.3 cid (1100 cc) flat four tweaked to deliver 44 bhp. Driven by two Frenchmen, Veuillet and Mouche, the little Porsche won its class with ease, a point driven home by the fact that the car was a production vehicle, not a "one off". This was the beginning of a successful racing career continued to this day; Porsche's record is so good, that the knowledge the Stuttgart firm is entering a team provides a greater threat than several Ferraris in the same event. Teutonic efficiency has few equals in this world of sport.

Twin tail-lights and reflector (top) were purely functional, as was everything else with the 356. The chrome bar on the hood (right) was growing, and this now carried Porsche's shield, the rough design of which is credited to Ferry Porsche, who drew it on a table napkin at the behest of Max Hoffmann. The final design was executed by artist Eric Strenger.

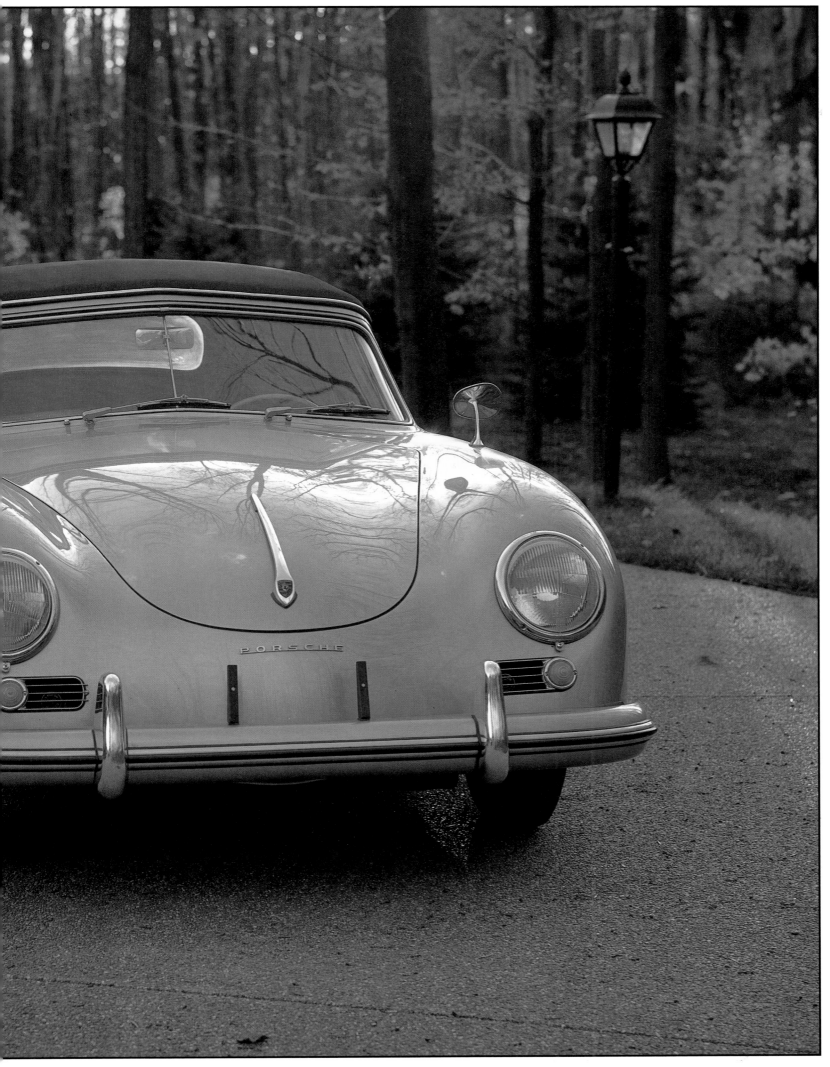

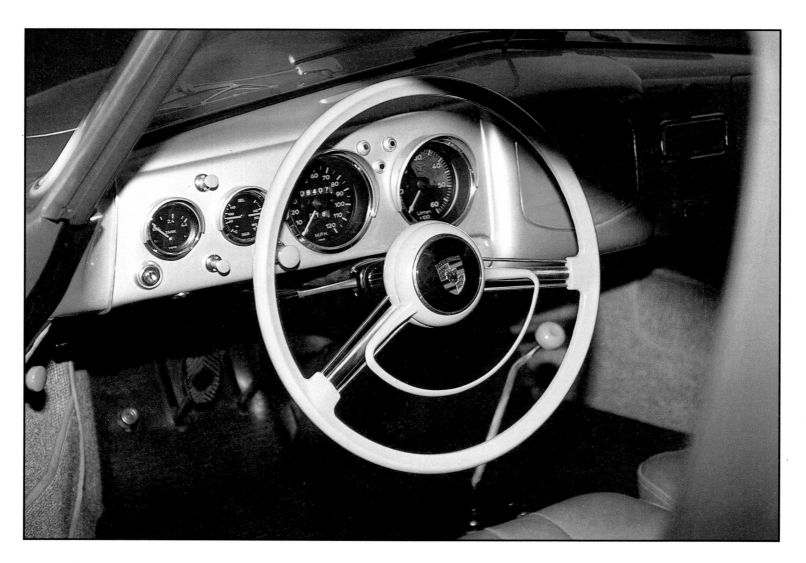

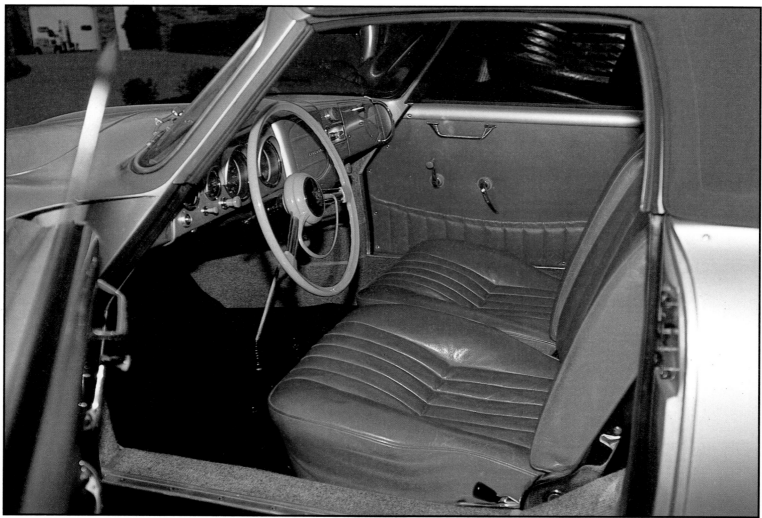

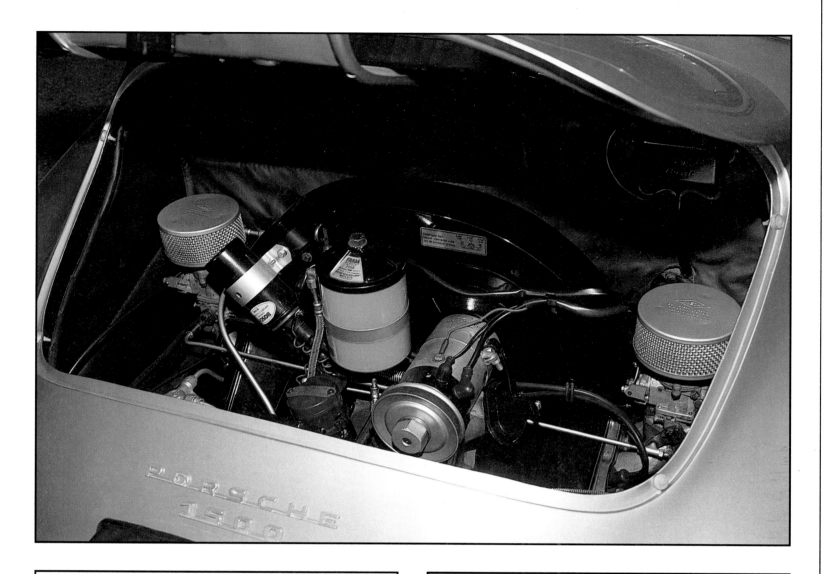

SPECIFICATIONS
1952-55 TYPE 356 1500

Engine: Porsche Type 546, four-cylinder flat-opposed. Bore and Stroke: 80 x 74mm (3.14 x 2.91 in.), 1488cc (90.8 cid). Bhp: 55 (DIN), 64 (SAE) at 4400 rpm. Compression ratio: 6.5:1. Overhead valves, four plain bearings, twin Solex Type 32PBI carburetors.
Chassis: As per 1953-55 1300S.
Measurements: As per 1951-52 1500.

Facing page top: a full set of legible instruments graces the Porsche 356 1500's dash while the nicely contoured bucket seats (facing page bottom) appear to be taking on a more luxurious appearance. The engine bay (top) looks roomy enough to prevent scraped knuckles when working on the engine. Right: the emblem on the right front fender, behind the wheel arch, identifies Reutter as being responsible for the coachwork.

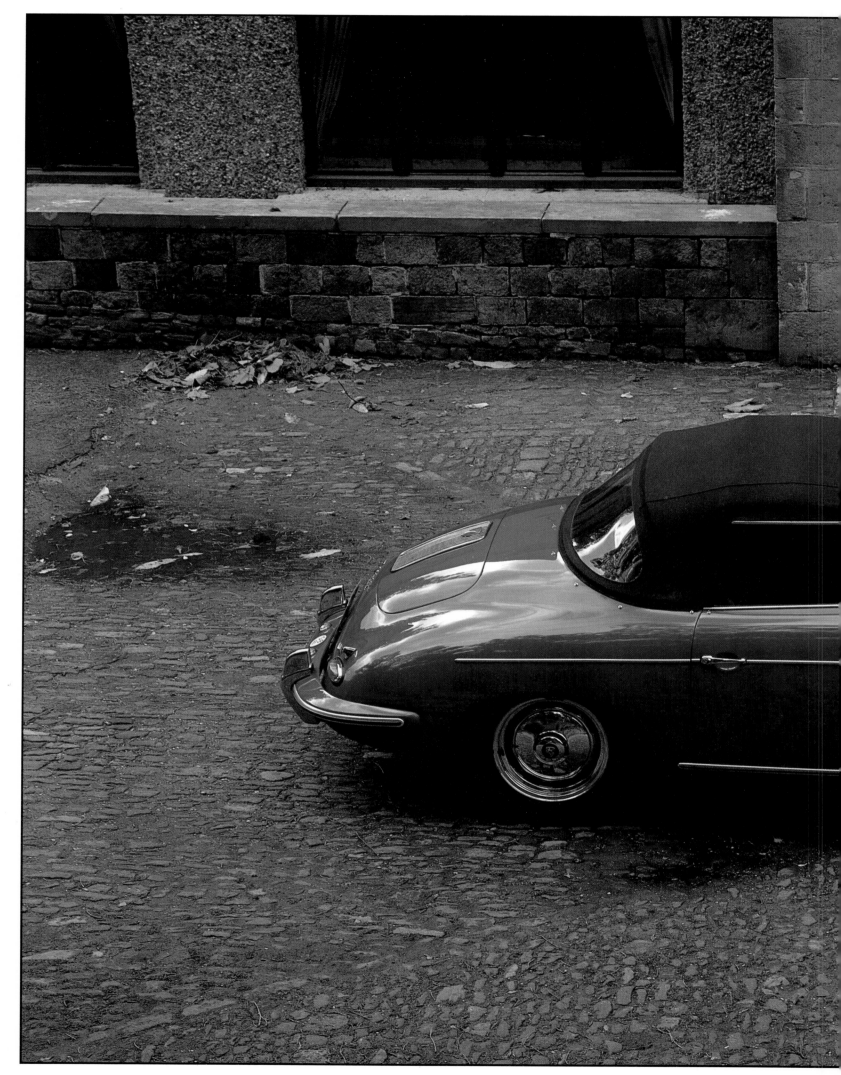

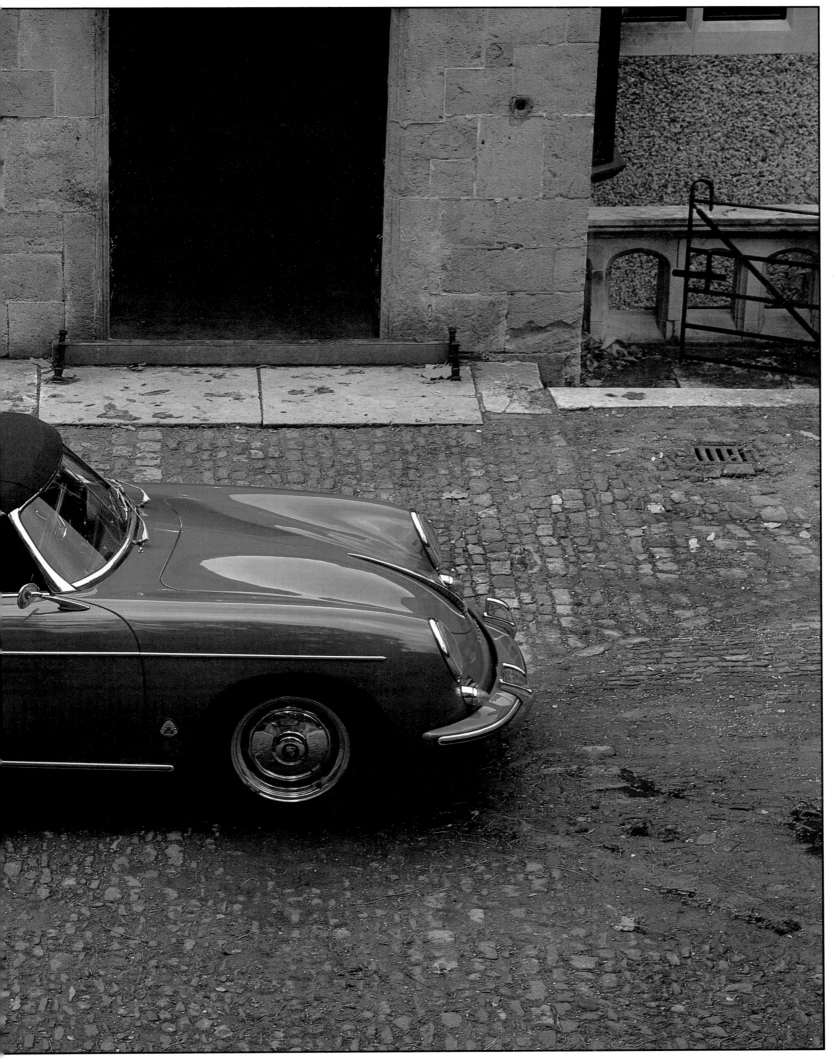

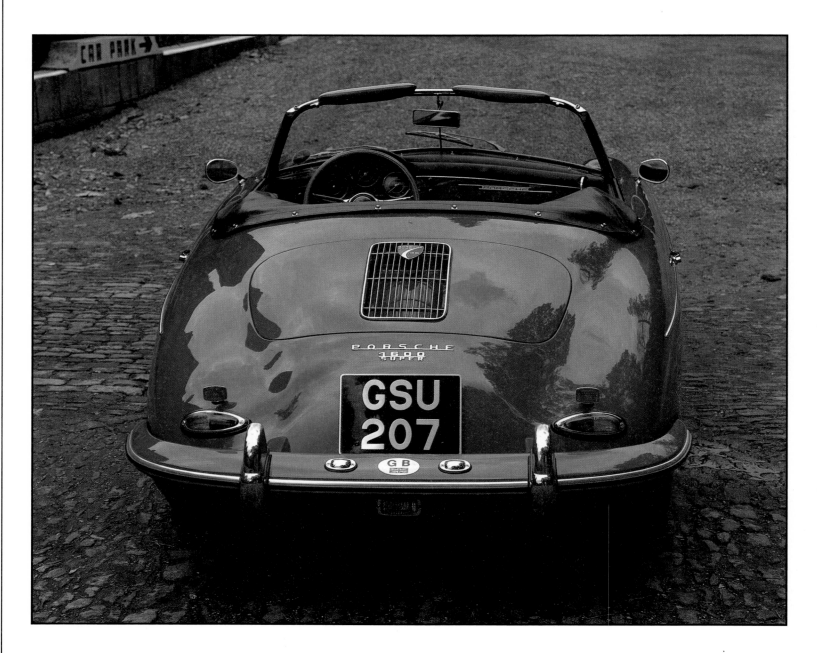

Selling cars in Europe five years after the war was not easy – Switzerland excepted of course. Currency restrictions, high taxes, prohibitive import duties all served to create barriers. One country amazingly free of such restrictions was the US. Enjoying the good life to an unparalleled extent, America was importing from Britain truckloads of MGs, Jaguars, and whatever else the UK could include in merchant ships' holds. Thus Porsche made it known that America was next on its export list.

Most of the credit for Porsche's introduction to America in 1950 was due to Max Hoffmann. A New York City dealer, Hoffmann was also responsible for bringing in the Volkswagen, selling two in 1949. By 1954 he was selling approximately ten, maybe a dozen, Porsches a week, but realized his error of having given up the VW franchise; he thought Americans would not buy the Beetle!

Another engine came in 1951, this time enlarged to 80.8 cid (1500 cc). It developed 55 bhp (DIN) at 4500 rpm and was good for 96 mph. Referred to as the Type 502 engine, it had twin Solex carburetors. Only 66 of these engines were built before a new version, the Type 547 developing 60 bhp (DIN), replaced it.

Germans are nothing if not perfectionists. Traditionally gifted as mechanical wizards the Germans will build something, keep it, perfect it, then start all over again. The same is true of their cars. They develop a design and over the years continually improve it until it is as perfect as man can make it. This admirable trait is part of Porsche's

trademark as was illustrated again by the engine change outlined above.

The Austrian born Max Hoffmann proved important in their sales drive in America. Almost single-handedly he created the postwar import car movement, bringing in all types of interesting European cars before narrowing his field almost exclusively to Porsche. An admirer of Dr Porsche and his son, he diligently promoted Porsche cars through racing and otherwise, in the US.

Noting American tastes ran to open-top, two seaters, Hoffmann suggested the factory produce a lightweight two place convertible which could rapidly be transformed into a track car. His request was duly met but the model did not fulfill its promise.

Built in 1952 and called the Porsche America, it was given another variation of the 1550 engine, the Type 528 S (for Super) which developed 70 bhp (DIN). The top speed of this nicely designed, aluminum-bodied roadster was reputedly 110 mph and 0-60 in 9.3 seconds, exceptional in 1952 – there were no American cars with juggernaut eights that could match it. They did later, but not in 1952.

These and previous pages: a gleaming 1959 356B roadster pictured in the courtyard of the Milland Place Hotel in Hampshire, England.

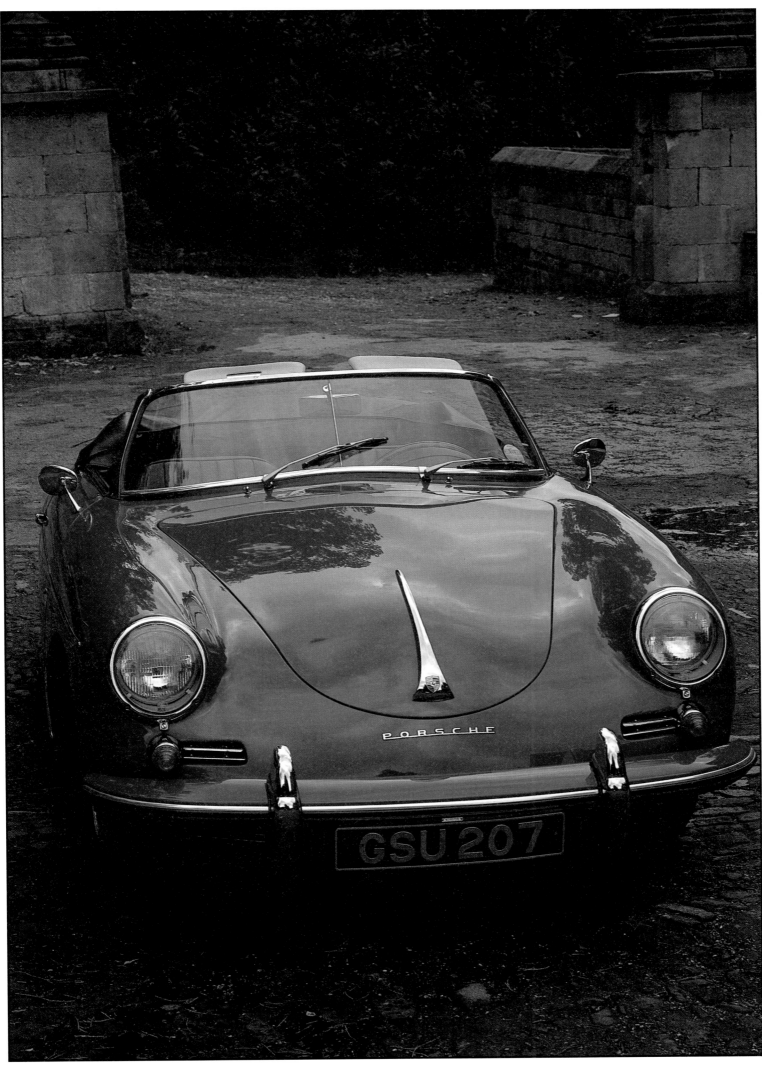

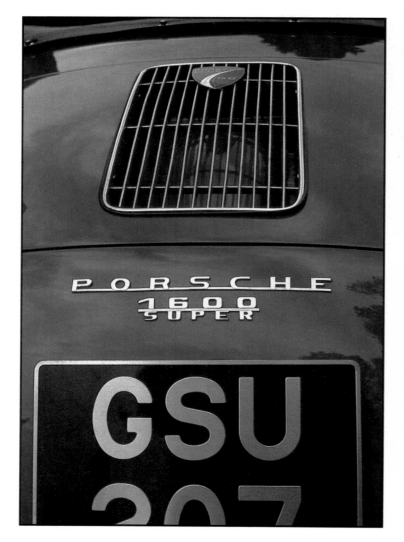

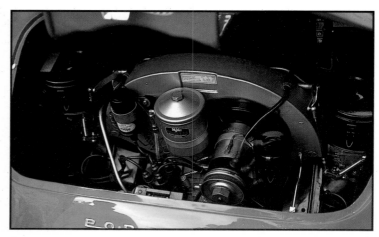

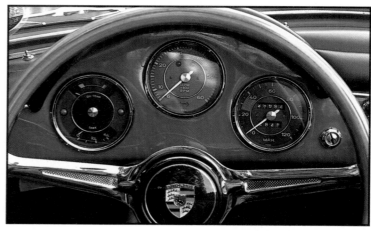

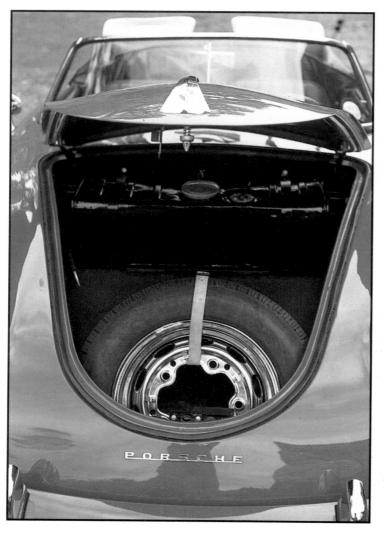

Top left: the gold lettering signifies a larger engine configuration. The 356B had a trio of 1600 power units: the standard one which developed 60 bhp; the Super which put out 75 bhp; and the Super 90, which offered 90 bhp. Porsches were never strong on luggage space as the frontal area (left), equipped with gas tank and spare, plainly shows. The wheels (above center) display quality with highly polished, heavy chrome, while the new instrument layout (above) could hardly be bettered.

SPECIFICATIONS
1959-63 TYPE 356B

Engines: Porsche four-cylinder flat-opposed. Bore and Stroke: 82.5 x 74mm (3.24 x 2.91 in.), 1582cc (96.5 cid). 1600: 60 bhp (DIN) at 4500 rpm, compression ratio: 7.5:1. 1600S: 75 bhp (DIN) at 5000 rpm, compression ratio: 8.7:1. 1600 Super 90: 90 bhp (DIN) at 5500 rpm, compression ratio 8.7:1, later 9.1:1.
Chassis: As per 1955-59 Type 356A 1600 except Al-Fin aluminium brakes.
Measurements: As per 1955-59 356A/1600, except Curb weight (lbs): 1980. Permissible total weight (lbs): 2750. Tire size: 5.60 x 15. Factory official maximum speeds (mph): 100 (1600), 110 (1600S), 116 (Super 90).

Top left: the chrome "basket handle" grows ever larger and wider, while parking lamps (left) protrude ahead of the body. The 356B was the most decorated Porsche so far – note the chrome strip along the sides (above). The bumpers were raised four inches in 1959.

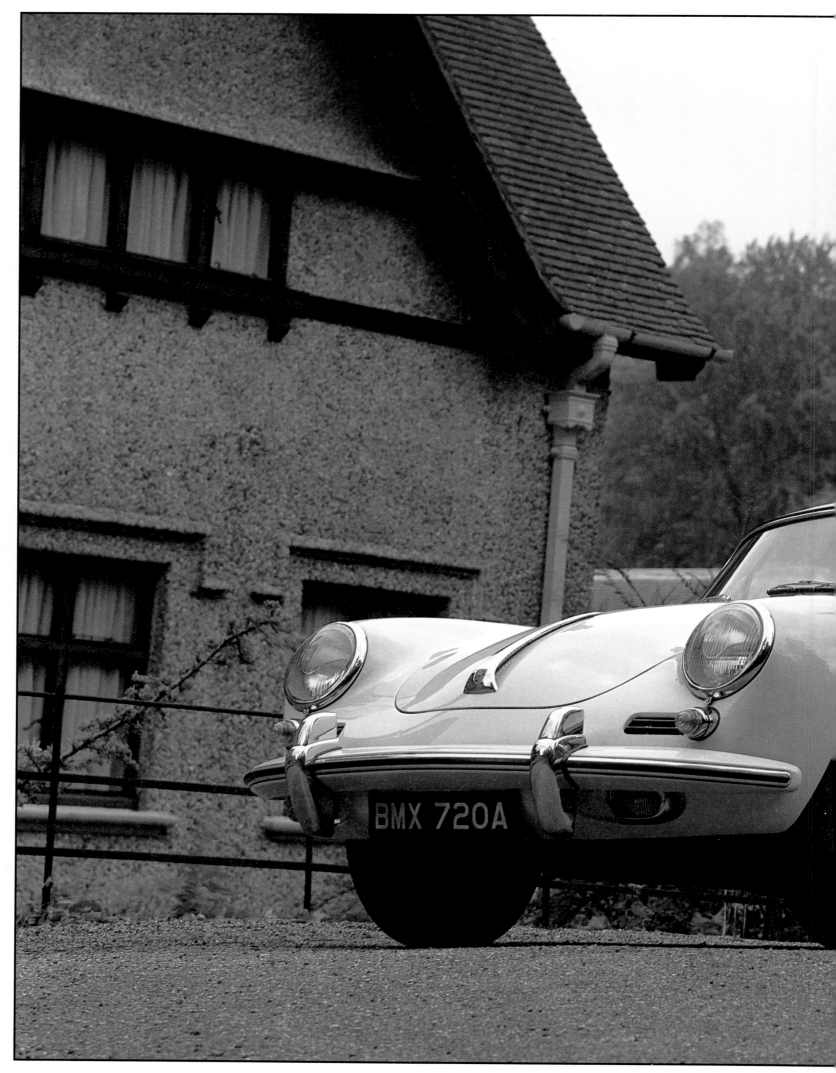

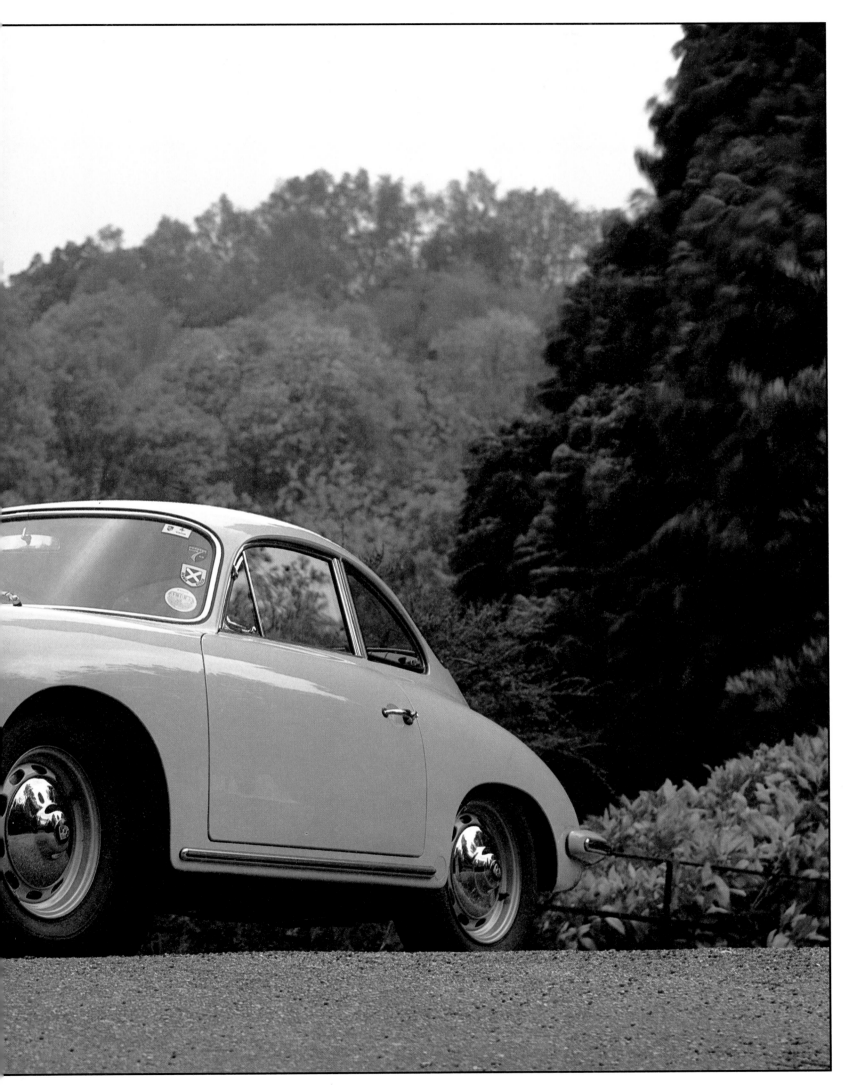

There had not been a bad Porsche up until 1952 and the America was no exception. Its attractive bodywork was executed by Glaser, coachbuilders of Ullersricht. Made of aluminum to keep weight down, the America also had aluminum frame seats, plexiglass side curtains and a thin snap-on canvas top. Its divided windshield could be "popped" and replaced by a racing one. By the time the car was finished it weighed a mere 1,600 lb; but cost a high (for 1952) $4,600.

Although questionable, price may have been one reason why the America was condemned before it had hardly begun. Ordinary super Porsches cost $4,284 for the coupe, $4,560 for the convertible; they sold well enough. The difficulties affecting the America were probably as much to do with logistics as with other causes. Reutter sent rolling chassis to Glaser where hand-shaped bodies were welded to them. The half-finished cars were then returned to Reutters at Zuffenhausen for completion. Transporting the vehicles to the other side of Munich was a long journey and expensive, without counting the cost of Glaser's work.

Taking everything into account, the price of $4,600 was not excessive.

Some say 20, others 50, Americas were built. Tragically only four were sold in the country it was named after and was meant for. Today an America is a priceless collectible, alongside the exotic Ferraris.

With 1953 came another Hoffmann idea. Up to then Porsche had no crest. Over lunch one day while visiting Max Hoffmann in New York, Hoffmann suggested to Ferry Porsche that the car needed an identification emblem. From a rough design on a table napkin, Porsche asked graphic designer Eric Strenger to create a suitable emblem.

This Strenger did; a yellow shield bearing Stuttgart's coat of arms, a prancing black horse, the black and red colors and six staghorns representing the state of Baden-Wurttemburg. Soon this emblem would come to be counted among the great badges of the world.

Apart from the badge few changes were made to 1953 models. Engines now ran from 1100/1300/1500 to 1300/ 1500 S (Super). Tail-lights were circular instead of oblong and a trip counter joined the speedometer. Parking lamps were moved inboard of the headlights.

Porsches arriving in America in 1953 had only the 1500 standard or the 1500 super engines. The normal 1500 displaced 90.8 ci and developed 55 bhp (DIN). The Super version had the same displacement but hp was 70 (DIN) like the ill fated America. Only Europe had the smaller 1100 and 1300 ranges in the interests of economy and taxation.

Again in 1954 changes were few, although Zuffenhausen celebrated its 5,000th car. The 1954 models got a standard windshield washer and oil filter, an interior passenger grab handle and a semi-circular horn ring. The major change on the outside were tiny grilles flanking the parking lamps.

The lack of interest in the America did not dampen Max Hoffmann's belief in the potential existing for a roadster, and in convincing Ferry Porsche he advised that it should not be too expensive and should be a permanent addition to the line. Thus, in September 1954 Porsche introduced the attractive Speedster.

Rural England is the setting for this pristine 1963 356B 90 (previous pages and right). Note the teardrop tail-lights and twin air intakes on the engine lid.

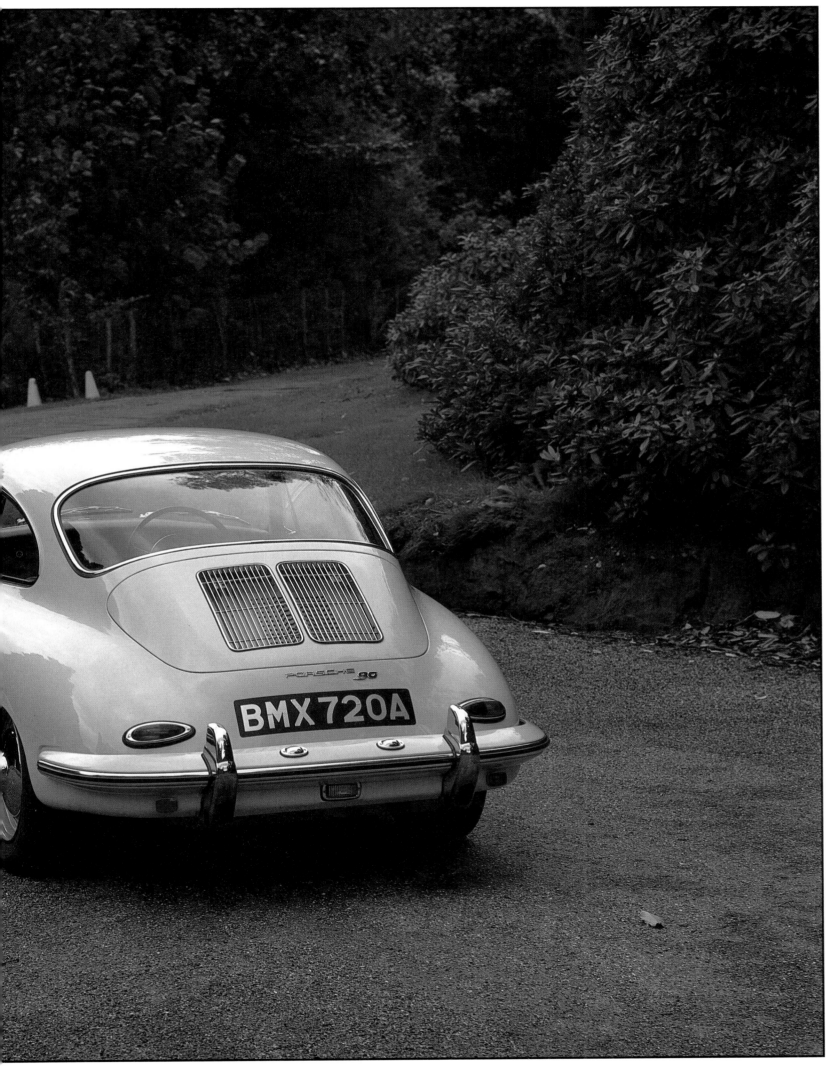

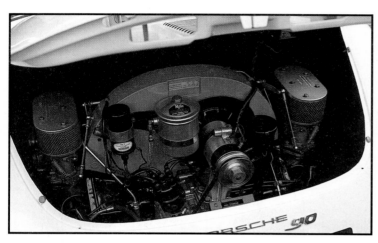

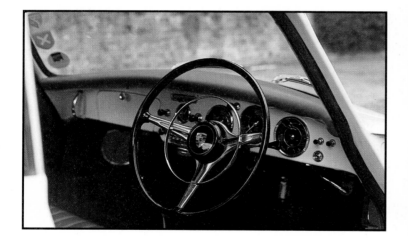

1963 was the last year for the 356B. Shown here is the Super 90, its horizontally-opposed engine (above center) little different from the 1948 version. The steering wheel and dash were now taking on a more luxurious appearance, and the top of the dash was padded. Koni shocks were fitted as standard on both the Super models from 1961 onwards.

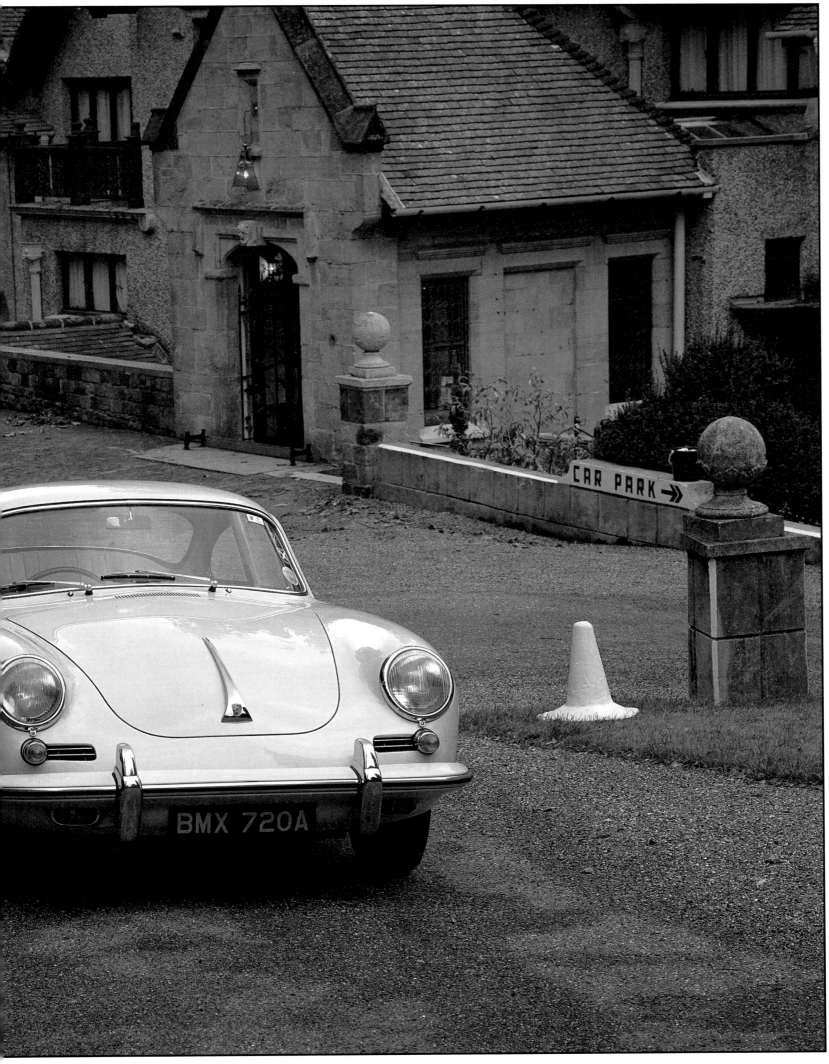

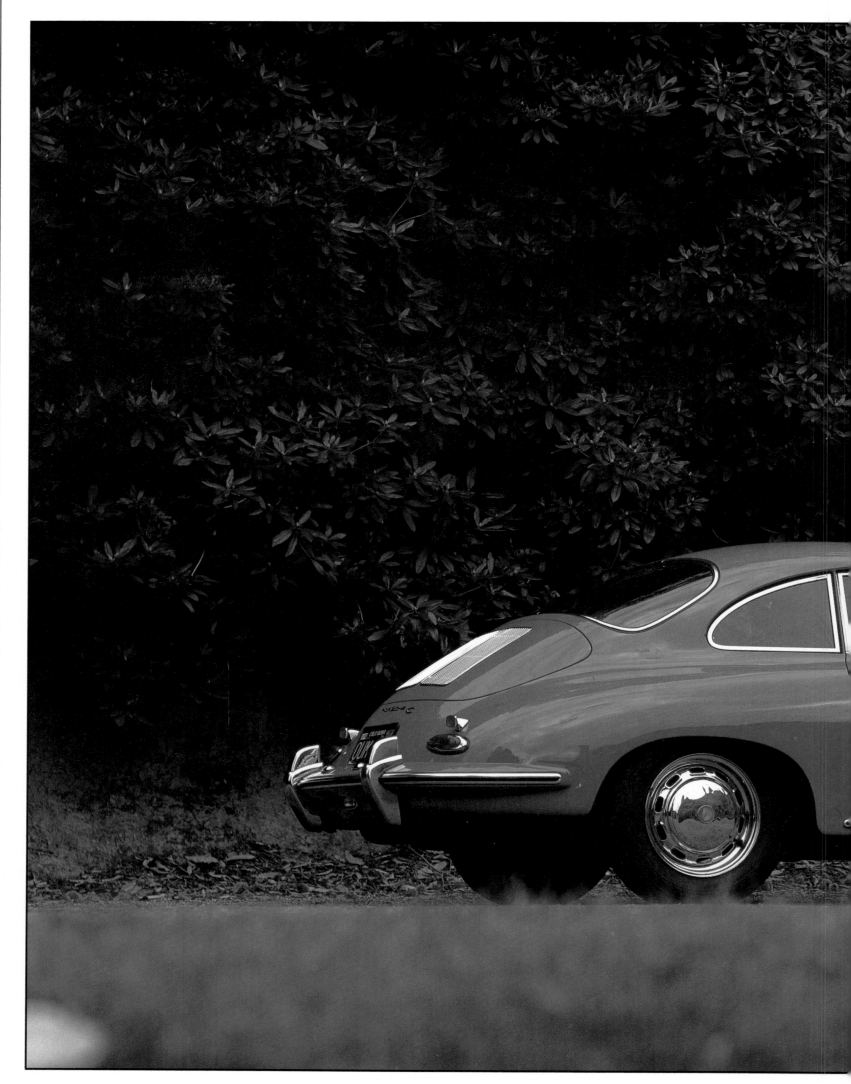

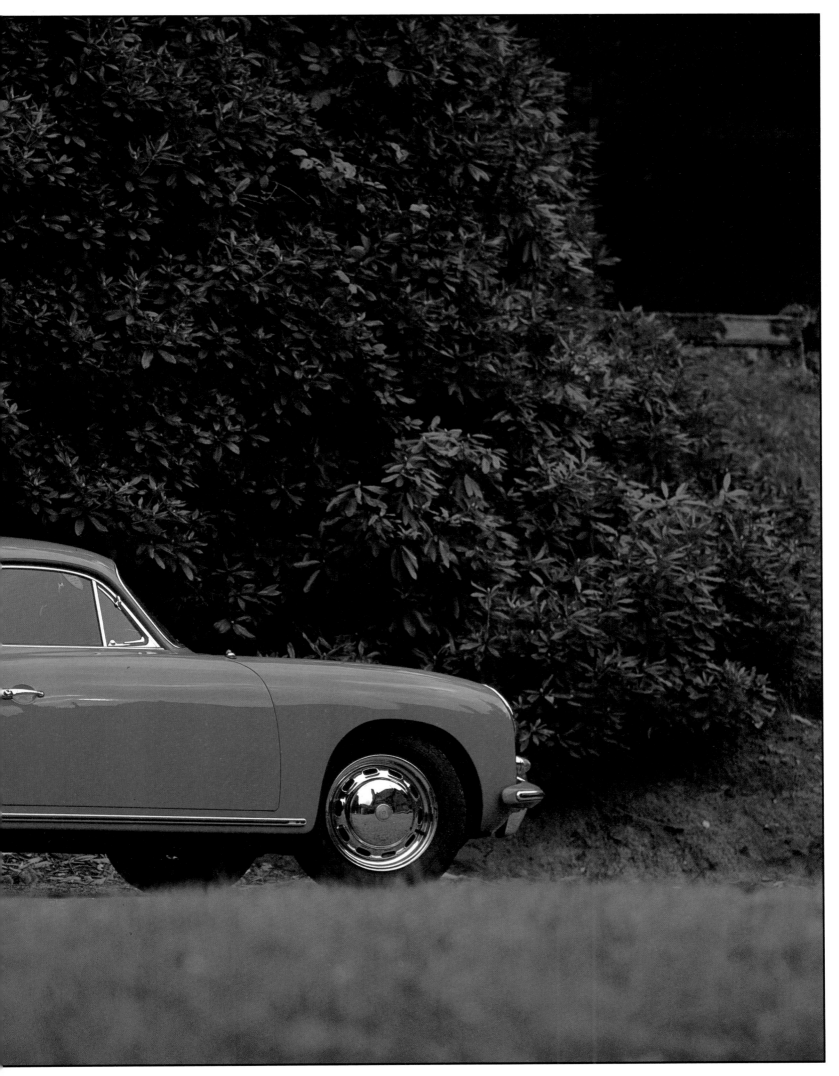

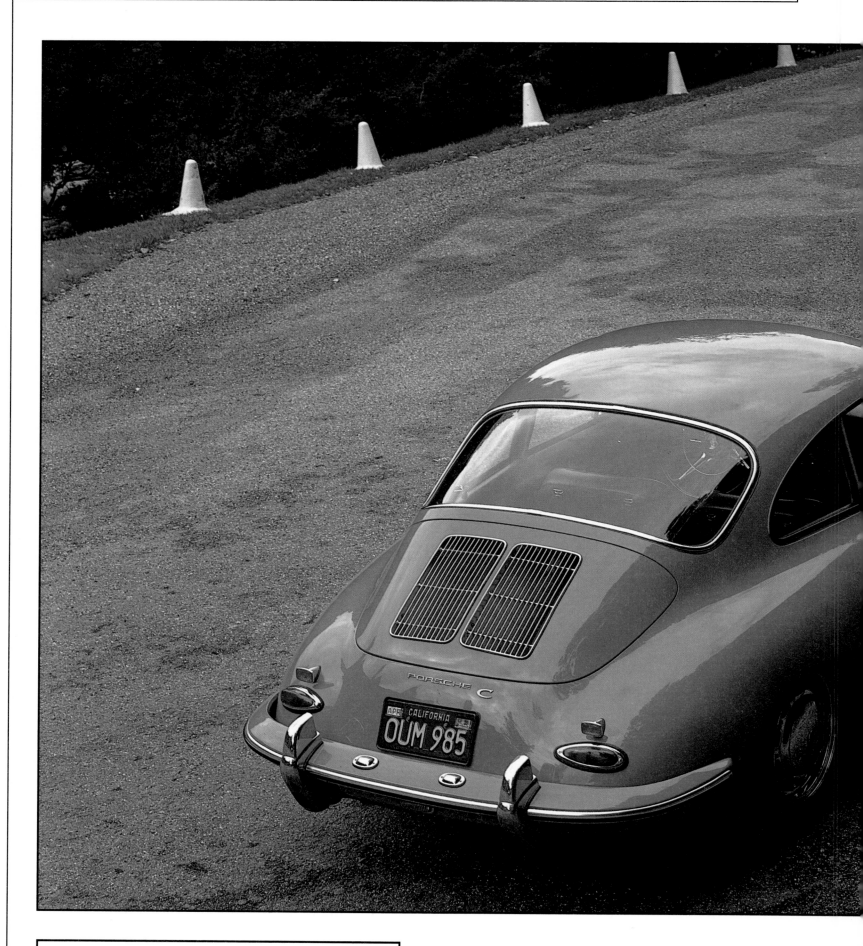

SPECIFICATIONS
1963-65 TYPE 356C

Engines: Porsche four-cylinder flat-opposed. Bore and Stroke: 82.5 x 74mm (3.24 x 2.91 in.), 1582cc (96.5 cid). 1600C: 75 bhp (DIN) at 5200 rpm, compression ratio: 8.5:1. 1600SC: 95 bhp (DIN) at 5800 rpm, compression ratio: 9.5:1.
Chassis: As per 1959-63 Type 356B except four-wheel disc brakes.
Measurements: As per 1959-63 type 356B, except factory official maximum speeds (mph): 110 (1600C), 116 (1600SC).

The 356C was the last of a magnificent series. This car (previous pages, above and overleaf), the 75 bhp 1600 C , was produced in 1963 for the 1964 model year. New features included four-wheel disc brakes and new hubcaps. A 110 mph maximum speed was quoted for the 356C, and 116 for the SC. As can be seen from these pictures, the lines of the 356C flow and meld into a cohesive whole – the epitome of good design.

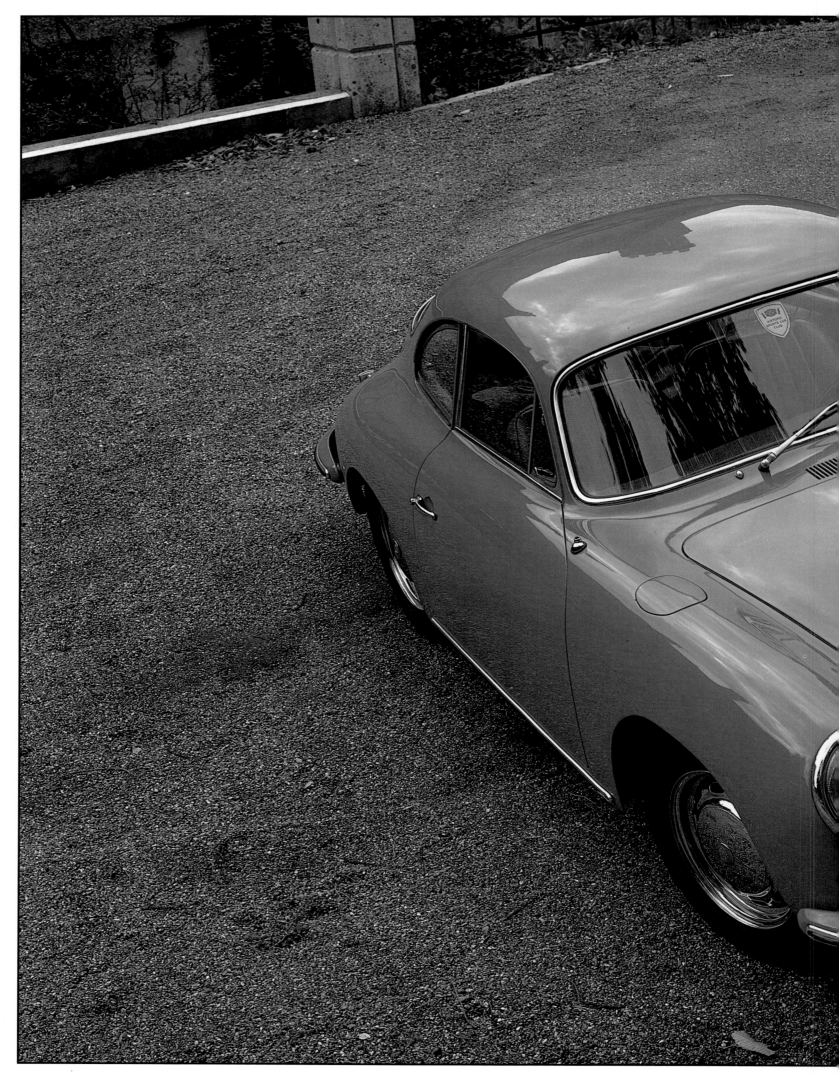

1963/64 PORSCHE 356 C

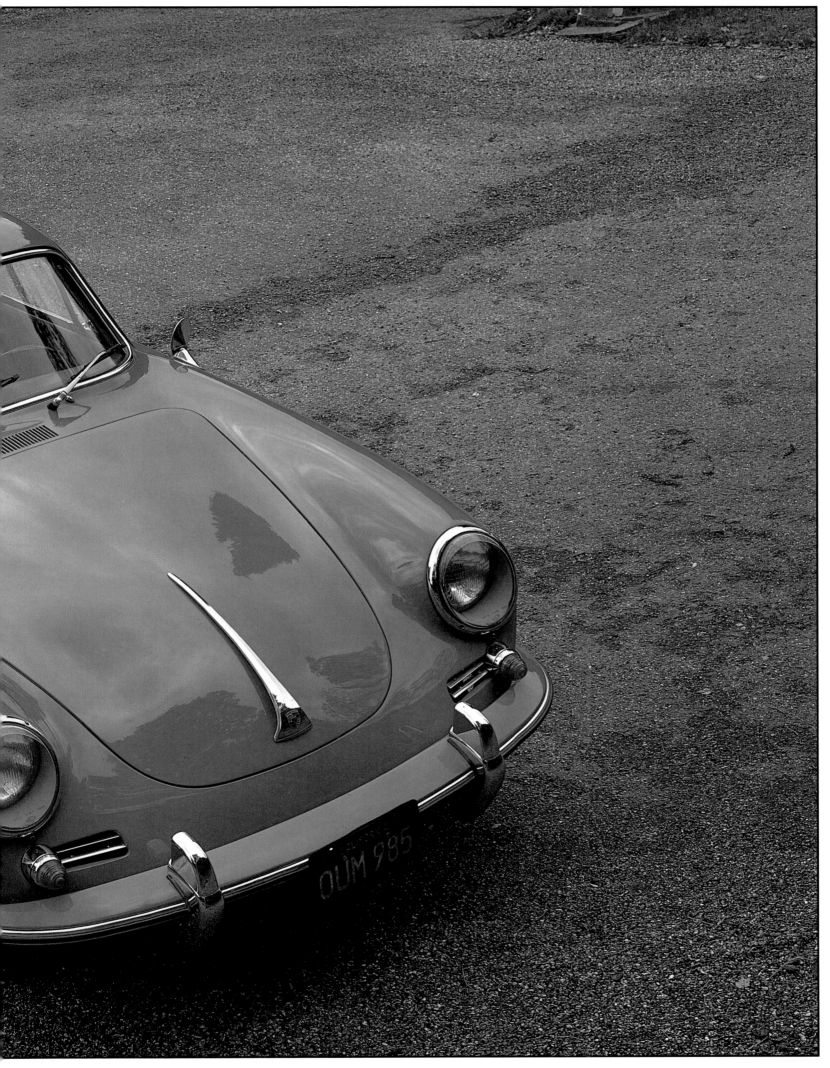

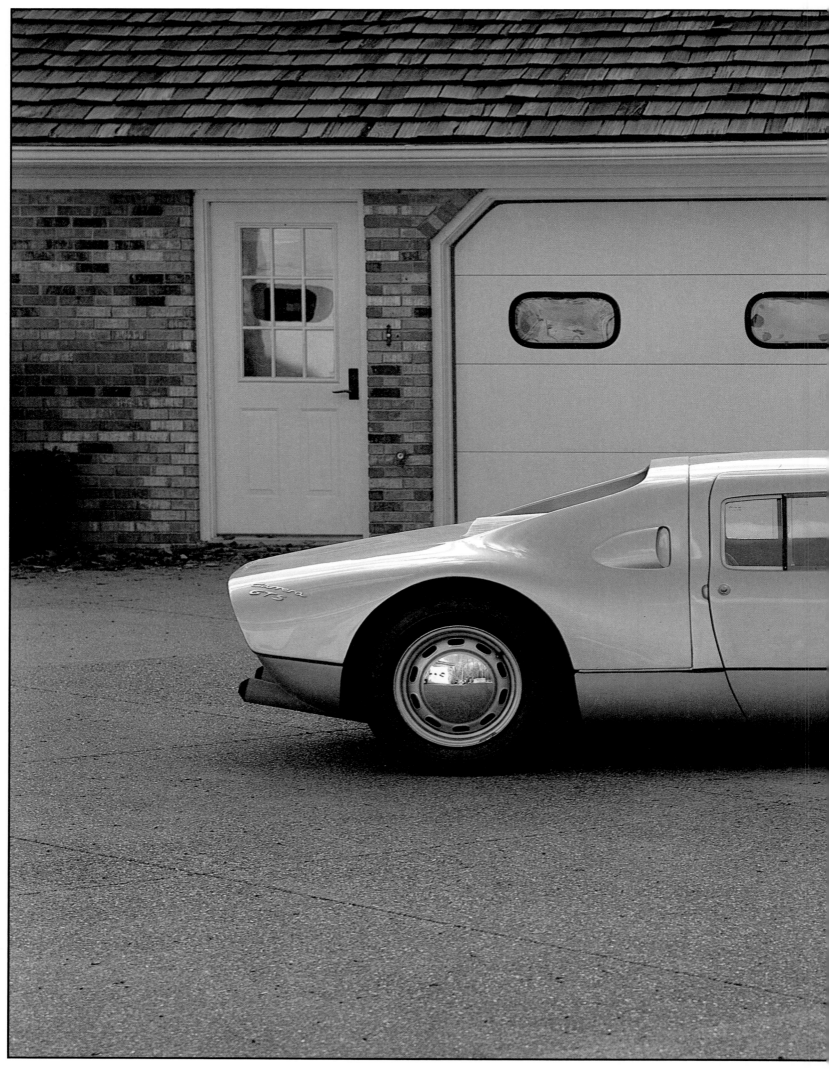

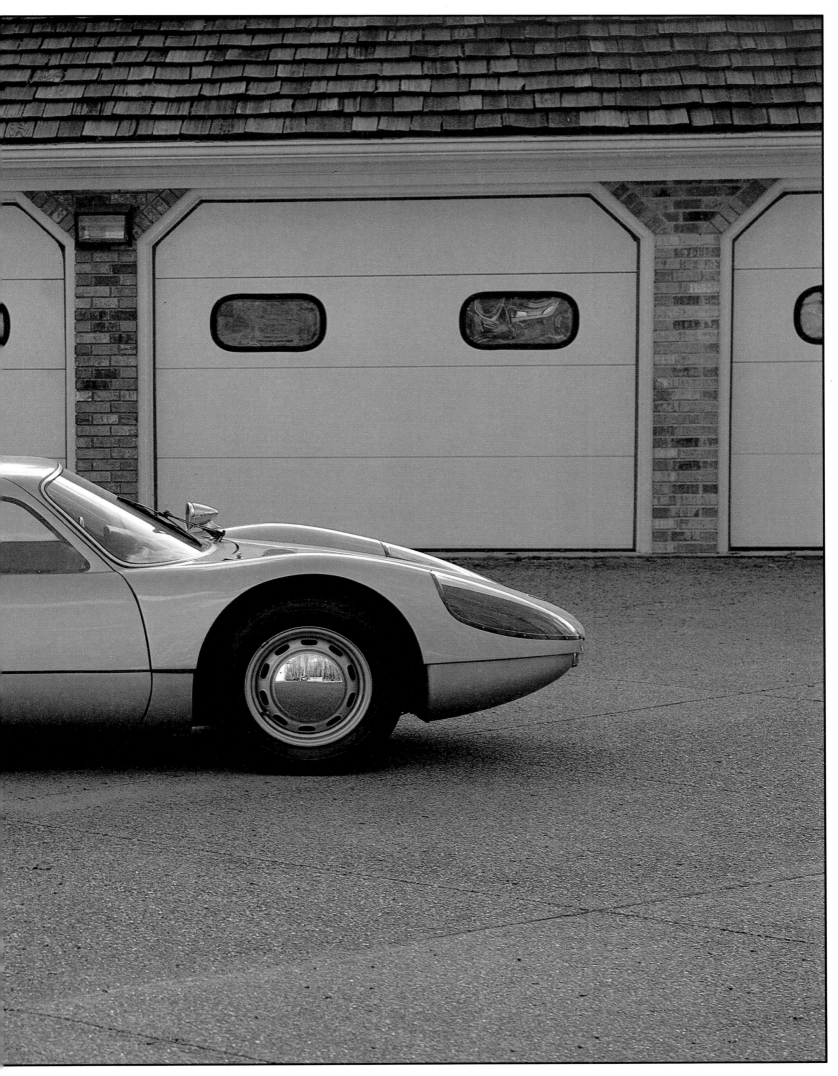

It was the quintessential sports car without being extravagant. With the standard 1500 engine the price was a shade under $3,000; with the 1500 Super installed, $3,495. Compared to the America from which this car evolved, this was a bargain.

Reutter's did all the work, taking a straight cabriolet body, dispensing with its luxury fittings, and giving it the America's canvas top and plexiglass side curtains. Instrumentation was sparse: just a speedo, tachometer and temperature gauge. The bucket seats had fixed backrests - no rake at all but the windshield was chopped 3 1/2 inches to add a more sporty flair. Cutting to the bone to save money also means sacrifices for the buyer. With the top up visibility was a shade less than arrow slit vision, hazardous when it rained. And when it rained the car leaked.

People loved it however. Motor magazines waxed lyrical. The Speedster was everything a sports car should be; a car that is fun to drive even today. Road manners, handling, cornering, braking are little short of perfect. It was an ideal vehicle for places like Los Angeles, San Diego, Phoenix or Albuquerque. (The Beach Boys should have written a song about Porsche Speedsters instead of Little Deuce Coupés - but that would have been un-American.

The year 1955 appears now as one of the last great years. Streets were mostly safe to walk on and folk were not as self centered as today. It was also Detroit's great record breaking year. As for Porsche, there were changes, not so much with the look of the cars - they remained the same as 1954, including the Speedster - there was a name change though. Again Max Hoffmann came to the fore. He suggested calling Porsche the Continental. And it was done. Thus all 1955 Porsche US models were "Continentals".

Then the snag revealed itself. Ford Motor Company was preparing a brand new, semi-handbuilt Lincoln for 1956 introduction. It was to be called the Continental Mark II. The Lincoln division claimed it owned the name - nobody said anything about the Bentley Continental that had been around since 1953. In fact, Bentley continued to use the name for its next Continental series. Lincoln was using it, too, but didn't try to get into a fight with Rolls-Royce, owners of the Bentley marque. So, why did Porsche have to give the name up? Was it Porsche's decision not to confuse the issue or did Lincoln have private words? Anyway, Porsche used the name for 1955 only. After that it was plain Porsche again.

A few engine changes were made for 1955. The 1100 was dropped, the 1300 series bore and stroke was almost square at 2.93 x 2.91 inches (74.5 x 74 mm) compared to the previous dimensions of 3.14 x 2.52 inches (80 x 64 mm). Among other improvements on all engines were better valve gear, tougher castings and three piece 4.5 liter aluminum crankcases instead of the earlier 3.5 liter two piece magnesium ones.

By 1963 the days of the 550 Spyder competition car were coming to a close. Racing was becoming more specialized and to meet the new challenges Porsche launched the 904 Carrera GTS (these and previous pages). Radically different in style from any Porsche that had gone before, the design was the work of Ferdinand "Butzi" Porsche, grandson of the founder. The car was completed by November 1963, and was the last competitive Porsche to use a "street" engine, albeit in modified form. Note the air intakes on the C-pillars, the clear plastic covers surrounding the headlights and the Ferrari-like rear window area.

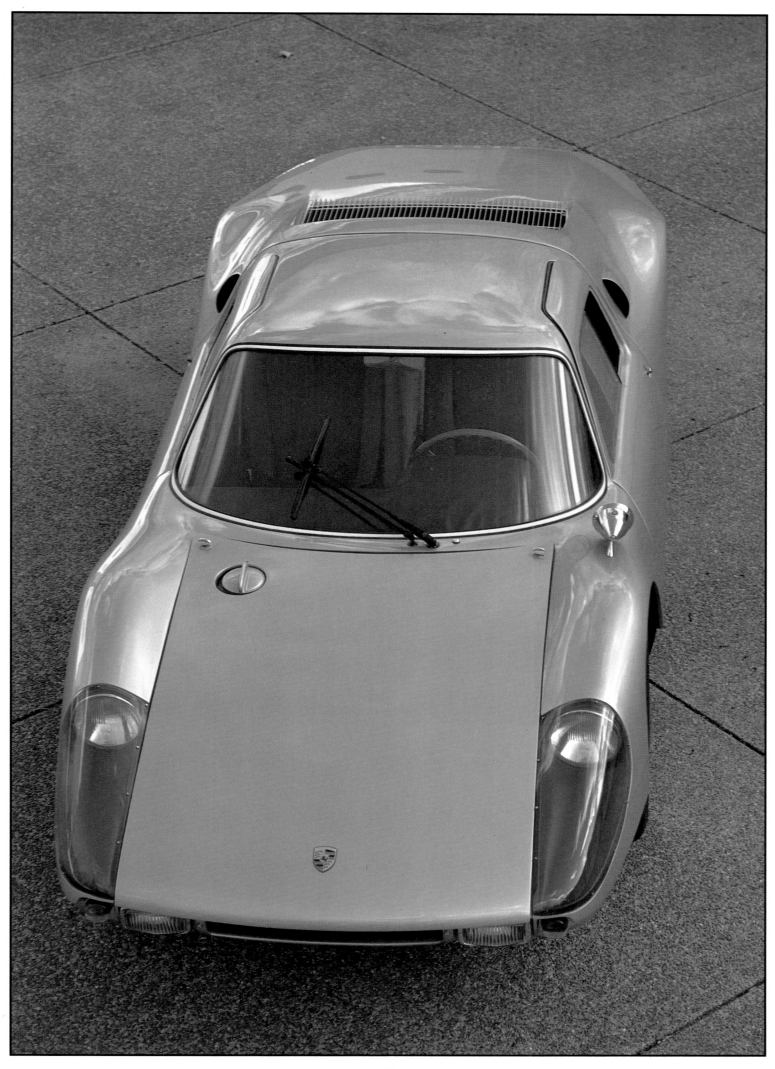

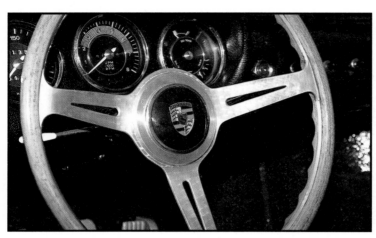

The 904 GTS's rakish body was a departure from previous Porsches inasmuch as it was of fiberglass. A large gas tank (top) takes up almost the entire front space, leaving little room for the spare, and the aluminum steering wheel (above center) has a wooden rim. Wheels have large air slots and central hubcaps. Not only was the car eyecatching, but its 150-mph-plus performance made it a useful track competitor as well.

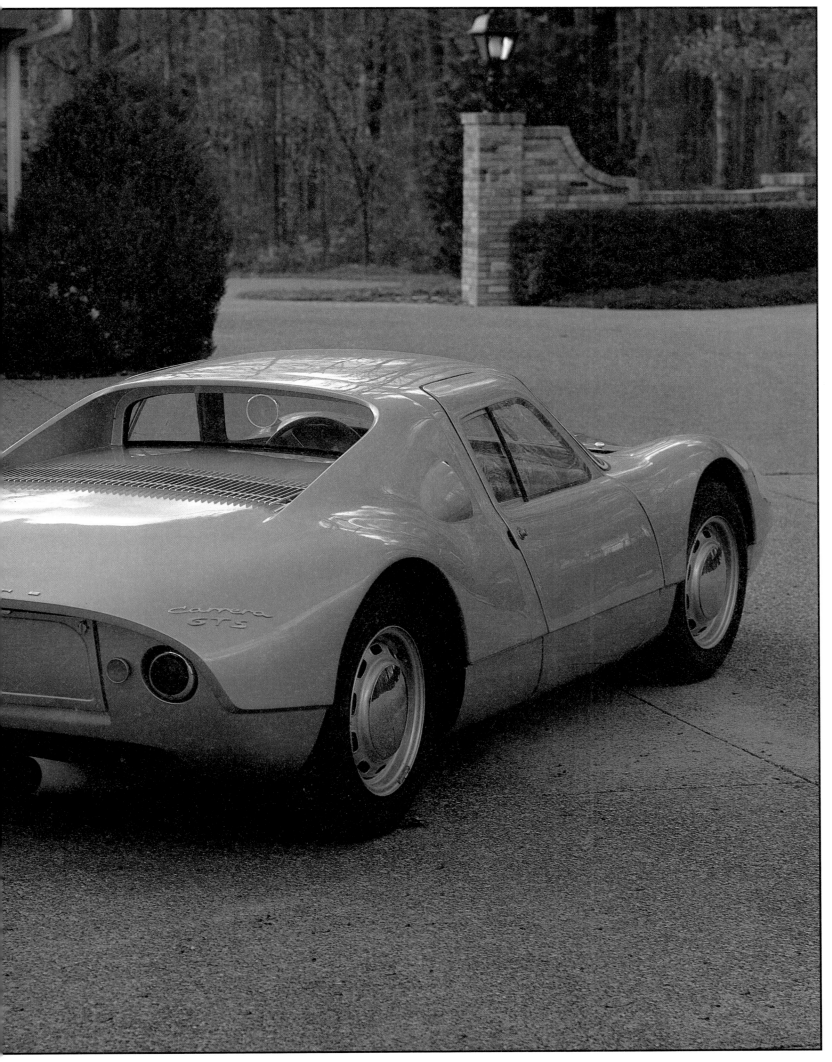

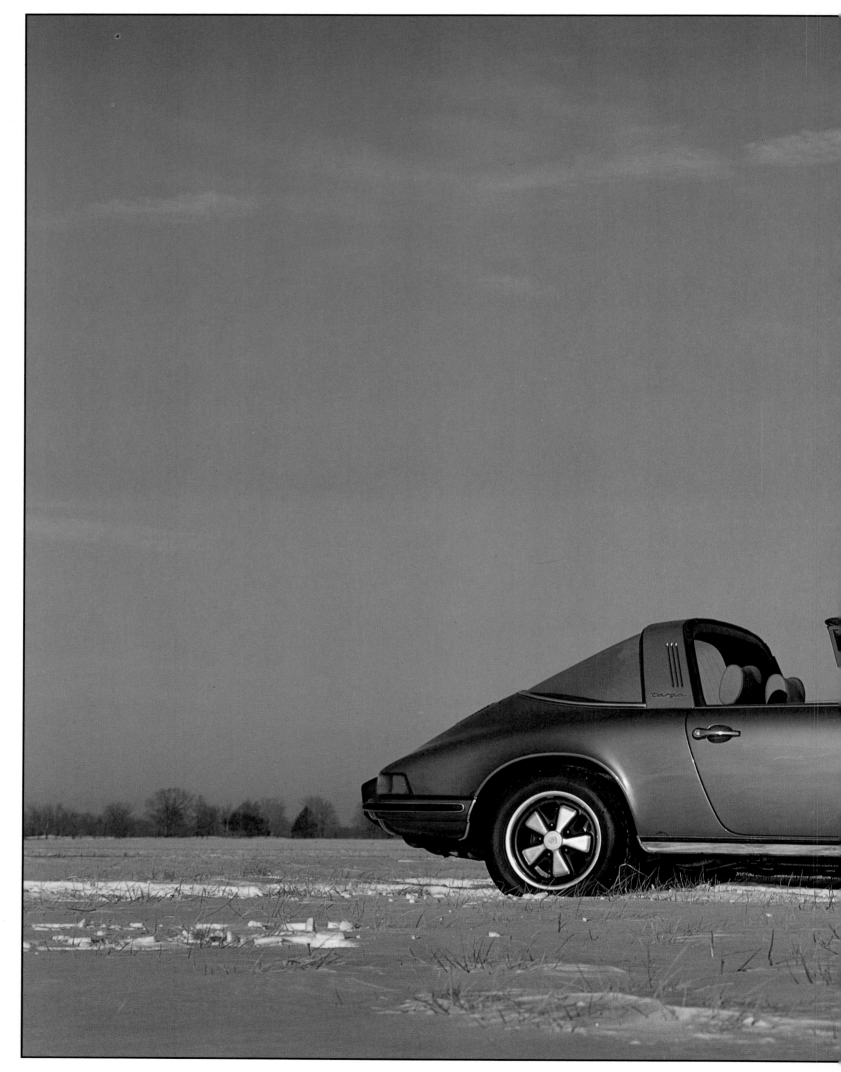

In a number of ways this benefitted Porsche and meant they were gradually placing less reliance on Volkswagen parts. What Ferry Porsche wanted to see was his cars as more specialized, more independent of other sources - even if VW was designed by his father.

Each year saw Porsche production go up; in 1955 just 48 short of 3,000 were built in the company's calendar year. It was the last year for the original 356, one of the all time great automobiles ever to be produced. But 1956 also had some good things in store

356/A/B/C A TRIO OF GREATNESS

Dateline: Frankfurt Motor Show, September 1955. Porsche unveiled its 1956 models. At first glance, they looked the same, but closer examination revealed a number of subtle changes.

Displayed in the newly designated 356 A Series were a coupé cabriolet and the Speedster. The only really visible changes were 15-inch wheels (lowered from 16 inches) with an increase in width to 4.5 inches in the interests of improved grip. A one-piece curved windshield was the other most noticeable alteration.

Underneath the cars there were modifications a ` plenty. The "A" suffix after "356" actually refers to a new chassis. This has been regarded in some quarters as Porsche's second most important improvement after the introduction of an all synchronized gearbox in 1952. Shock absorbers were vertical instead of at an angle as before; the front anti-roll bar was enlarged in diameter; to obtain a softer ride, leaves were removed from the front torsion bars while the rear ones were lengthened about three inches to 24.7 inches. Even the steering was altered and to reduce road shock through the wheel, a small hydraulic damper was fitted. These alterations resulted in a vastly improved road car which ironed out all the little imperfections such as front end wander at high speed and rear-end breakaway.

Five engines were offered but two of them, the 1300 and 1300 Super would be axed the following spring. From the earliest days Porsche had gone racing and while the 1300 had been successful, its competitors were coming out with larger engines. Instead of trying to suck blood out of a stone, Porsche concentrated on its new 1600 cc unit after the FIA (one of Europe's motorsports governing bodies) decreed 1000 cc would be the new competition limit.

To achieve this increase Porsche engineers took the 1500 block and enlarged the bore to 3.24 inches (82.5 mm) - Porsche had its 1600 engine.

Actually Porsche had two 1600 engines. One was the Type 616/1 with a ci displacement of 96.5 (1582 cc) and developed 60 bhp (DIN) at 4500 rpm; compression ratio was 7.5:1. The other was the Type 616/2 with exactly the same dimensions yet a compression ratio of 8.5:1 and 76 bhp (DIN). The top speed for the 1600 S was 110 mph and 29.5 mpg for the thrifty buyer.

The interiors of the 1956 models featured a padded top above the flat metal panel, three large, legible dials consisting of speedometer, tach and a combination fuel/oil level gauge. For easier entry the floor was lowered an inch and a half.

Sporting buffs will have heard of the Carrera Pan-Americana, the famous long distance Mexican road race. "Carrera" is the Spanish word for "race" and this particularly gruelling event was held in the early fifties, the last "Carrera" being held in 1954. Cars from all the motoring nations took part and it was generally either an Italian or German car that won overall. In 1952, 1953 and 1954 Porsche entered the race, the first year in private hands. Two were entered,

The 911 Targa made its first showing at the Frankfurt Auto Show in September 1965. Designed by Ferdinand Porsche's grandson Butzi, the Targa was named after the famous Targa Florio race in Sicily. Features included a new lift-off roof design, a brushed stainless steel built-in rollbar and a zippered plastic rear window (this was later changed to glass). Targas were available either in the cheaper 912 or the 911, the former powered by the four, the latter boasting the six. The example shown (previous pages and above) dates from 1973 and has a real glass rear window.

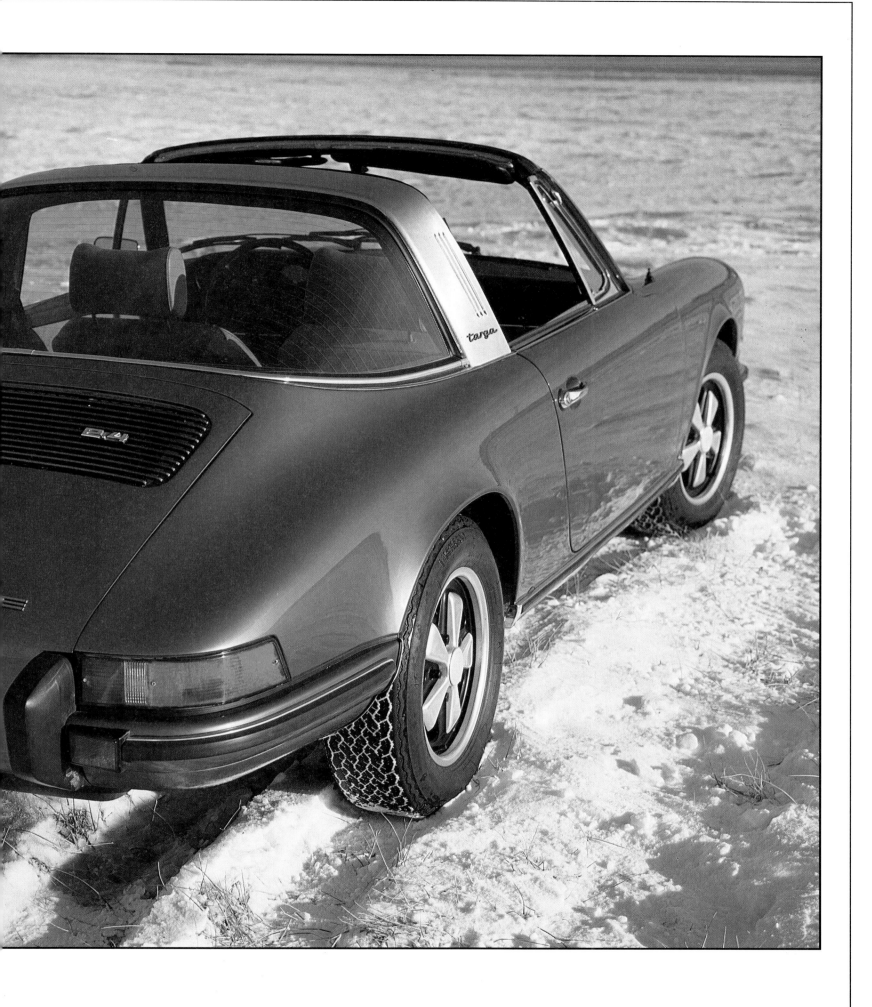

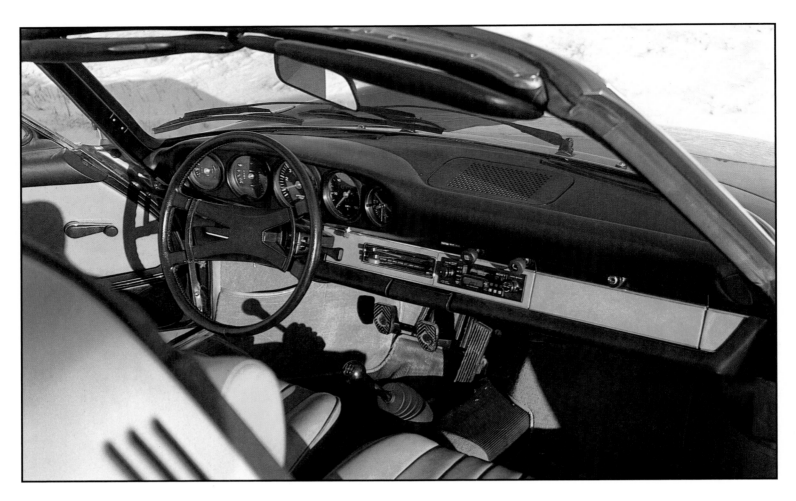

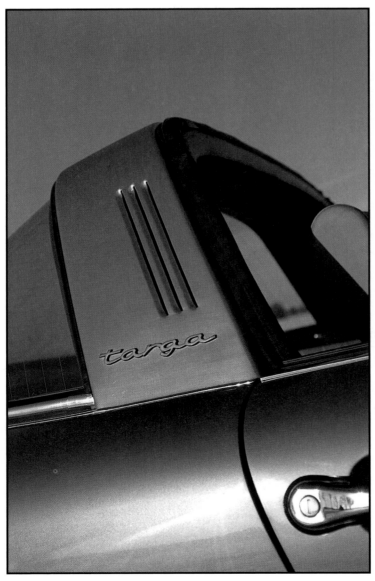

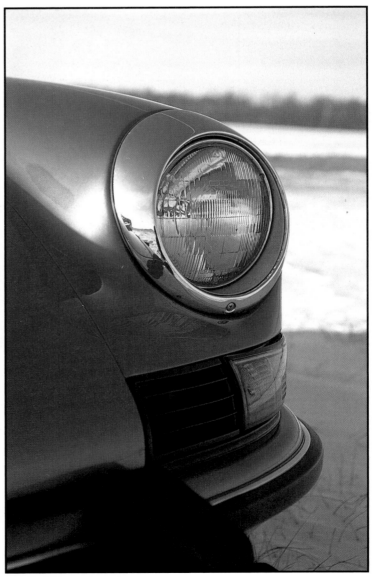

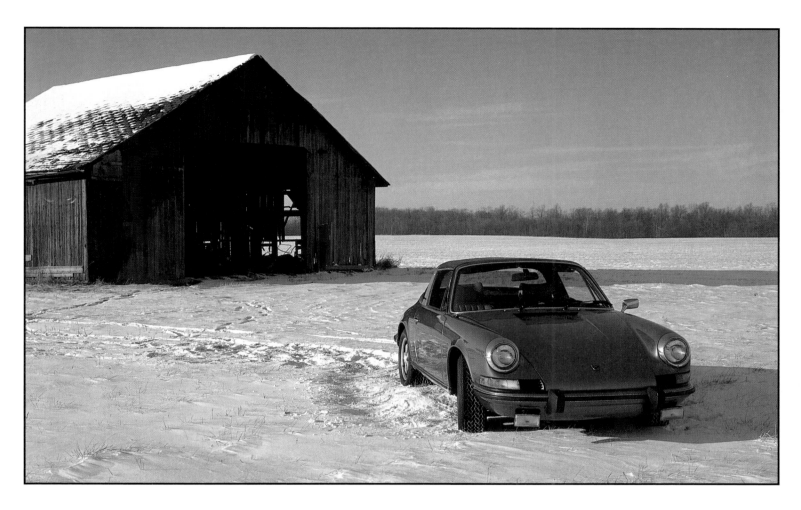

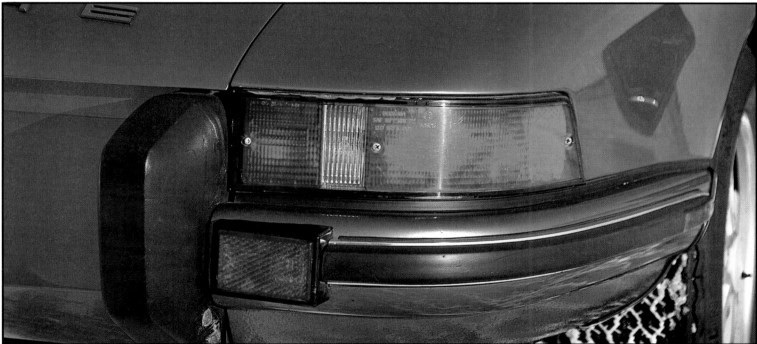

SPECIFICATIONS
1972-73 TYPE 911 T/E/S

Engine: As per 1964-68 Type 911/911L except Bore and Stroke: 84 x 70.4mm. Displacement: 2341cc (142.9 cid). Bhp (DIN): 140 at 5600 rpm (T), 165 at 6200 rpm (E), 190 at 6500 rpm (S). Compression ratio: 7.5:1 (T), 8.0:1 (E), 8.5:1 (S). Bosch mechanical fuel injection all models; Bosch K-Jetronic fuel injection on T from mid-1973.
Chassis: As per 1964-68 Type 911/911L except softer shock absorber valving and adoption of Type 915 five-speed manual transmission with conventional shift pattern.
Measurements: As per 1969 Type 911 models except Curb weight (lbs): approx 2480-2550. Tire size: 165HR-15 (T), 185/70VR-15 (E and S). Overall length: 168.4". (1973 models).

More dials, more features, more luxury, and more expensive, the 911 Targa served up comfort as well as performance. The lift-off roof clamps to the roll bar (facing page bottom left), which looks thick enough to survive a roll-over. Detail finishing, as shown in the headlight rims (facing page bottom right) is exemplary, although, surprisingly, red rather than amber turn signals are used on the rear (above).

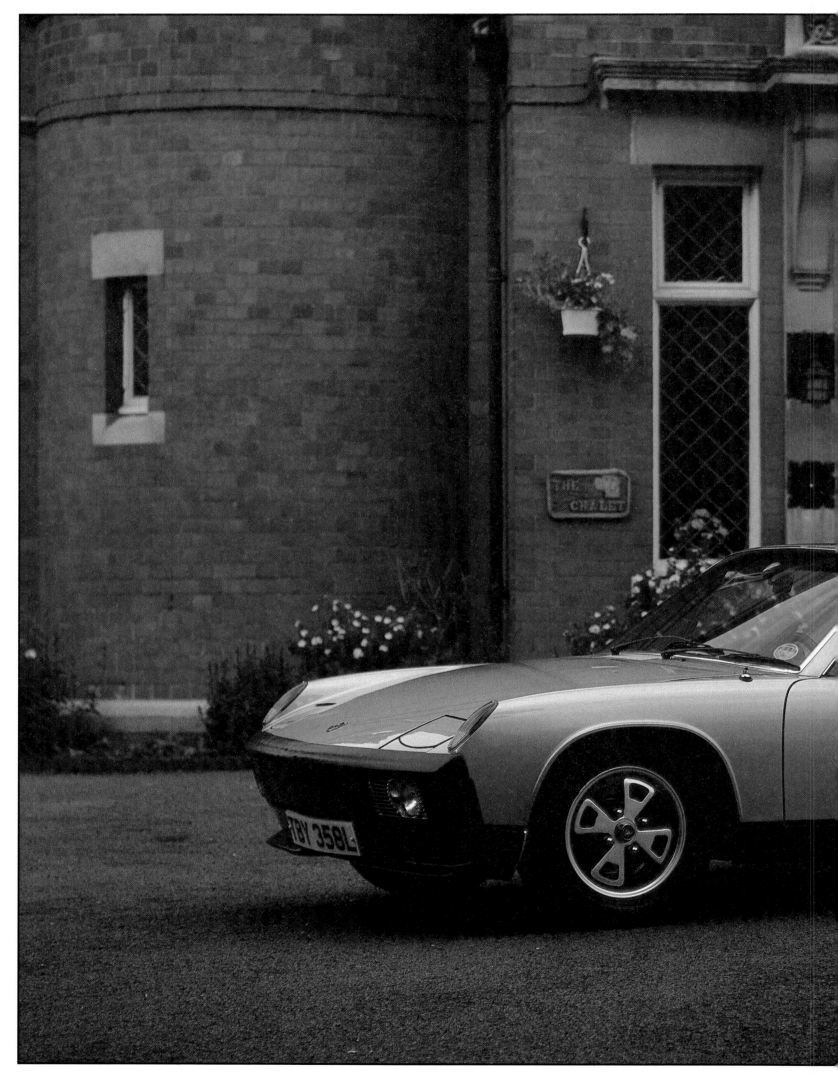

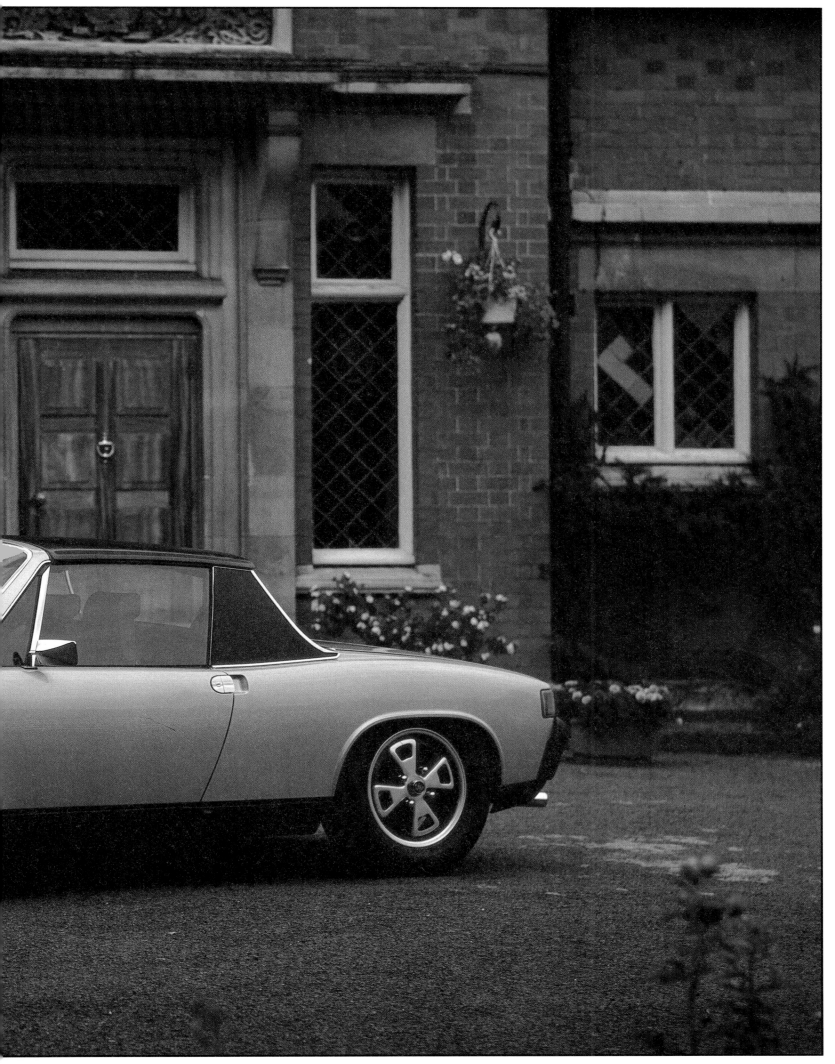

one retired and the other, a 1500 roadster, finished eighth overall.

In 1953 and 1954 the factory entered a pair of cars in each race. Engine failure and front axle difficulties brought Porche's 1953 attempt to an ignominious end, but 1954 was successful with 1, 2, class win and a third and fourth overall behind two big Ferraris of 4.5 and 4.9 liters respectively. To celebrate this achievement Porsche created the 100 bhp (DIN) Carrera.

Its 1500 GS engine was a detuned version of the competition four camshaft unit originally developed for Porsche's wildly successful 550 Spyder, of which more later. The engine was first thought about in 1952 when Ferry Porsche, Karl Rabe and Porsche's engineering team were debating the potential of an air-cooled boxer engine. They decided to find out.

Dr Ernst Fuhrmann was the new engine's principal designer. In 1953 his engine passed its initial tests with flying colors. Shortly after, the DOHC unit saw service in the Type 550 Spyder. Now the natty new Carrera would carry it to the street.

Externally the Carrera looked much the same as any other Porsche apart from the tell-tale gold lettering spelling "Carrera" on the rear engine cover. At $5,995 it was not cheap, more than double the price of a Corvette, but certainly more refined.

In 1957 teardrop tail-lights replaced the previous round ones and the speedometer changed places with the oil/temperature gauge. Later in the year the Speedster and Cabriolet got larger rear windows. The roller bearing crankshaft was replaced by plain bearings in the 1600 which also switched to cast-iron cylinders to cut cost.

Run on odd years, the Frankfurt Motor Show always had something displayed to make the event a must for car enthusiasts. In 1959, besides the dream cars, the one-off Ferraris and similar, the 1960 Porsche 356 B made its world début. Again, a quick look revealed little change, yet something registered in one's mind as being different.

Front and rear bumpers were larger, eye-catcher with enormous bumper guards that looked as though they had been taken from a Chevrolet. Headlights were not so laid back and were set higher, thereby forcing a straighter fender line. A longer, wider chrome embellishment decorated the fuller looking hood, and the hub caps had the Porsche crest in the center. Parking lamps were larger and longer, the little horn grilles they flanked less pronounced than before.

Model line-up remained as before, but it is worth mentioning the Speedster D. Although a 1959 model, Porsche introduced it in August 1958 partly to catch all the press, partly to be the first '59 on sale. The Speedster D replaced the original model, had a taller windshield framed in chrome, roll-up windows, a top that was half-way between the spartan original and the cabriolet's padded version. Why a D suffix? This denoted Drauz, who was contracted to supply the bodies. This did not last long however; within months Porsche rechristened the car just plain Roadster.

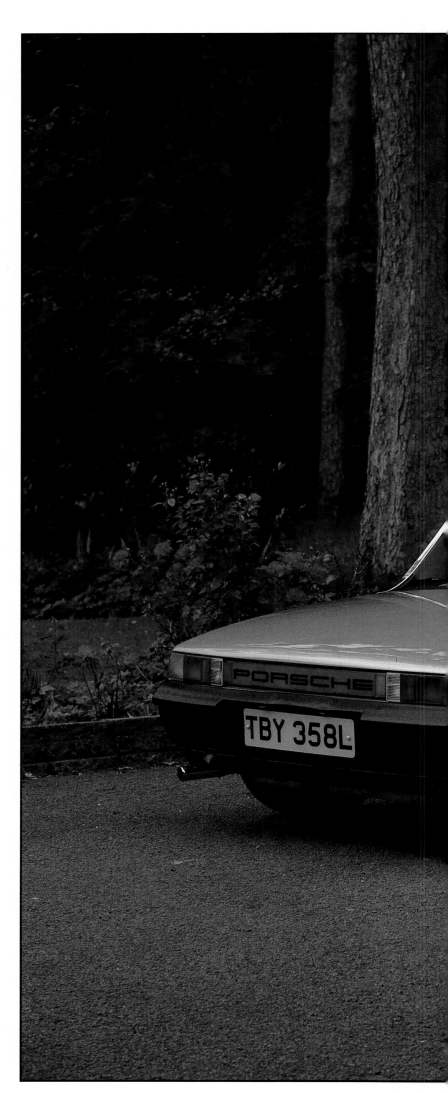

By 1970 high prices were turning away many prospective Porsche buyers. To rectify the situation, Porsche brought out the Volkswagen-based 914 (previous pages and right). Here, Porsche hoped, would be a sports car that everybody could own. The car – a mid-engine two-seater designed by Porsche but based on VW mechanicals – was the result of co-operation between the two companies.

74

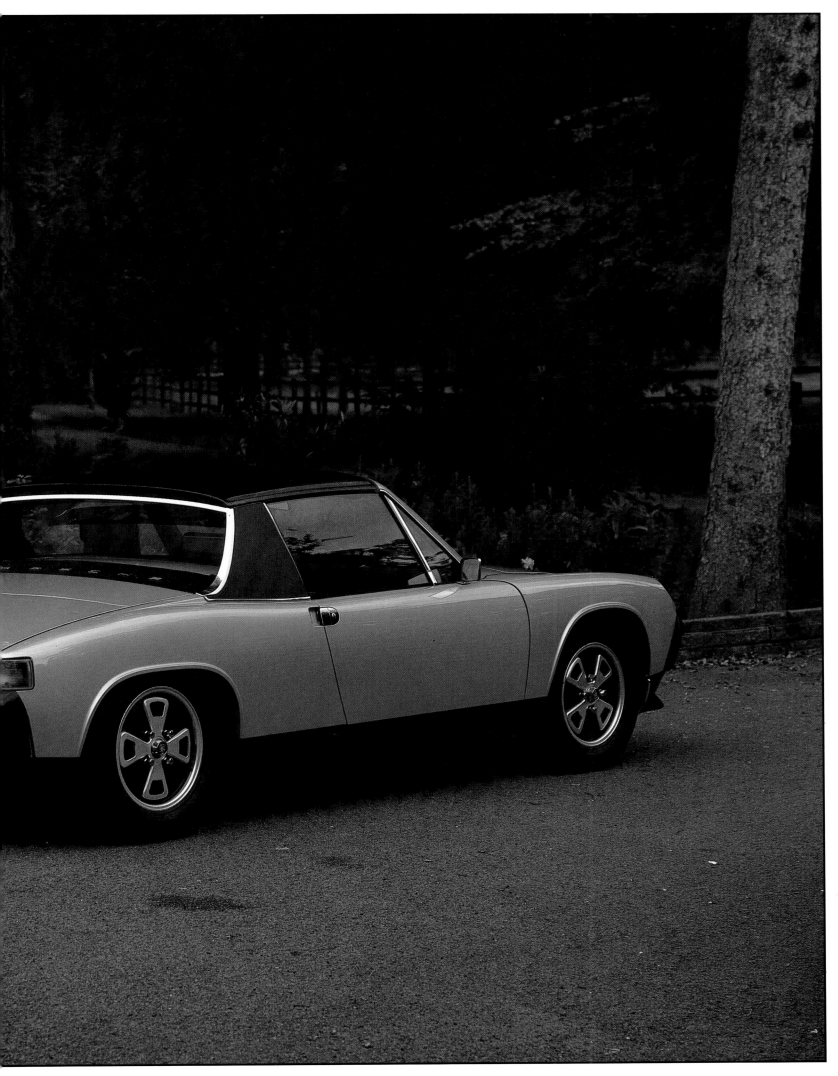

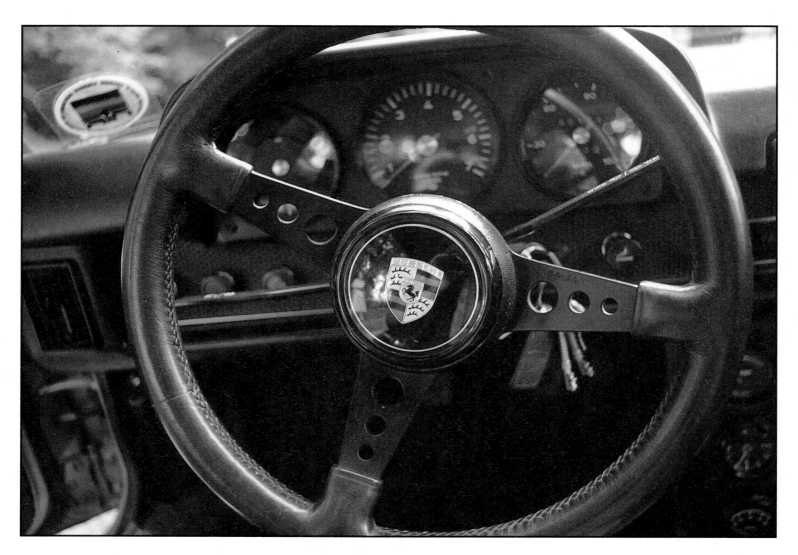

SPECIFICATIONS
1973-76 TYPE 914 2.0 LITER

Engine: As per 1970-73 Type 914/4 except Bore and Stroke: 94.0 x 71.0mm. Displacement: 1971cc (120 cid). Bhp (SAE net): 91 at 4900 rpm (84 bhp after 1973). Torque (lbs/ft SAE): 109 at 3000 rpm (108 at 3500 rpm after 1973). Compression ratio: 7.6:1.
Chassis: As per 1970-73 Type 914/4 except solid-rotor four-wheel disc brakes with vacuum assist.
Measurements: As per 1970-73 type 914/4 except Curb weight (lbs): approx 2150. Tire size: 165HR-15. Overall length: 161.2″ (159.4″ on 1973 models).

The 914 engine was a mid-mounted VW flat opposed air-cooled four. In 1970 the engine displacement was 102.5 cubic inches and the unit developed 80 bhp (DIN). By 1973 displacement had increased to 120 cubic inches. The leather-wrapped steering wheel (facing page top) had racing type spokes and the Porsche emblem on the hub; the four-lug wheels (facing page bottom) also had the badge centrally located. Other external features included flush-mounted door handles (top) and vinyl-covered roof and C-pillar (left).

Nobody thought it would happen but it did. America welcomed the compact unreservedly.

On the mechanical side, new cast aluminum drum brakes with 72 radial fins and cast iron liners replaced the previous circumferential finned brakes and in 1961 Koni shocks were standard on 1600 S models and the Super 90. The latter was the designation for a new 1600 engine with 90 bhp (DIN), hence the name. This unit first appeared in March 1960 and was the largest of the three 1600s that made up Porsche's engine range. Smallest was the 1600 N (Normal) with 60 bhp (DIN), and the middle was the 1600 S (Super) which cranked out 75 bhp (DIN).

The year 1962 found the 356 B still evolving, always improving. Twin air intake grilles replaced the single one in the rear engine lid while the front hood/trunk cover was flatter. A new and swifter Carrera, the Carrera 2, appeared in the spring. The 2 meant 2.0 liters and was the first road going Porsche to have four wheel disc brakes. These were Porsche designed and were used on the company's Formula 1 and 2 racing cars.

At this period of expansion over 70 per cent of the firm's cars were exported; there was a workforce of almost 1,200 and production approximated 7,500-8,000 units a year.

A return to flat hub caps was the only visible change on the 356 C which succeeded the B series in July 1963. Four-wheel disc brakes were standard but not of Porsche's own design as originally used on the Carrera 2. Cost was the reasoning behind the switch to Dunlop disc brakes; it was a proven system and readily available through the German licensee, Alfred Teves.

Engines in the 356 Cs were three, including the Carrera 2. Gone was the 60 hp plant to be replaced by the 1600 C giving 75 bhp (DIN). A 95 hp version was the 1600 SC, while the Carrera 2 pumped out 130 horses during its short tenure. During 1963 Porsche took over Reutter presumably, feeling it more advantageous to have all its eggs in one basket. Later on Porsche made another name for itself when it created a Reutter subsidiary company well known to the world as Recaro, the famous seat maker.

September 1965: 76,303 cars and 15 years after its inception, finally the last of the great 356 models drove out of the Zuffenhausen factory doors. The car had come to the end of a long and distinguished road. It was, to use that much hackneyed phrase, "a legend in its own time", more than worthy of the term "classic".

SPECIFICATIONS
1974-75 TYPE 914/4

Engine: As per 1970-73 914/4 except Bore and Stroke: 93.0 x 66.0mm. Displacement: 1795cc (110 cid). Bhp (SAE net): 73 at 4800 rpm. Torque (lbs/ft SAE): 89 at 4000 rpm. Compression ratio: 7.3:1.
Chassis: As per 1970-73 Type 914/4.
Measurements: As per 1970-73 Type 914/4 except Curb weight (lbs): approx 2160. Tire size: 165SR-15. Overall length: 161.2".

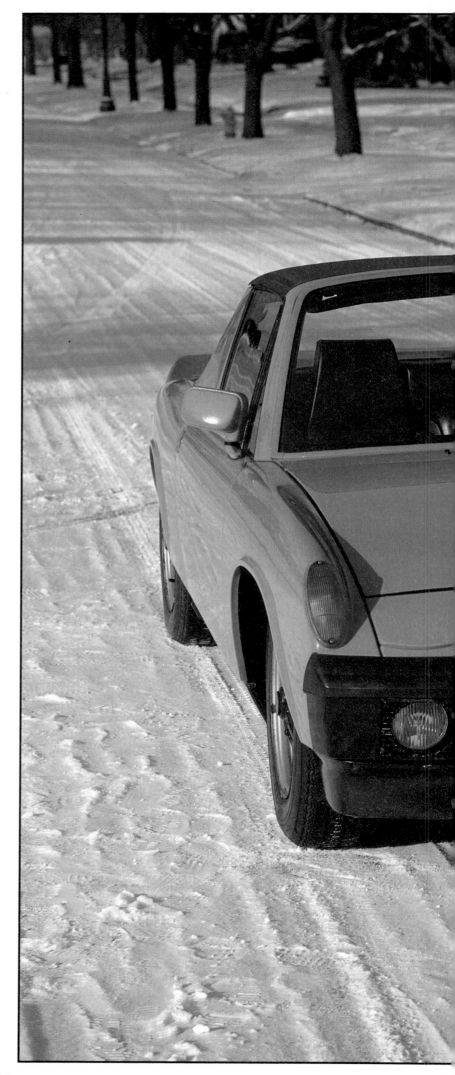

The design of the 914 originated from Gugelot Design GmbH, located in the town of Neu Elm, some 50 miles from Stuttgart. Gugelot had produced a prototype car to test a possible new body material. Although the material proved unsuitable, Porsche showed an interest in the car's design, which, under the direction of Butzi Porsche, was revised to take an amidships engine and drivetrain. And so the 914 (these and previous pages) was born.

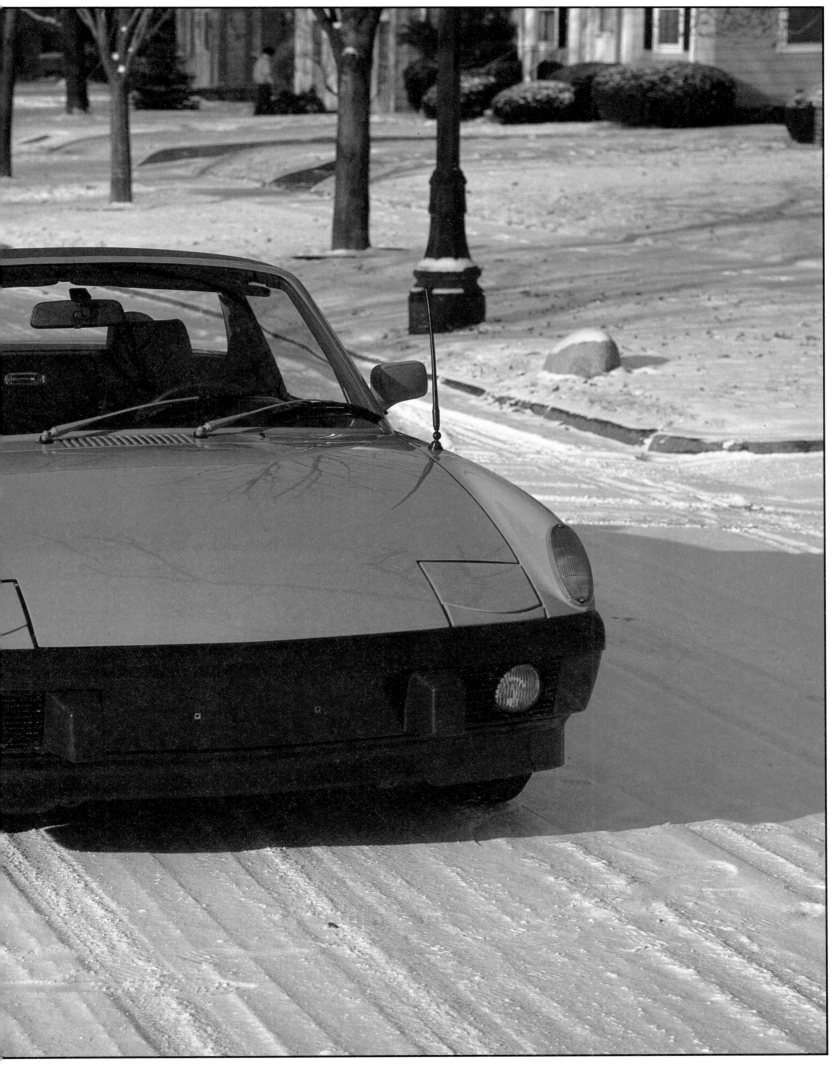

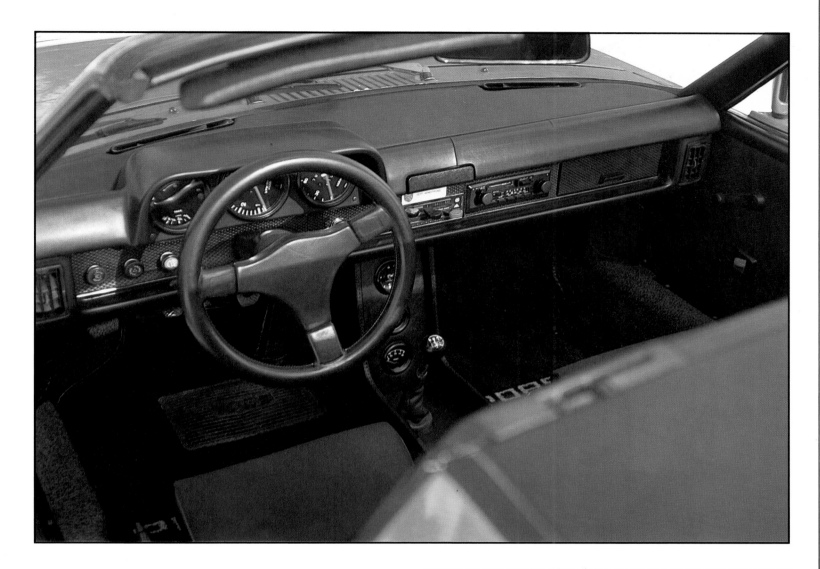

THE GREAT 911

Production of the 356 A had hardly begun when Ferry Porsche laid down guidelines for a logical extension of the then current theme. He told his son, Ferdinand Alexander III, popularly known as Butzi, who was given the job of designing the new car, that it should retain the qualities of the 356 but performance, comfort and space should be improved. Initially Ferry Porsche was thinking of a full, four-passenger vehicle, but when he saw the code-named T-7 prototype designed by Butzi he changed his mind, opting for Porsche's traditional 2+2 format instead.

Bearing in mind his father's original brief, Butzi Porsche performed a remarkable design feat. He enlarged the interior space to a full four seater by lengthening the wheelbase only a fraction. The car featured a sloped hood, straight fender lines, a fastback roofline and greatly increased glass area. From the B-pillars forward the T-7 would be transplanted with little change to the eventual 911.

Over 100,000 914s were built between 1970 and 1976, plus another 3,351 914/6 models. The 914/6 was Porsche's answer to the critics' charge that the 914/4 was basically a dressed-up Volkswagen. The 914/6 carried Porsche's own six-cylinder engine and was built at Porsche's factory. Non-standard steering wheel, blacked out wheels, and C-pillar minus its vinyl covering are owner modifications on the 914 illustrated here.

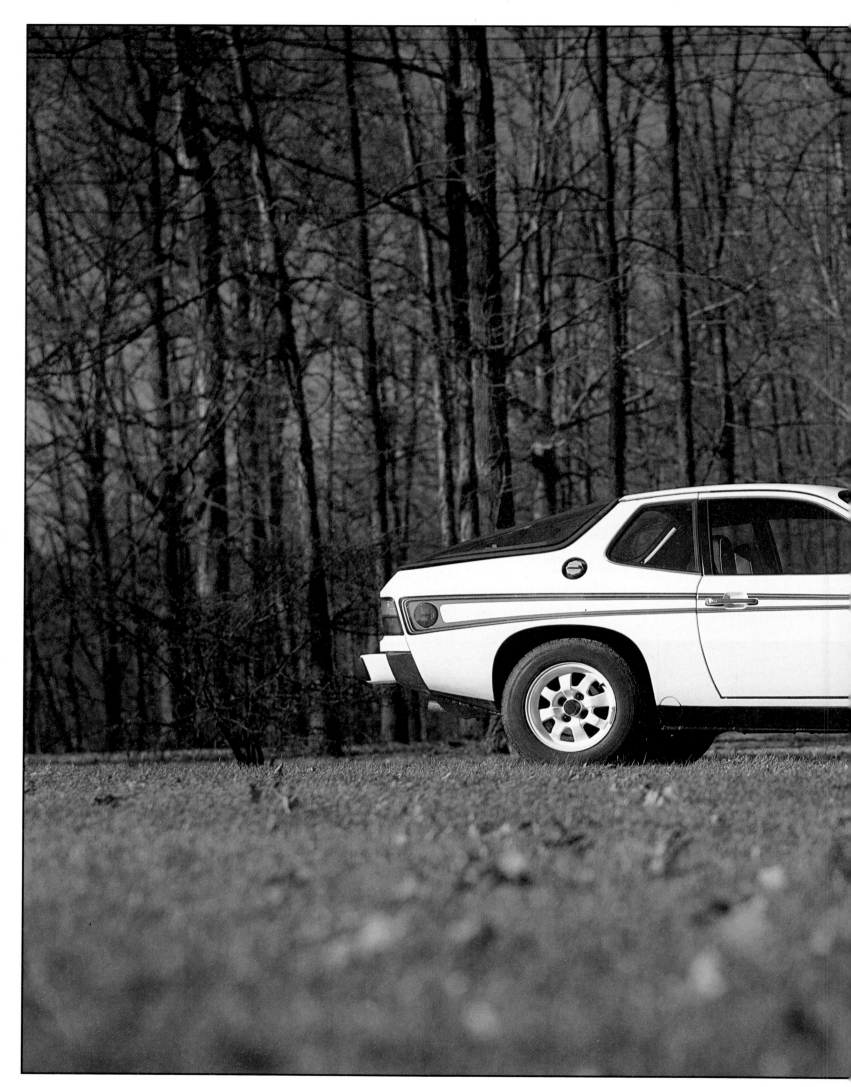

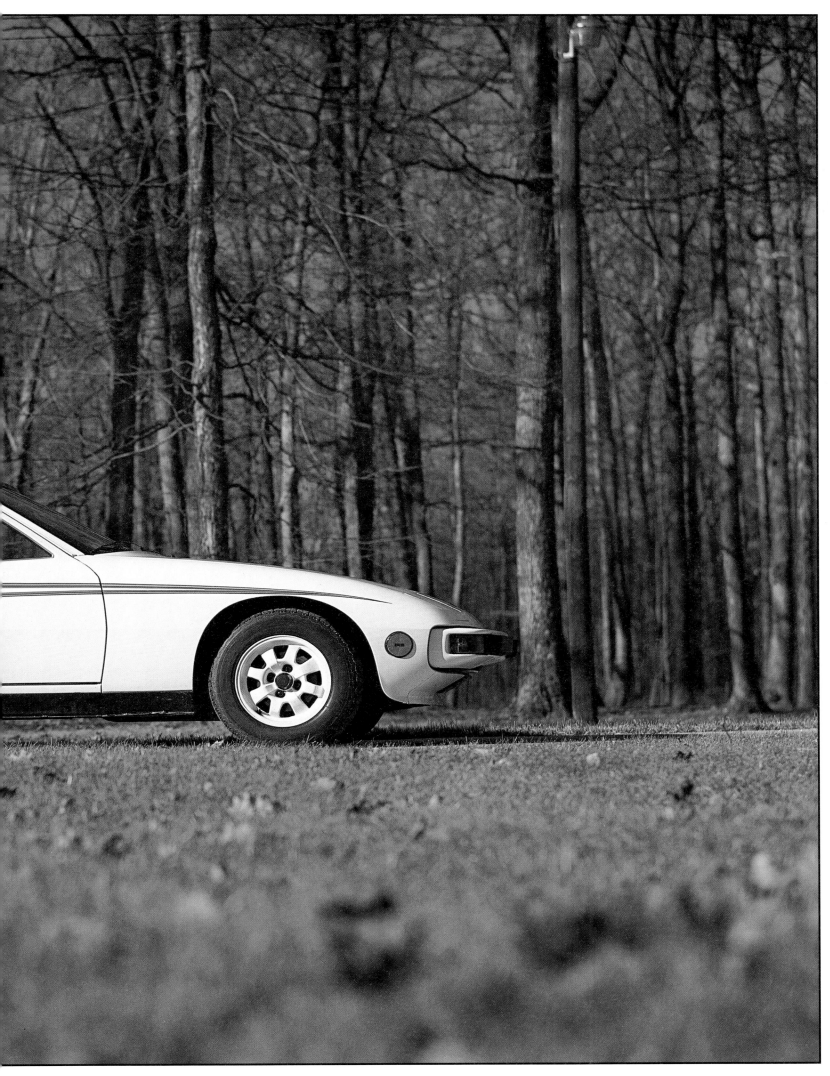

SPECIFICATIONS
1977-82 TYPE 924

Engine: Four-cylinder inline, water-cooled. Bore and Stroke: 86.5 x 84.4mm. Displacement: 1984cc (121 cid). Bhp (SAE net): 95-115 at 5500-5750 rpm. Torque (lbs/ft SAE net): 109-111.3 at 3500 rpm. Compression ratio: 8.0:1-9.0:1. Single overhead camshaft, five main (forged-steel) bearings, cast-iron cylinder block, cast-aluminium alloy cylinder head, CIS electronic fuel injection (with oxygen sensor from 1980).
Chassis: MacPherson strut front suspension with coil springs and negative roll radius geometry (anti-roll bar optional), independent rear suspension with integral transaxle, diagonal control arms, transverse torsion bars, anti-roll bar (optional); rack-and-pinion steering; front-disc/rear-drum brakes with vacuum assist; Porsche five-speed overdrive manual or Audi three-speed automatic transmission; single dry-disc clutch. Final drive ratio: 3.44 to 5.00:1 (manual transmission), 3.73:1 (automatic transmission).
Measurements: Curb weight: 2625-2675 lbs. Tire size: 165HR-14, 185/70HR-14 from 1979 (205/60HR-15 optional from 1980). Track: 55.9″ front, 54.0″ rear. Wheelbase: 94.5″. Overall length: 170.0″. Overall width: 66.3″. Overall height (unladen): 50.0″.

Designated the 901, the new Porsche was unveiled at the 1963 Frankfurt Motor Show. Naturally, it drew a lot of attention; rumors had been circulating about a new model for a number of years. Butzi had done a magnificent job on revising the backend to bring it into line with the proposed 2+2 configuration. Although still adopting the fastback design, Butzi softened it by rounding out the rear side window at the base of the C- pillar.

While the design was evolutionary, the 901 was nothing like the 356 series. It did not have the fleshy look, rather it was trim, flatter - not fatter - in profile. The deeply sloped hood line extended to the bumper and the parking lights/turn signals wrapped round to the sides beneath the set back headlamps. This show car was a prototype; the 356 C production run was well under way at this point and there was little chance of the 901 being produced immediately. Harried by the question when? Porsche countered probably summer 1964.

It was under the rear lid that the really big developement lay. Here was a brand new 2.0 liter horizontally opposed air-cooled flat six featuring a single overhead camshaft per cylinder bank. Horsepower was 130 at 6100 rpm, 0-60 was reached in approximately 8.5 seconds and the top speed was quoted at 130 plus.

An improved all-independent suspension system was logical for the new car and it got it in the form of MacPherson struts up front. Single lower transverse A-arms were connected to longitudinal torsion bars. At the rear the old swing axles gave way to transverse torsion bars and semi-trailing arms. Road testers later found this system far better than the 356 suspension due to more positive control. Oversteer was an occasional complaint with the 356i; on the 901 its behavior was neutral.

The 901 was well received, and many pages of the printed word were expended on it. Peugeot, however, protested it had rights on three-figure numbers with a zero in the middle - if Porsche wanted to sell cars in France, well, a number change might be advisable. Not wanting long drawn out litigation over a number, Porsche promptly changed it to 911!

The 924 was designed by Porsche to be a Volkswagen, but ended up as a Porsche. All through Porsche's history there has been a strong link with VW, beginning with Dr. Porsche's design of the "Beetle." In 1970 it was realized that the 914 was not going to share the legendary appeal of the 356. The result was the 924 launched in 1976 and based somewhat on VW components. The car illustrated (previous pages and right) is the 1977 924 "Championship Edition" produced in limited numbers to celebrate Porsche's winning of the 1976 World Championship of Makes and Sports Cars.

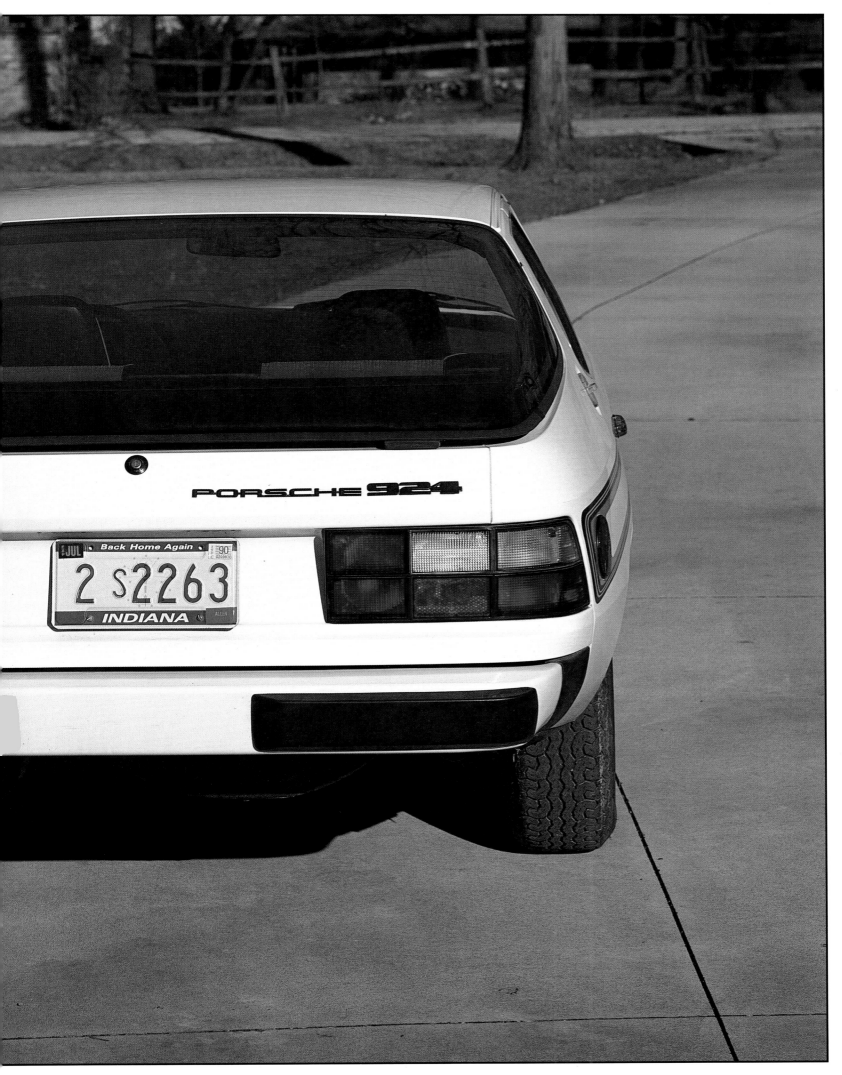

There was also a 912. Fearful that the $6,300 US price for the 911 might scare away potential buyers, Porsche used the 1600, 90 bhp (DIN) flat four under the 911 rear lid, removed a couple of instruments and the 911's teakwood dash veneer. The 912 listed at $4,696 yet provided excellent performance and a top speed of 115 mph. Apart from the mentioned deletions the 912 was identical to the larger engined 911, even down to its new ZF rack and pinion steering (this replaced the old VW worm-gear type thereby virtually divorcing Porsche from its long dependence on the Wolfsburg company).

As Porsche promised, the 911 went into production a little over a year after its début, arriving in the US early in 1965. American car magazines applauded it; in their inimitable idiom they thought the 911 the best thing since some cowboy dreamed up the hamburger. Even the price, though dreadfully high, was excused, ignoring the fact that the very sophisticated fully equipped Corvette Stingray sold for $1,800 less. True, the 911 was a superlative automobile when it first came out and has improved immeasurably since then. But in 1964 there were sports cars equal, some even superior, to the Porsche.

Only 2,000 Championship Edition 924s were built, thereby making it something of a collectors' car today. The interior (facing page top) was exclusive to the Championship Edition though the instruments (facing page bottom) were standard to all models. The car was the first production Porsche to adopt the front engine-rear drive configuration. The engine (top) was a water-cooled in-line four with a single overhead camshaft. The six-lens lighting cluster at the rear (above right) includes back-up and amber turn signals. The emblem (right) displays the Stuttgart coat of arms and six stag horns taken from the crest of Baden-Wurtemburg.

The smaller engined 912 reached America in September 1965, five months after it went on sale in Europe. Road tests were very positive, the car much liked, even by hypercritical *Road & Track* whose reputation for cutting cars down to size is world renowned.

A Targa model of the 911 and 912 appeared at the 1965 Frankfurt Motor Show. It featured an enormous wrapround rear window, a thick brushed stainless steel roll bar and a removable roof panel above the front seats. Porsche chose the name Targa because it conjured up the famed Sicilian Targa Florio road race. The rear window, by the way, was originally a plastic zip-out one but was changed to glass later on.

A quarter century on and the 911 is still with us. The changes and modifications it has had defy all but the most dedicated follower of Porsche. It is impossible to list all those changes here, but a few of the more important models are noted.

In 1967 the 911 S was born. This was the performance model with horsepower raised to 160 from the 2.0 liter six cylinder engine, which received new camshafts, larger valves and higher compression (9.8:1 compared to 9.0:1 on standard 911 models). Ventilated disc brakes, Koni shocks, a rear anti-roll bar and distinctive five spoked alloy wheels. Perhaps Porsche was mindful of the growing "muscle car" boom stateside, because the 911 S would thunder up the torque curve in true Detroit kick-in-the-back fashion.

During 1969 came a 2.24 inch longer wheelbase bringing it to 89.3 inches overall. Length remained the same, at 163.9 inches. Road tests since 1967 complained of rearward weight bias, oversteer and power slides were more apparent. Fifty-seven per cent of the car's weight was over the rear wheels, and although Porsche engineers had increased the wheelbase, thus shifting a fraction of the static weight toward the front, and introduced Boge self-adjusting hydropneumatic front struts, they could not entirely eliminate rear-end drift. This factor received criticism - yet it was not unnoticed that the critics were quite happy to blast down the road in a late sixties' American "muscle car" with a huge 7.0 liter engine weighing a ton up front, and relying on a downright dangerous outmoded suspension system to keep them intact. At least Porsche was conscious of the problems and was trying to eliminate them, irrespective of the cost.

Other Porsche models arrived; there was the Porsche 911 L (this was for luxury), a 911 T and a 911 E (this replaced the L after a couple of seasons). Then came the 911 T for 1972. Horse power and acceleration figures for the three models were: 911 T-130 bhp (DIN) at 5600 rpm, 0-60 in 6.9 seconds 911 E 165 bhp DIN at 6200 rpm, 0-60 in 5.8 seconds and the 911 S had 190 bhp at 6500 rpm, 0-60 in 6.0 seconds. Carburetors were replaced by Bosch fuel injection in 1969. Porsche also brought out a new option, Sportomatic, a semi-automatic transmission aimed at the American market. There was no clutch, but one could shift by hand if needs really demanded.

Apart from the red rear mid section, this 1978 Porsche 924 (previous pages and right) is identical to the previous year's model. Base price was under $9,500, compared to over $15,000 for a standard 911, and buyers got a lot for their money. Suspension was a mixture of VW Beetle and Golf/Rabbit: the Rabbit supplied the rack and pinion steering and lower A-arms, while the front disc brakes came from the Beetle, as did the semi-trailing arms. VW's K-70 sedan provided rear drum brakes and the VW Type 181 utility vehicle loaned the half-shafts.

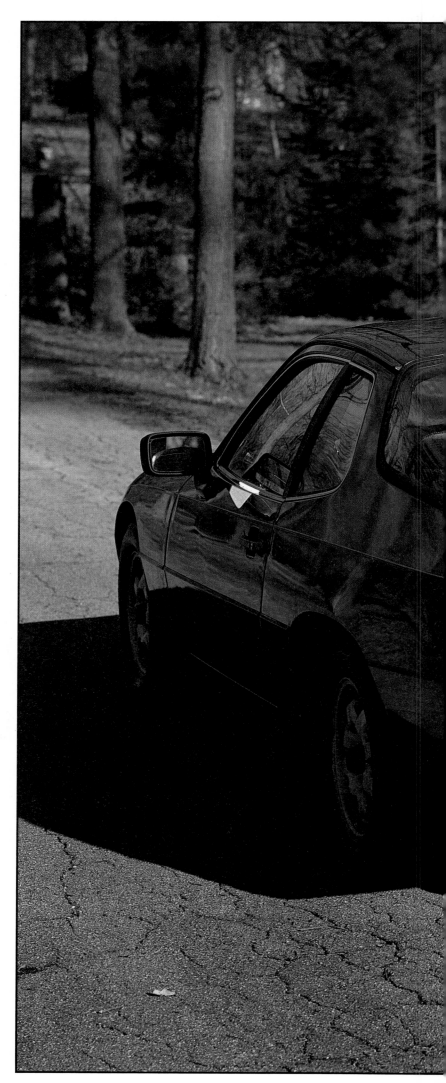

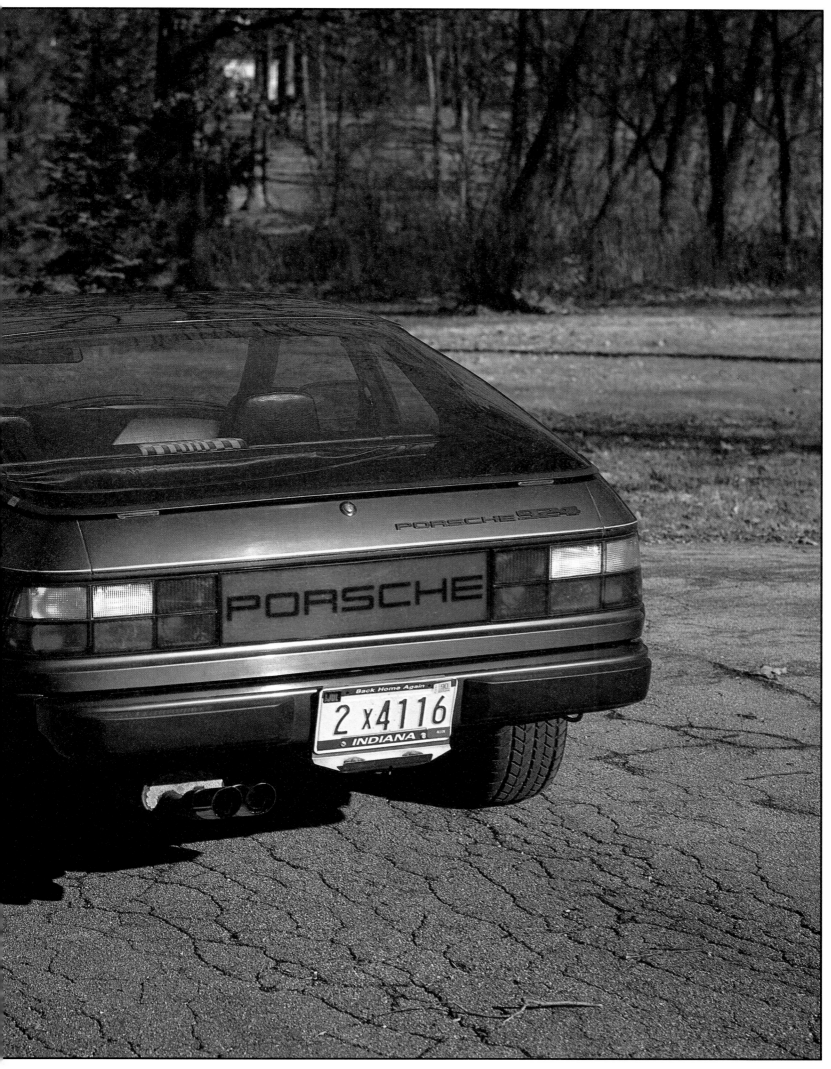

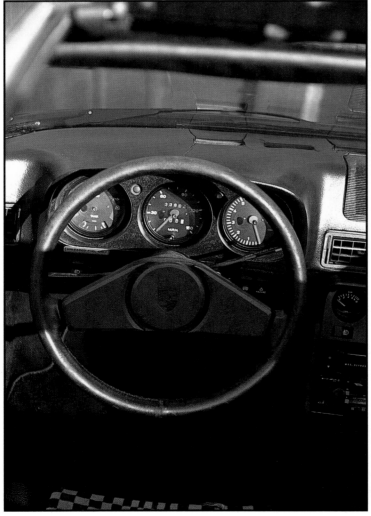

As with all cars, plastic was becoming a way of life even in the Porsche 924. Round instruments (left) carried the traditional white on black theme and the enormous wrap round rear glass (above) – not unlike a piece of Fifties Detroit – served as a hatch to the trunk. The checkerboard seating fabric (above left) provided a touch of pizazz to the interior.

Sadly the 912 had been set aside; in its place came the 914, not one of Porsche's better ideas, which is dealt with in the next chapter. By 1972 the cheapest Porsche was the 911 T at $8,804, while the 911 S cost an astonishing $10,750.

The hydropneumatic struts were replaced by conventional suspension, which included larger diameter front and rear anti-roll bars, Macpherson struts, torsion bars, Koni or Bilstein shock absorbers.

America's federal authorities had burdened the motor industry with a number of mandatory safety and emissions features that caused most car makers concern. These regulations began to take effect in 1968 and Porsche dutifully complied. Unlike the other car makers who suffered reduced performance because of the strangling emissions, Porsche managed to produce more powerful models than those they replaced. However, there was one model eager American Porscheophiles could not get; the 1973 911 Carrera 2.7 RS.

Originally only 500 were meant to be built for homologation in Group 4 competition. Due to this car's desirability, Porsche built three times that many in 1973, thus allowing the RS to race in Group 3.

There were three models: 911 RS which was an unashamed road racer sporting a 2687 cc engine, a lightweight body constructed of thinner steel and fiberglass, no sound insulation, thin shell seats and no comfort features. Then there was the RST, a normal 911 S trim and the competition RSR. The normally optional 5 speed transmission was standard and the 2.7 liter engine developed 210 bhp (DIN), could race up to 150 mph plus and zoom to 60mph

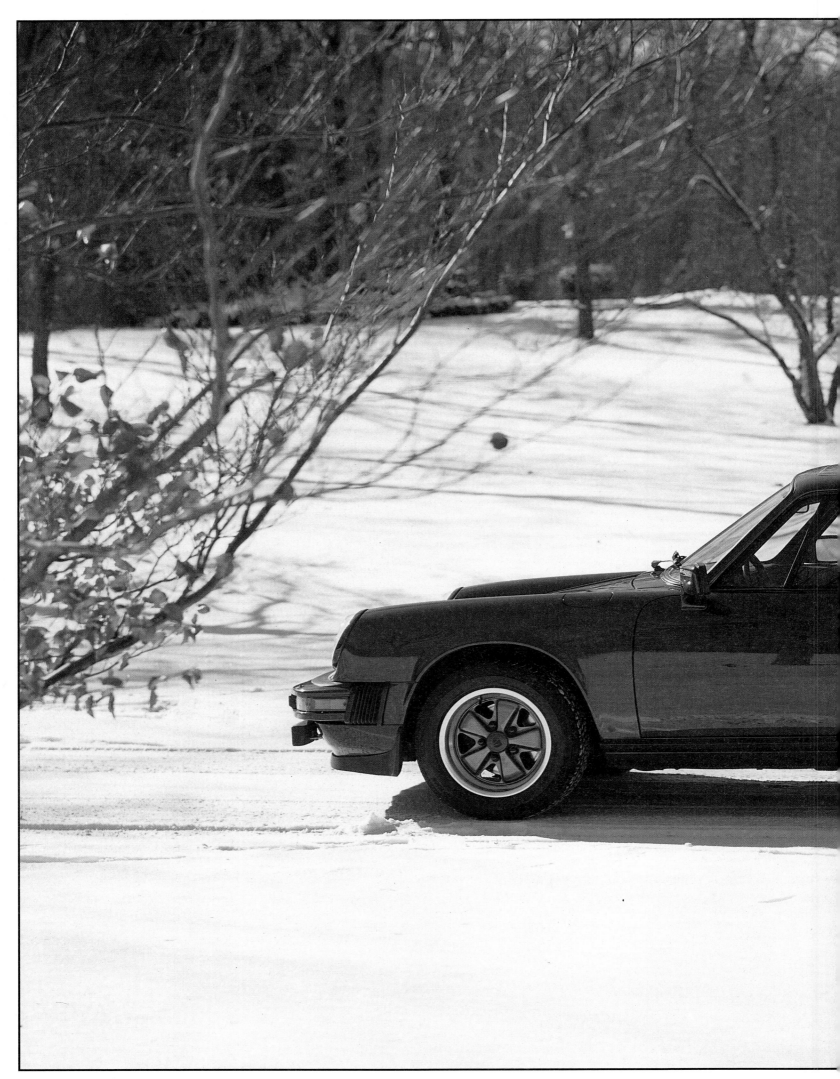

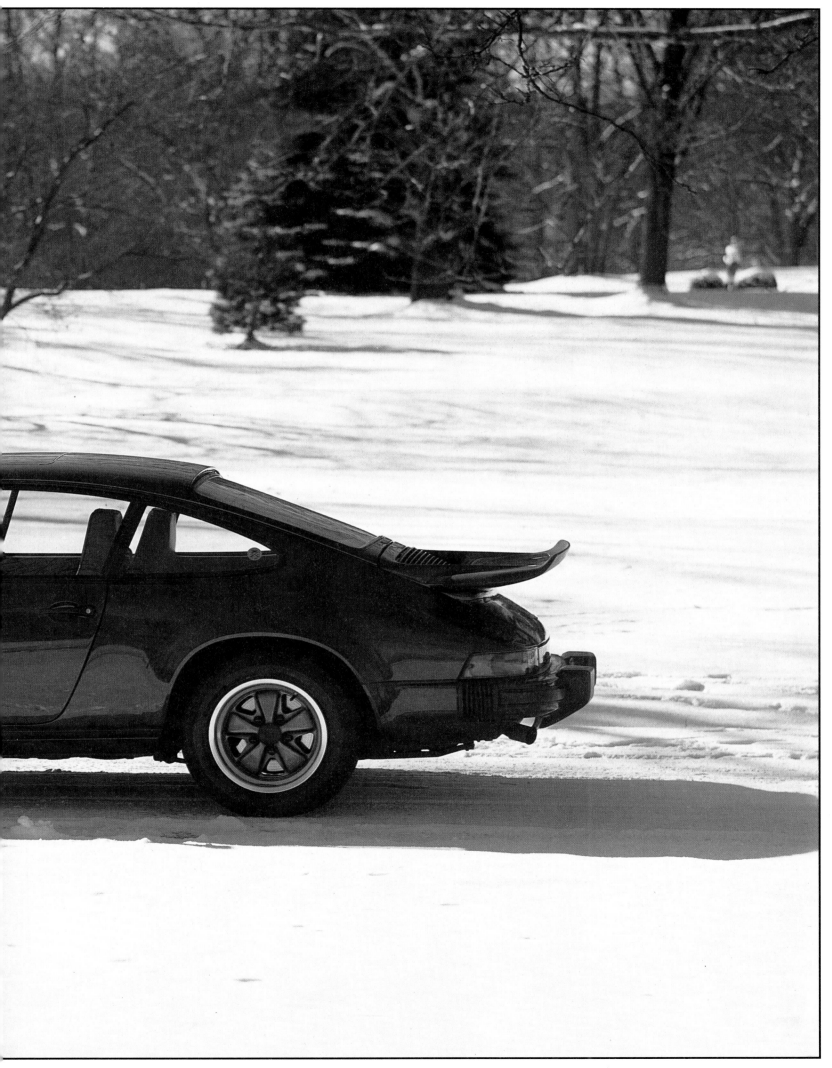

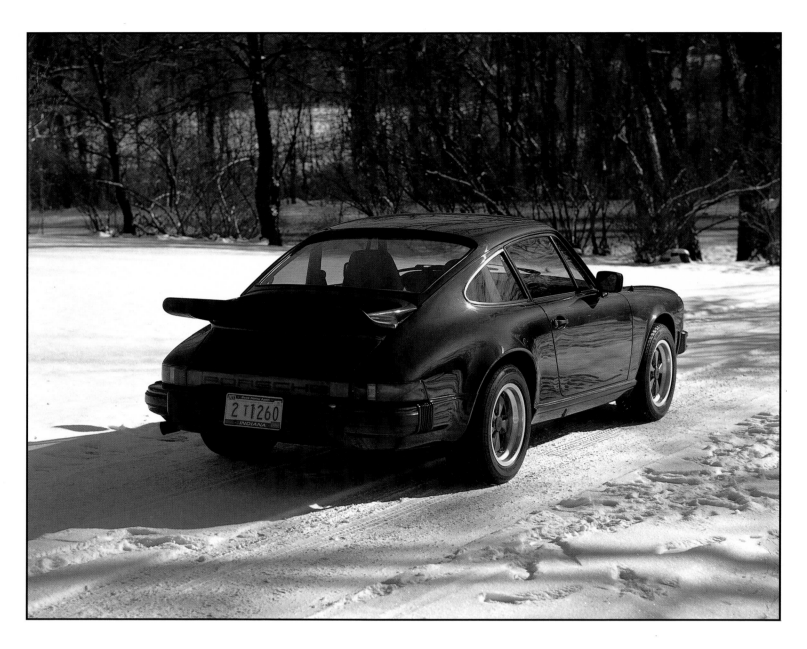

in 5.5 seconds. With American insurance companies' mistaken belief that speeding is worse than bad driver training, it was perhaps good that this Porsche did not reach America.

Big, fat, rubber bumper-guards and steel door reinforcements heralded Porsche's nod to federal decrees in 1973. A year later all Porsche models got the 5 mph impact bumpers as required by the mandate. Unlike some car makers, Porsche did a good job of blending the heavier, more massive bumpers into the bodywork. Behind the body colored bumper "skin" lay hydraulic shocks attached to a heavy steel bar. If hit, the shocks would be driven back, then rebound like a spring. Simple but effective technology shared by almost all car makers.

In 1974 Porsche built their first Turbo. Introduced in August for the 1975 season, the turbo came by way of the race track, having been successfully used on a 2.1 liter Carrera as well as on 2.8 and 3.0 liter RSR competition cars. Its pedigree was sound so Porsche put the turbo into production.

Turbo-charging a 911 was the work of one man: Ernst Fuhrmann, chairman of Porsche since 1972. Fuhrmann was another brilliant German engineer, and it was he who had designed the 356 Carrera quad cam four and had been behind the RSR.

Both the Porsche and Piech families gave up control of the company in 1972, Fuhrmann becoming chairman and the company a joint stock corporation with a board of directors. In Fuhrmann Porsche gained a chairman who was a true enthusiast, a businessman and a great engineer.

Europe got the turbo Porsche first, then America in 1976. The engine was the 183 cid (2993 cc) flat six Carrera RS unit, but blown. American versions developed 245 bhp (DIN). The more fortunate Europeans' engines developed 260 bhp (DIN) - and had a price of $25,880. At that price expectations were high, but they were met.

It was characteristic of Porsche to fly against the wind. From 1973 onwards the motoring world, especially in America, was in upheaval from the oil embargo. Limiting the American's gas was an unthinkable restriction, and with rampant inflation, powerful cars were distinctly unpopular. Detroit was in the desperate position of having to prepare cars to meet federal laws and make them economical. And here was Porsche doing exactly the opposite.

This Weissach Edition of the 911C (these and previous pages) came out in 1980 specifically for the U.S. market. Weissach is where Porsche has its research and development center, and it was a fitting name to give to a model that was limited to a production run of just 400 units.

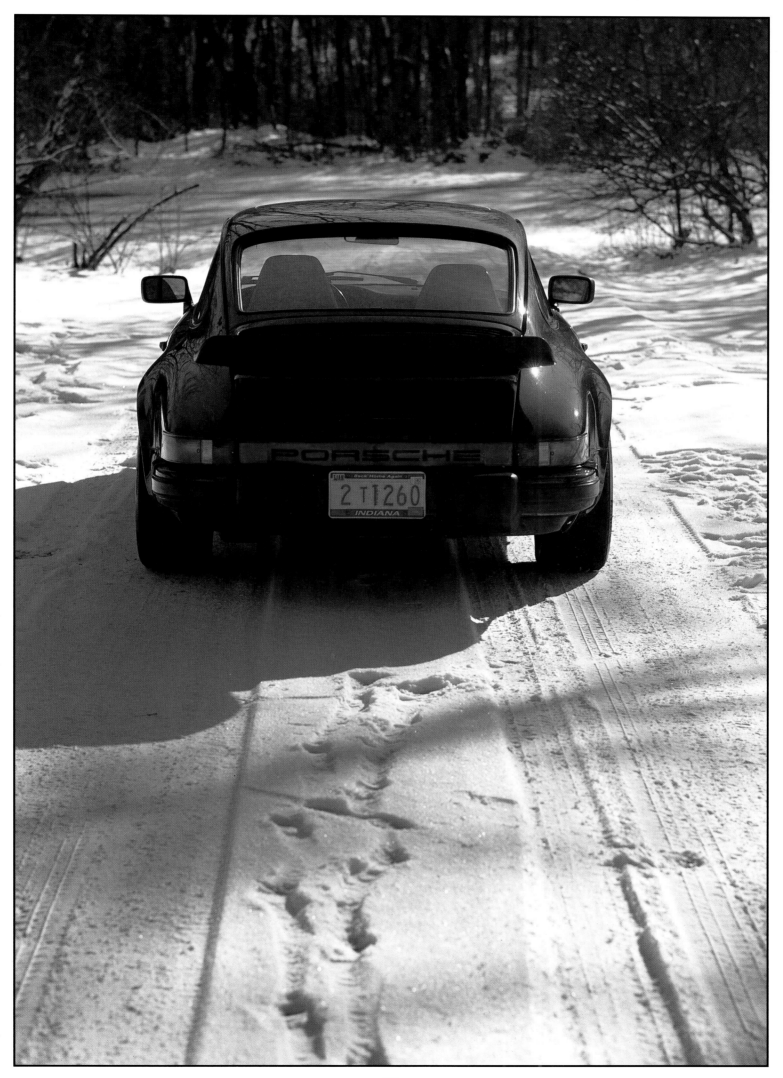

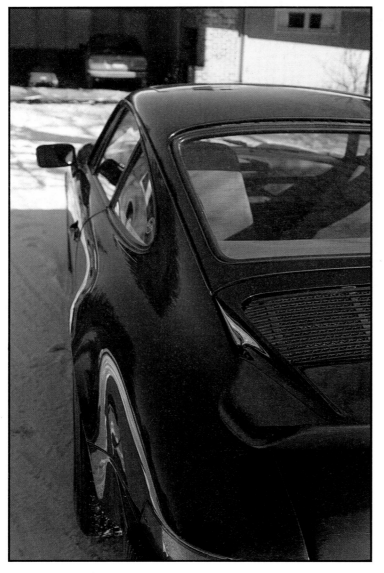

For the asking price of $32,000, the 911C Weissach Edition offered choice of special black or gold paint finish, gold-colored wheels, stiffer shocks, leather trim, sealed beam halogen headlights, as well as a few other niceties. According to Porsche, the extras on the Weissach Edition represented a 15% saving over buying these for the standard 911 coupé, which retailed in 1980 for $27,000 without any goodies. As can be seen from the interior shots, the Weissach was a cut above the standard Porsches, and that's saying something!

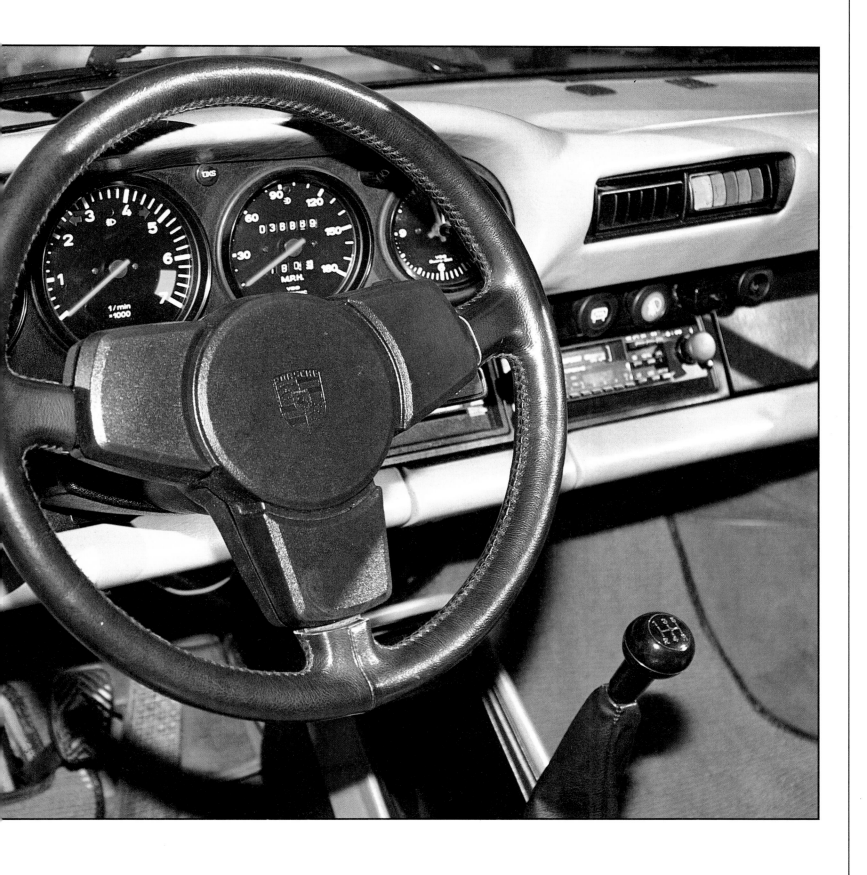

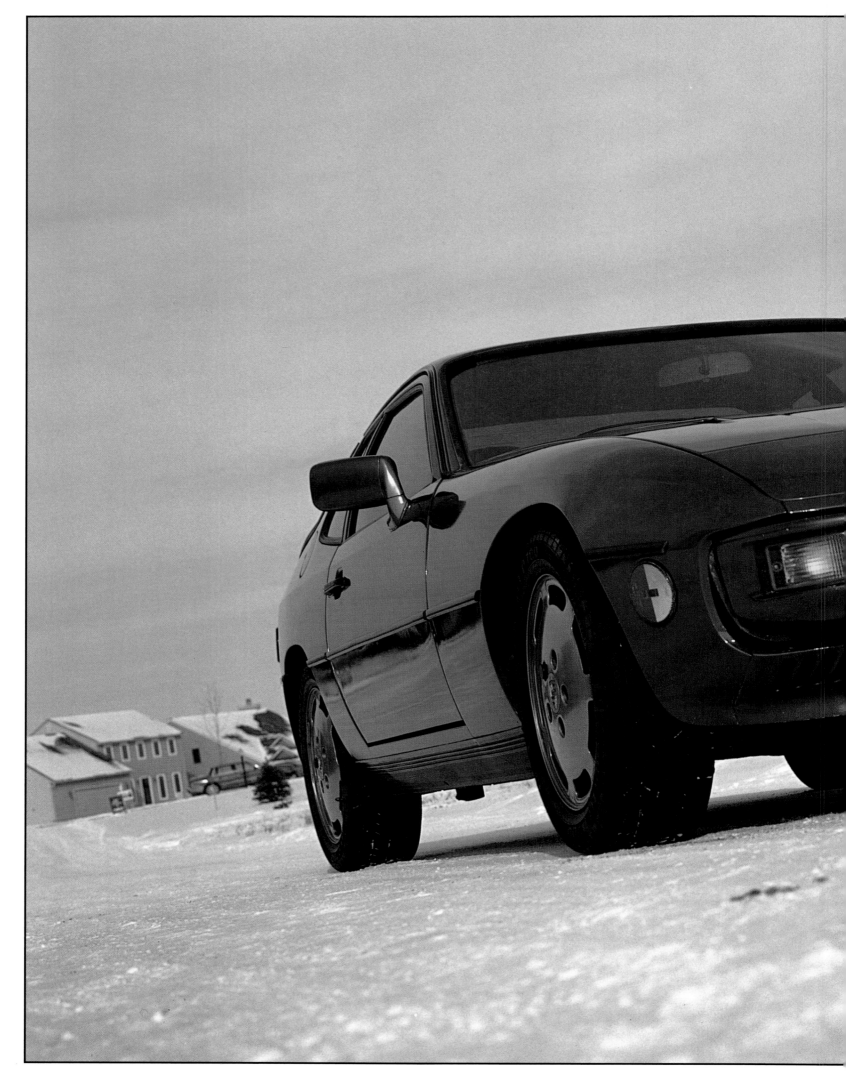

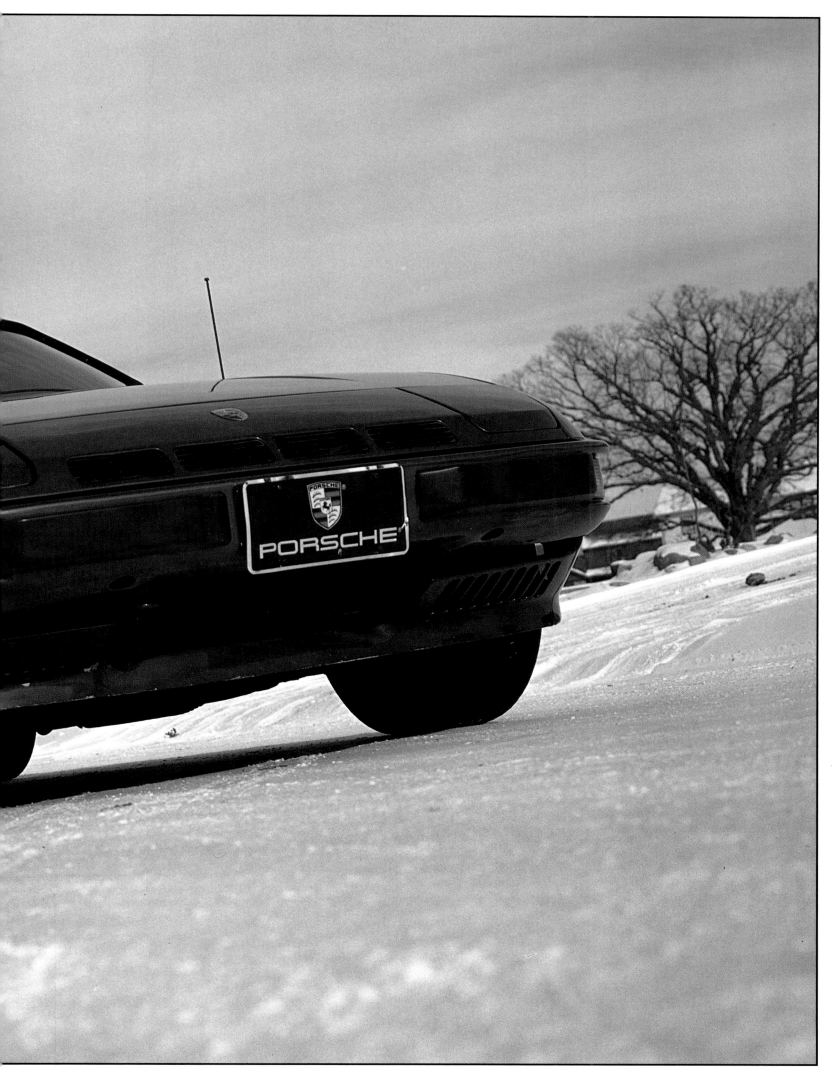

Porsche succeeded where others did not because its engineers did their homework right. The American auto industry thinks only in terms of dollars - make it cheap; anything over a dollar fifty is too much. In Europe, especially Germany, they believe in spending to achieve their goals, which is why Mercedes, BMW, Audi and Porsche are world leaders. High priced, yes, but unrivalled value.

It had never been done before but Porsche succeeded. The engineers took the 3.0 liter engine, placed the blower on a cast aluminum manifold and set boost pressure at 11.5 pounds per square inch. The plastic tubes for the fuel injection now sat between manifold and intake ports. Such was the importance of this turbo that it got its own number: the 930. Then US-mandated emissions were added and while the 930's hp was 15 less than in Europe, the Turbo Porsche still could muster a healthy 246 lb of torque.

The publicity given to the industry's alleged lowering quality encouraged Porsche to galvanize both sides of its body shells in 1976. A six year no rust warranty came as part of the package. Even at high prices people still bought Porsche and in far greater numbers than Ferrari, Lamborghini, Aston Martin and Maserati put together.

The year 1978 saw the demise of the Carrera and the birth of the 911 SC. Priced at $22,000 the SC sported the 3.0 liter engine but hp was less than the Carrera, at 172 (SAE). DIN had been dropped; everybody followed Europe's SAE system which means hp is derived from a complete engine, not just the block - which is what DIN meant.

Changes were few; over the next few years it was the time honored Porsche policy of constant improvement. New models had been introduced - the 924 and 944 were examples - but the aging 911 kept on going despite repeated rumors to the contrary. Just when the public media thought it had driven its last mile, once again the 911 appeared.

Dr Ernst Fuhrmann retired in 1981 and his place as chairman was taken by Peter Schutz. He was, as were all Porsche's leading lights, an inveterate car enthusiast with a special regard for the 911. He was against killing it off as some wanted to do, and in this case Ferry Porsche backed him to the hilt.

At the 1981 Frankfurt Show Peter Schutz displayed the direction he was going with the first convertible of the 911 series. What was particularly interesting was the car's four-wheel drive system.

This convertible 911 went into production two years later but with conventional drive only. A four-wheel drive version was tried out in rallies, one winning the arduous Paris-Dakar run, after that it was dropped.

A new Carrera was produced in 1984, reaffirming Peter Schutz' commitment to the 911. Displacement for the horizontally opposed six was up to 193 ci (3164 cc). Compression ratio was 9.5:1 US, 10.3:1 in Europe. By 1988 hp had reached 214 (US), 232 (Europe).

A lot of work had been done on its engine. The turbo's longer stroke crankshaft had been attached to the alloy block. Larger valves, higher compression pistons, new manifolds coupled with Bosch's new DME (Digital Motors Electronics) mapped injection and ignition systems, indicated that this was virtually a new engine. What is surprising is that the body, which is plain trim as in the Carrera 3.2, is almost exactly the same as it was 25 years ago. Yet people keep on buying it.

Another attractive car emerged in 1989, the 911 Speedster. This is the car for a place in the sun. Its engine specifications are the same as the Carrera 3.2 but it is open top. Top speed is 152 mph and 0-60 takes 6.1 seconds. A novel feature - for Porsche - is the convertible top's plastic

Europe got a turbocharged version of the 924 (previous pages and above) in 1979, while the U.S. had to wait until the 1980 model year. The engine was the same 2.0-liter block, but with a new Porsche-designed cylinder head. This featured, among other things, hemispherical combustion chambers and larger valves. The turbocharger was by Kuhnle, Kopp & Kausch, and a 924 so equipped could rustle up 0-60 times of 6.9 seconds. DIN-rated horsepower was 125 at 5500 rpm. A turbo-boosted 924 was easy to spot by its NACA air duct on the hood and four air slots on its nose (previous pages).

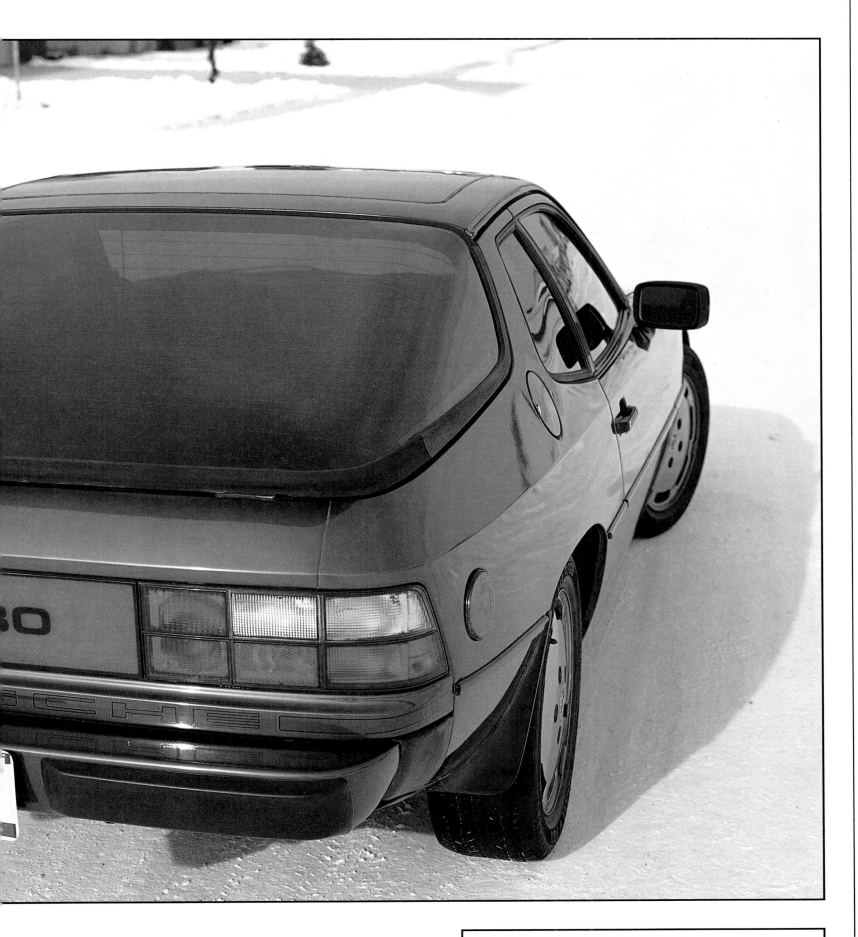

SPECIFICATIONS
1980-82 TYPE 924 TURBO

Engine: As per 924 except bhp (SAE net): 143 at 5500 rpm. Torque (lbs/ft SAE net): 147 at 3000 rpm. Compression ratio: 7.5:1.

Chassis: As per 924 except standard 23mm-diameter front anti-roll bar; 14mm-diameter rear anti-roll bar optional with Sport (S) Group. No automatic transmission option. Final drive ratio: 4.71:1.

Measurements: As per 924 except Curb weight (lbs): approx 2825. Tire size: 185/70VR-15 (205/55VR-16 optional with Sport Group). Overall length: 168.9″.

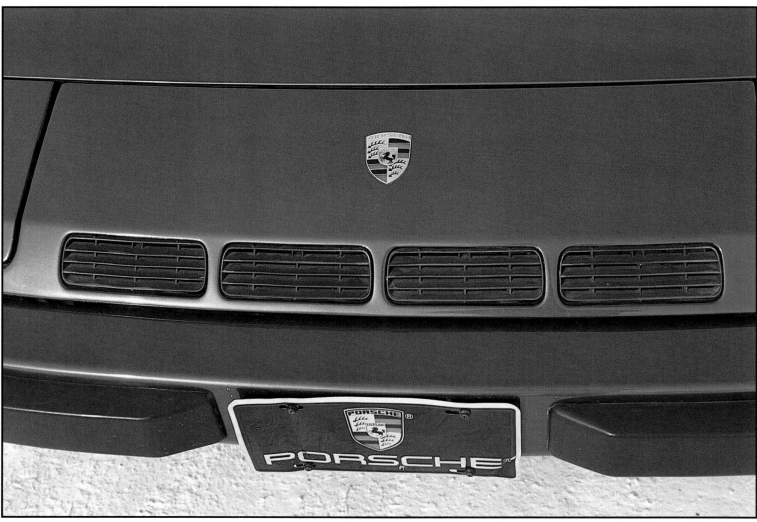

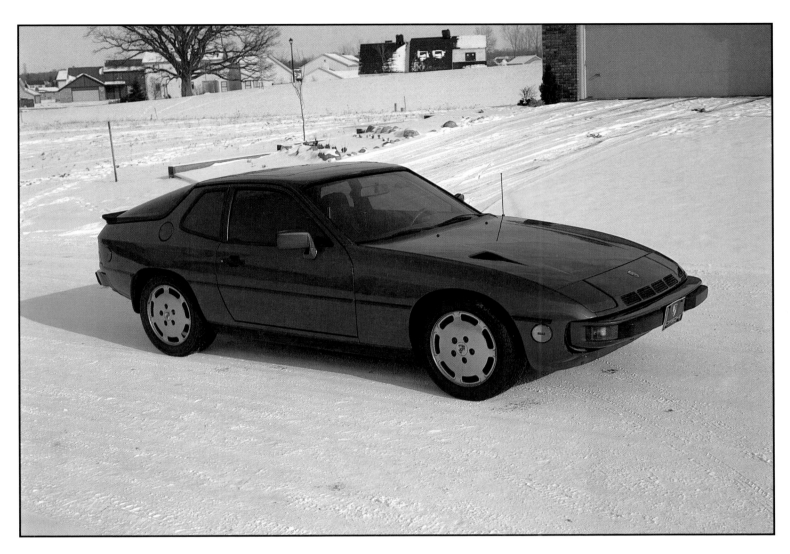

The slots in the nose of the 924 (facing page bottom) identify this as the turbo variant, as do the alloy wheels and spoiler. While the standard 924, like the 914, had been adjudged by many enthusiasts to be a Porsche in nothing more than name, the 924 Turbo helped restore some of the lost confidence and helped pave the way for the introduction of the 944.

cover. This cover follows the contours of the body and is painted in the same color thus giving a very clean, unbroken line to the overall shape.

One interesting variation on a theme has been the turbo slant-nose, so-called because of the extreme slant of the front end. Hidden headlights, louvers behind them, rear brake scoops all suggest a car to the racing 935 model's design. After-market suppliers were turning 911s into turbo slant-nose models, so Porsche decided to cover this obviously profitable niche with its own "genuine" version. Although the cost was high at $23,244, a few of them are seen in southern California.

The 911 is still very much with us in 1989-1990. Peter Schutz has gone, because he disastrously misjudged the American market in the mid to late eighties. Now Heinz Branitski has the job of keeping Porsche's wheels turning.

Current models range from the 911 Turbo now priced at a staggering $48,000, a Coupé, Targa or Cabriolet. Then there is the Speedster. The Turbo, incidentally, now puts out 282 bhp (SAE) at 5500 rpm and is brutally quick.

We have not yet mentioned the exciting 959, the ultimate Porsche, which is described in the last chapter. Only 200 were made of this first Porsche to be classed as a supercar, not only because of its colossal $200,000 price but also because its superlative technology gives a hint of what to expect in the 21st century.

Group B competition was all the rage in the early eighties. Manufacturers excelled themselves to produce the best handling, fastest car to compete in this off-road rally-cum-speed class that was not only dangerous but a great spectator sport as well. To drive in Group B needed nerves of steel, faster reflexes than a Mach 1 jet pilot and the ability to go from start to finish without getting hurt.

From Mini Metros to Lancias, they all entered cars that in reality were nothing like the cars they were supposed to be. Porsche decided it would be a good idea to build a car to compete in Group B which, besides being an exciting race was also a terrific marketing exercise. People identified with the cars that at least looked like the showroom models, even if they were covered in air dams, spoilers and wings.

Once again the Frankfurt Auto Show played host to Porsche's latest: the 959 was announced at the 1983 event. At the time, it was described as a Group B design study. Group B demanded 200 units to be built for homologation, but Porsche, unlike other manufacturers, were also considering the 959 as another model for regular production.

Neither Group B nor production came to fruition. A series of fatalities as a result of hideous accidents in the races caused this most lethal sport to be banned. Then Porsche went through a crippling strike reminiscent of the strikes that helped kill off British Leyland. Finally though, production began in 1987 as a limited edition model of no more than 200 units.

Shown at the Geneva Motor Show in March 1977, the 928 (previous pages and right) was quite a departure for Porsche. With this model came Porsche's first production V8. Equipped with a single overhead cam per cylinder bank, alloy cylinder heads and Bosch K-Jetronic fuel injection, the unit put out 240 bhp (DIN) at 5500 rpm, with a top speed of 144 mph and 0-60 in 7.7 seconds. A unique styling feature were the laid back headlamps, which were uncovered; Porsche claimed that the reason for this was to enable the lamps to be cleaned when the car was washed.

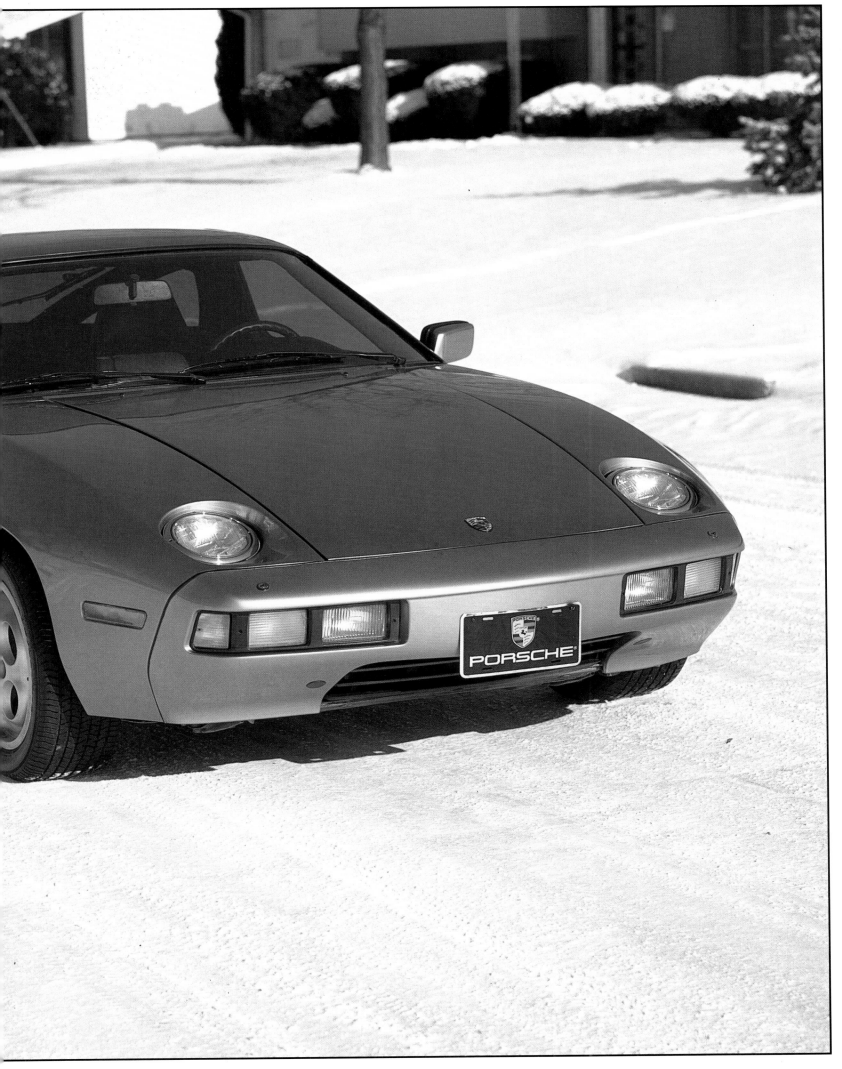

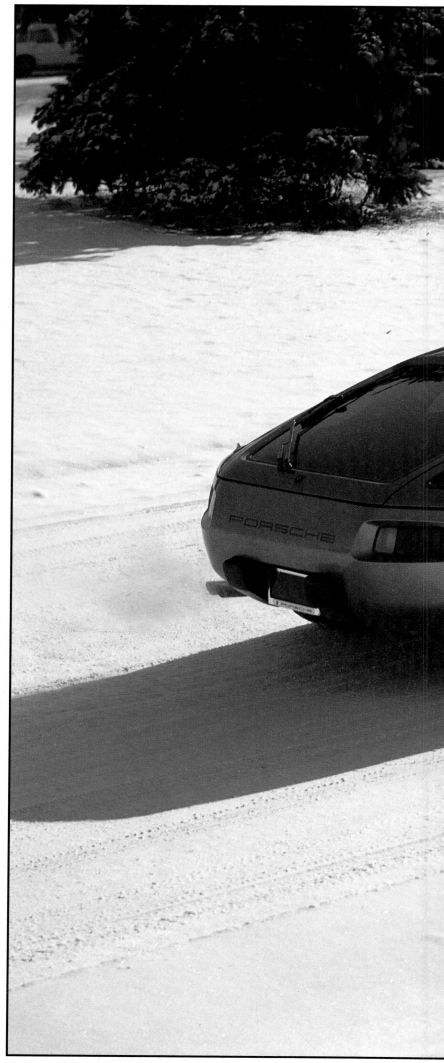

SPECIFICATIONS
1980-82 TYPE 928

Engine: As per 1978-79 Type 928 except bhp (SAE net): 220 at 5500 rpm. Torque (lbs/ft SAE): 265 at 4000 rpm. Compression ratio: 9.0:1. Bosch L-Jetronic electronic fuel injection with oxygen sensor and three-way catalyst.
Chassis: As per 1978-79 Type 928 except 2.12:1 final drive ratio with automatic transmission on 1981-82 models.
Measurements: As per 1978-79 Type 928 except Tire size: 215/60VR-15 (225/50VR-16 with optional Competition Group). Curb weight (lbs.): 3351 (manual), 3385 (automatic).

The 928's design shows a relationship with the 924/944 models, although its rather more space-age looks created quite a stir in motoring circles. Eschewing a design that might be immediately acceptable and hence boring, American-born design chief Anatole Lapine opted for this radically new shape. With the new look came a standard of luxury previously unseen on a Porsche. Top: the 928's recessed headlights assume a "frog-eye" appearance when in use.

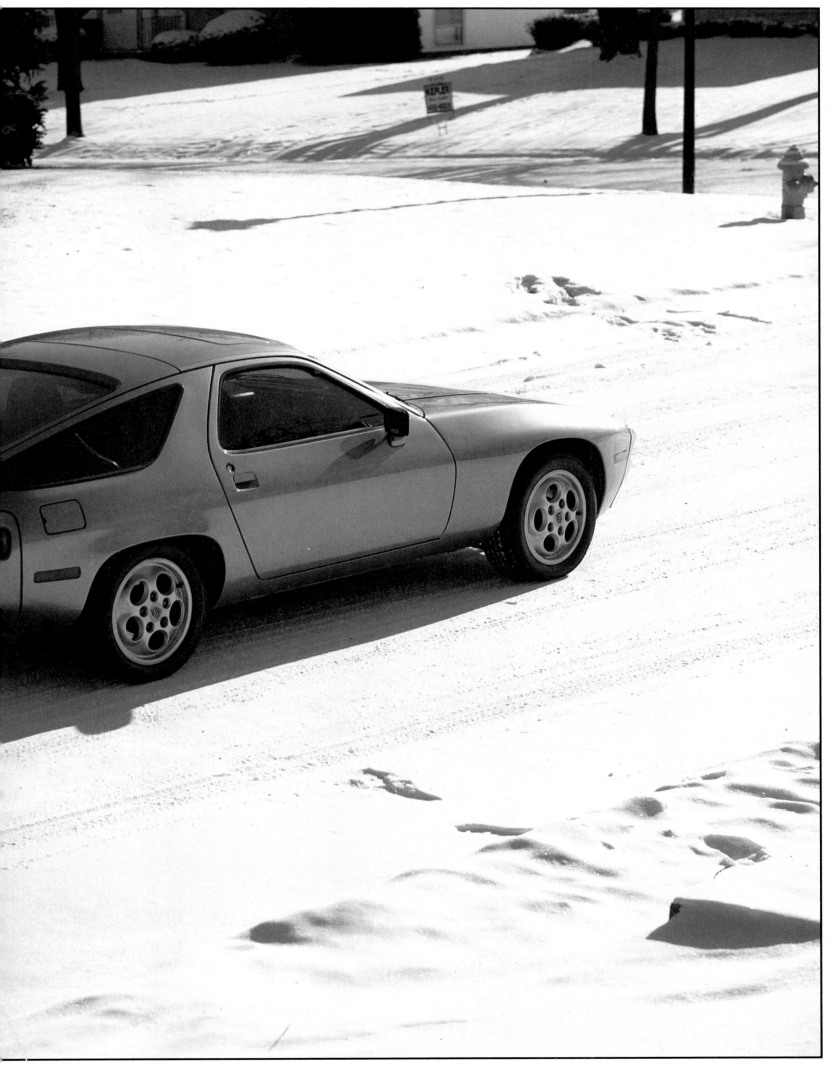

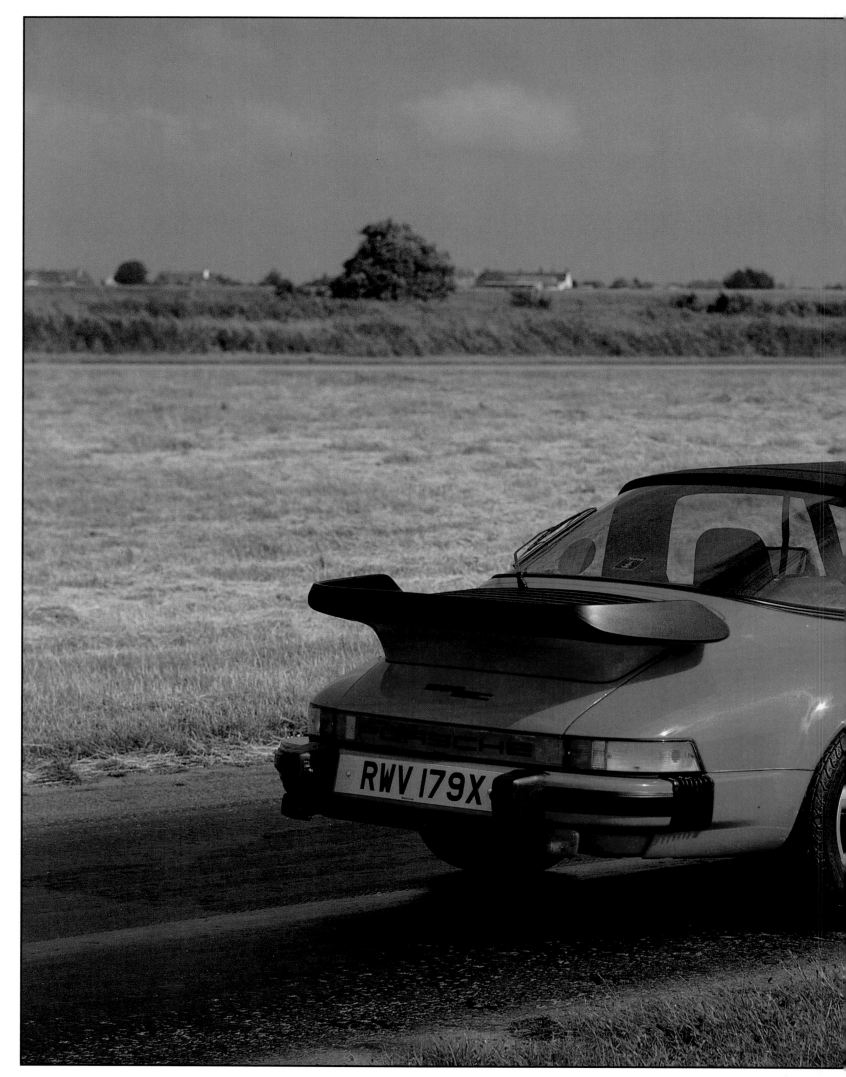

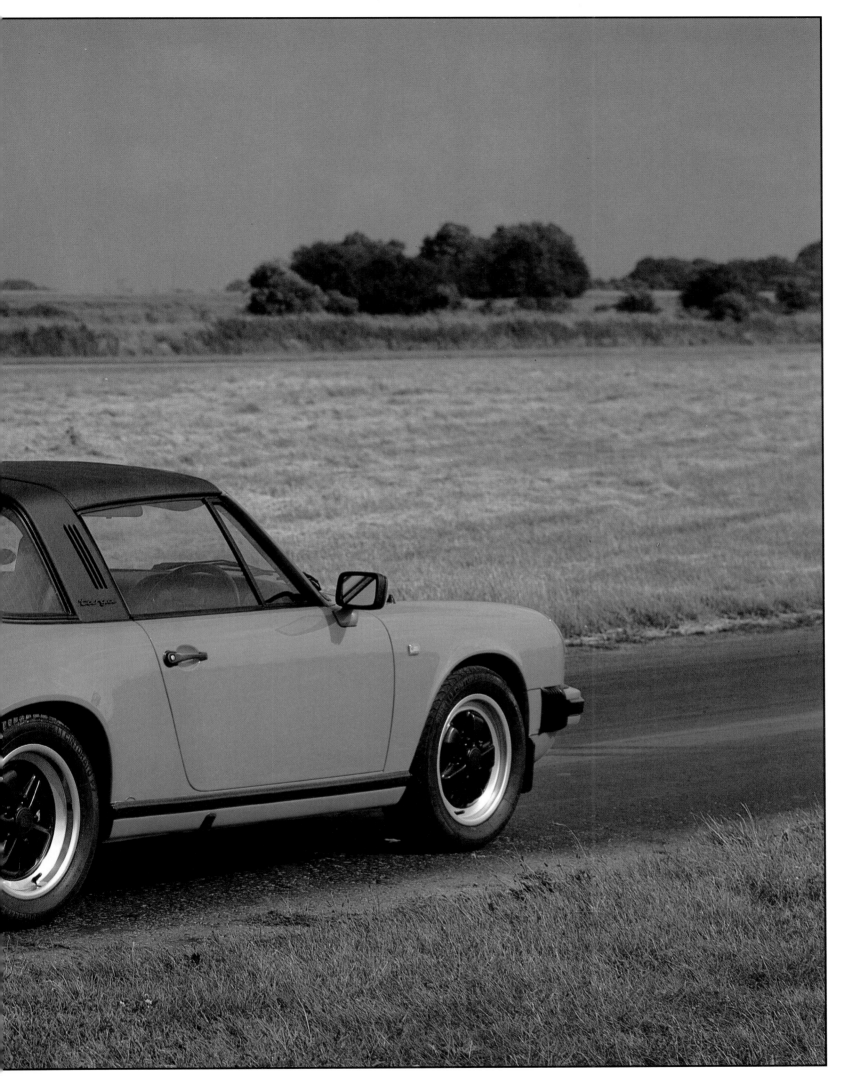

SPECIFICATIONS
1978-83 TYPE 911SC

Engine: As per 1964-68 Type 911/911L except Bore and Stroke: 95.0 x 70.4mm. Displacement: 2994cc (183.0 cid). Bhp (SAE net): 172 at 5500 rpm. Torque (lbs/ft SAE): 175 at 4200 rpm. Compression ratio: 9.3:1. CIS fuel injection with oxygen sensor.
Chassis: As per 1974-77 Type 911 models except front and rear anti-roll bars standard. Sportomatic transmission no longer available. Final drive ratio: 3.875:1.
Measurements: Curb weight (lbs): 2756. Tire size: 185/70VR-15 front, 215/60VR-15 rear (205/55VR-16 front and 225/50VR-16 rear optional). Track: 53.9″ front, 54.3″ rear. Wheelbase: 89.5″. Overall length: 168.9″. Overall width: 65.0″. Overall height (unladen): 51.6″.

The specification included automatic level control, massive wheels with tires that are able to run 50 miles after a flat, and electronic sensors warn of any change in pressure. The car also featured a six-speed transmission, then the world's first electronically modulated four-wheel-drive system which can vary the torque split between front and rear axles. This terribly complex system has four computer programs which can be set to provide maximum response in any given situation. For instance, if the "traction" mode is selected the 959 supposedly will plunge through mud and snow as if it were on a dry interstate. If "ice" is chosen, torque is split 50/50, while "wet" and "dry" apportions it 40/60 to 20/80, the latter for foot-to-the-floor acceleration.

Shock absorbers are computer controlled to vary ride through the stages of soft to hard, allowing the car complete stability regardless of conditions. The top speed is nearly 200 mph, with a phenomenal 0-60 in 3.7 seconds (without air conditioning, extra sound insulation – these speeds and acceleration refer to the near competition version). The engine capable of such devastating figures is Porsches air-cooled, horizontally opposed 173.8 cid (2849 cc) flat six. It has dual overhead camshafts, four valves per cylinder, aluminum blocks and water-cooled heads. Dual sequential turbochargers give the 959 its death or glory dash. Horsepower in the road car is an immense 450, but the racer boasted 200 more.

Those lucky few who have driven the 959 say that there are not enough words to describe it; that it is an experience that has to be lived rather than described. The 959 is a technical masterpiece, a state-of-the art motorcar with the 21st century in mind.

The 200 examples built between 1987 and 1988 were all sold. Due to Britain and America's tight emission and safety laws neither country was able to have the car, although one is bound to slip through eventually, but at a cost of two to three times its original $200,000 figure.

Compare the 959's roofline, its doors, with the 911. Clearly the 959 is based, however loosely, on the 911 even if its body is made from galvanized steel monocoque, Kevlar-reinforced fiberglass and aluminium. Overall length is 167.7 inches, wheelbase 89.4 inches.

Because Group B was cancelled before the 959 got a chance to compete, a prototype proved itself in the Paris-Dakar race in 1986 by winning convincingly. Later it took a class win at Le Mans and that was the end of the matter. Today, the 959 née 911 is a legend, one of the most desirable sports cars in the world and developed from a 25-year-old model that will still be producing great cars in another 25 years.

Nine years on and the 911SC Targa (previous pages and right) looks little different. Among the changes, however, are an increase in horsepower – up to 172 (SAE) – front and rear anti-roll bars, rear windshield wiper and the roof roll-over bar is no longer stainless steel but has a flat, crinkle black appearance.

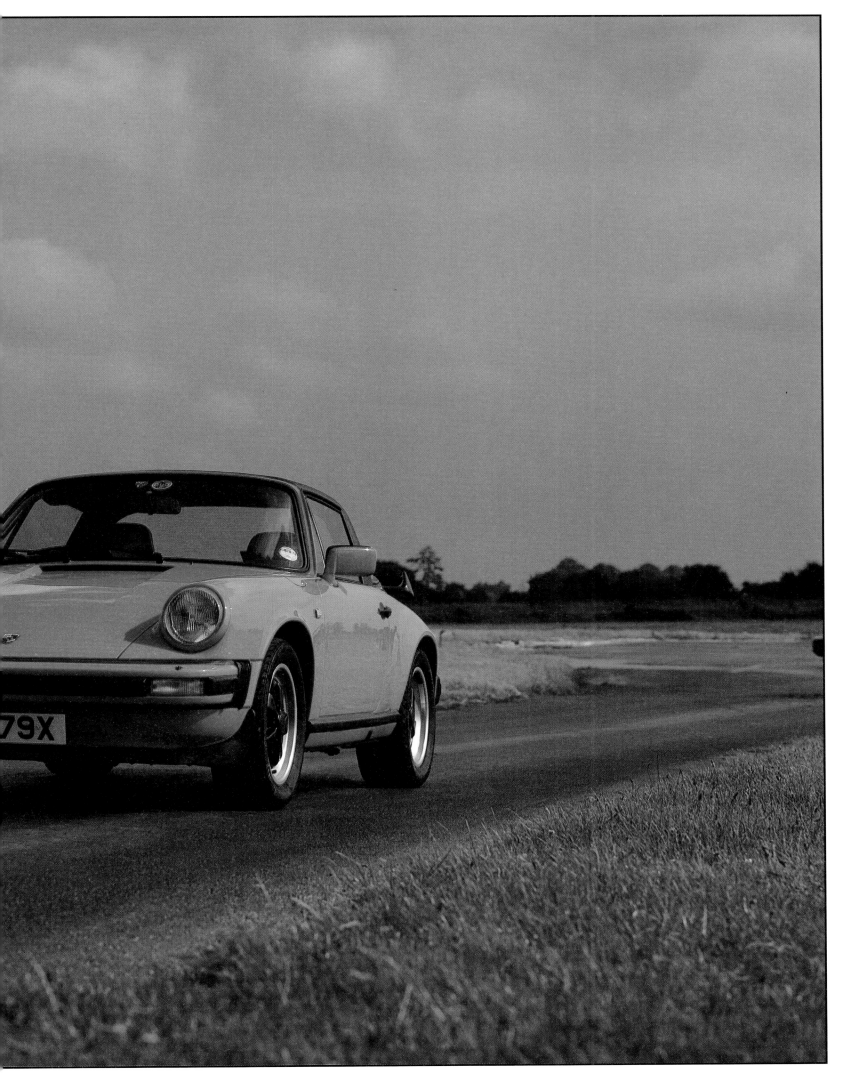

THE NOT-SO-LEGENDARY PORSCHES

We are almost at the end of this book, and so far most of the talk has been of 356s and 911s, which is hardly surprising bearing in mind their tremendous significance in the motoring world. When folk think Porsche, they think 356 or 911.

There are other Porsches, though. The 914 for one. It was first shown to the public in September 1969, at the unusual Porsche venue, the Frankfurt Motor Show. The 914 was very advanced, with its mid-engined layout, all independent suspension, four-wheel disk brakes and a five-speed transmission. Two models were offered, one with six cylinders, the other with four. While it was distinctive, the 914 did not look like a Porsche and really was rather ugly.

As we already know, Dr Ferdinand Porsche had been designing mid-engined cars such as the V12 and V16 Auto Unions well before the war. Later, his son Ferry continued what almost became a Porsche trademark: that of racing cars with mid-engines, including the famous 550 Spyder, 904 GTS, 906 and 908 models.

Dealers had been getting restless. Every time they took delivery of next year's 911 or 912s the price had risen. The reason for this, however, was not so much greed as need, for coupled with a fluctuating currency market and high engineering and design costs, the Zuffenhausen company was generally forced to put up prices.

The dealers, however, were not convinced, and looked to Porsche for a cheaper car, one to replace the not-so-popular 912.

The wish for a cheaper car was one thing; building it down to a price was quite another. Admittedly Ferry Porsche desired another line of cars and he and his engineers had looked at the possibility of a mid-engined design similar to theirs and other companies' racing cars. But it would take a large investment resulting in higher prices.

To relieve the monotony of the world's No. 1 small car, the "Beetle", VW president Heinz Nordhoff had been playing with the idea of a sporty VW. A strong bond existed between VW and Porsche, and both parties came to the same conclusion: why not pool resources to produce a car suitable for each company. Both sides would benefit: Porsche a VW-engined 914; VW a VW-Porsche sports car. Porsche and Nordhoff entered into a joint venture whereby Karmann, coachbuilder of VW's other attempt at a sporty car, the Karmann-Ghia, would build the new bodies for both sides.

Tragedy struck when Nordhoff died suddenly in April 1968. He was unable to see the fruition of his ideas in full because the shared car idea was still in its infancy when he died. However, the general design had been laid down. Nordhoff had expressed the desire that the car did not look like a VW and Ferry Porsche certainly did not want another 911.

Shown on these and previous pages is a very special model: a copy of the competition 935 "Slope Nose" Porsche. Its success in racing prompted aftermarket operators to supply 935 body kits for 911 models. This displeased Porsche, who countered with their own, genuine modification package. This included fender louvers, flip-up headlights, scoops, wide wheel arches, special rocker panels and much more. A 911 so equipped retailed for a staggering $106,254!

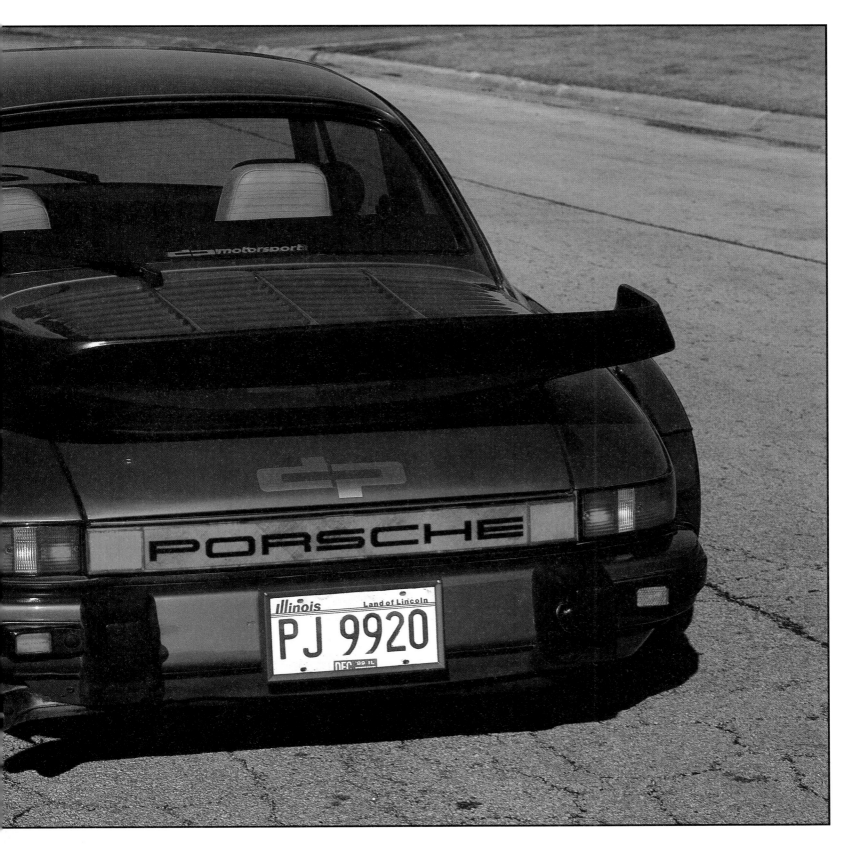

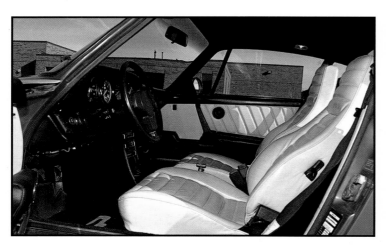

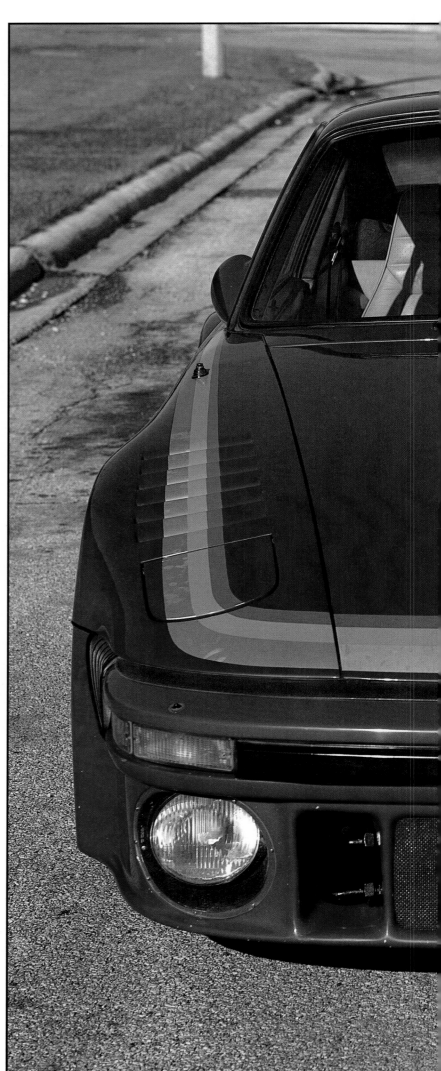

The 935 was the logical extension of Group 4's successful Porsche 934. It was capable of 0-60 in a heart-stopping 3.3 seconds and a top speed of over 200 mph on the track. The 911-derived engine pumped out 600 bhp and had twin turbos. Not surprisingly, the 935 dominated whatever event it entered: Trans-Am, Imsa, Le Mans, Sebring 24 Hours; all fell to the 935s. Small wonder then, that there was a demand from enthusiasts for a street-legal look-a-like. The engine (top) is fairly stock, not the howling racing version, and no racer would have such a plush interior. Graphics, coolers and spoilers make this ultra-expensive Porsche a one-of-a-kind automobile your neighbors are unlikely to own.

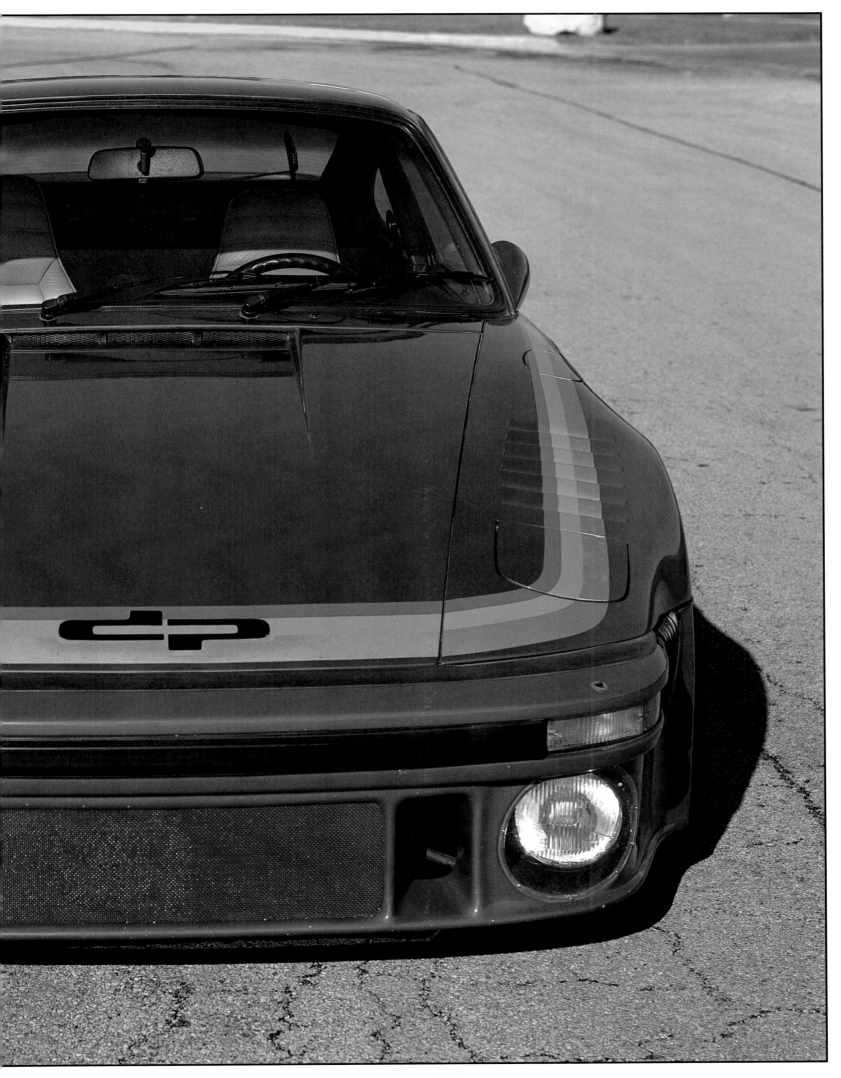

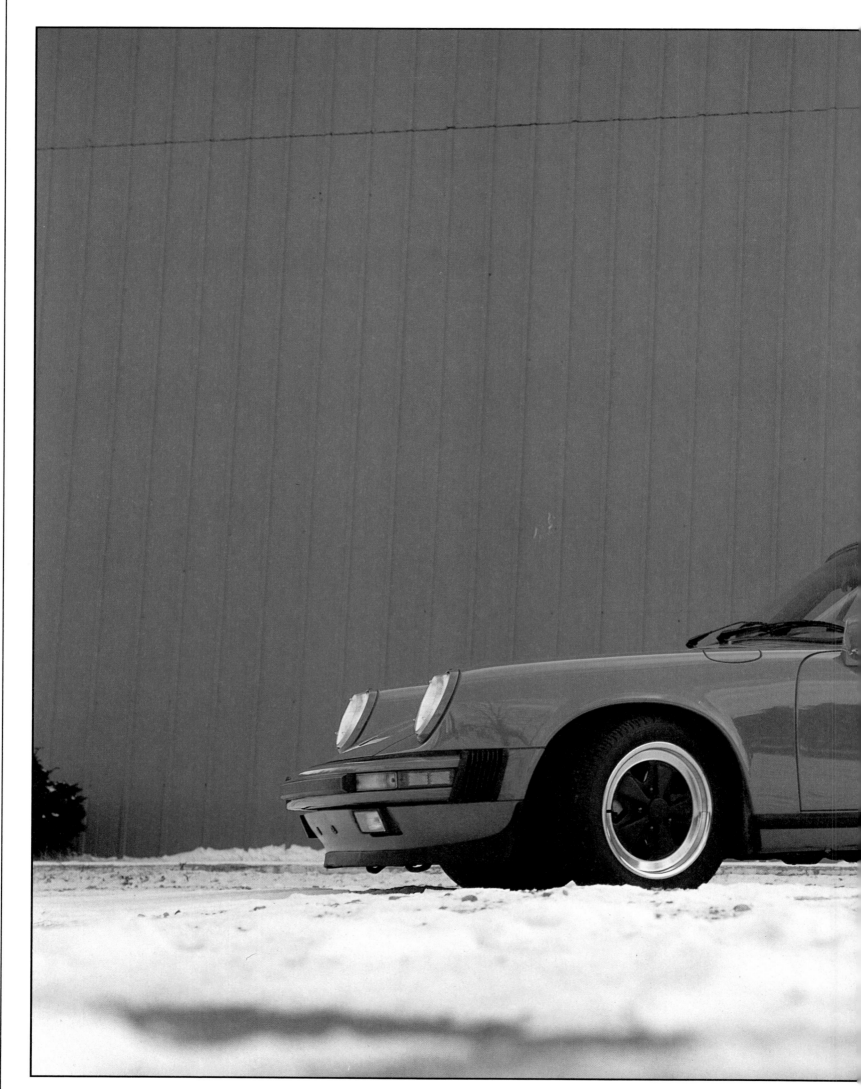

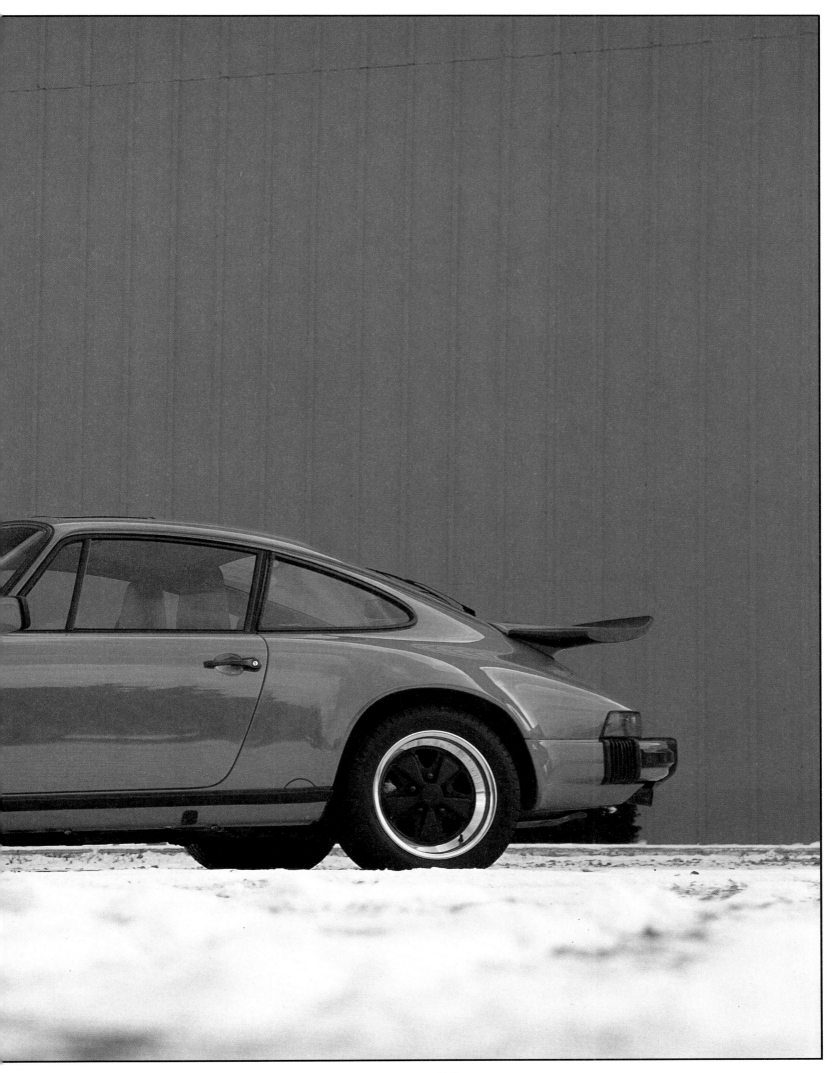

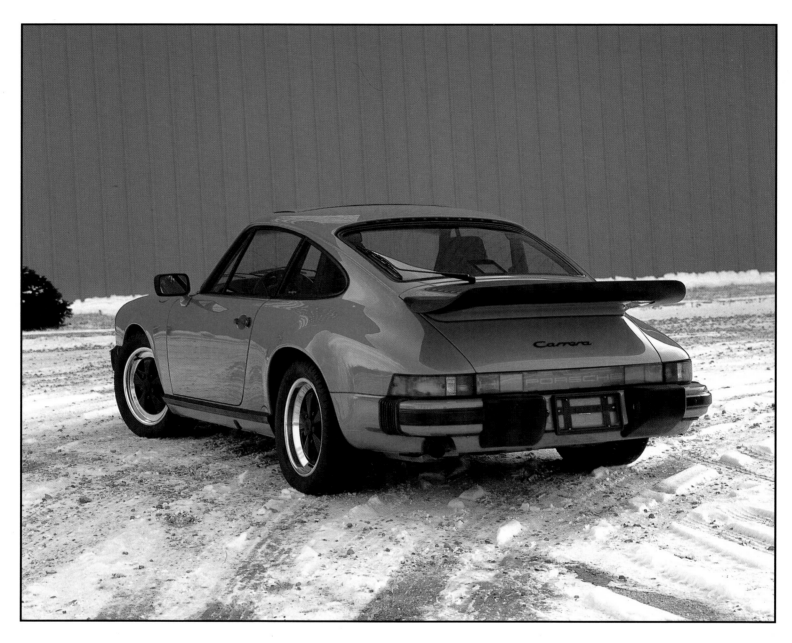

In the event both parties were lucky. A company called Gugelot Design GmbH, operating about 50 miles from Stuttgart, had built a front-engined prototype car to demonstrate a new material comprising a foam core sandwiched between bonded fiberglass layers. The body material didn't interest Porsche or VW, but the car's design did. An agreement was reached and the design handed over to Butzi Porsche and his team for revision, mainly to alter the car's geometry for a mid-engine drivetrain. Then the finished design was handed to Karmann who would make the bodies.

The friendly relationship shared between Ferry Porsche and Heinz Nordhoff was based on a high degree of respect and trust. So much so that the 914 project was formed on a verbal agreement. The new master of VW, Kurt Lotz, did not believe, however, in conducting business in a traditional, gentlemanly manner; his was the modern, unsympathetic approach. He looked over the VW-Porsche deal and changed it.

VG Motors was part of the new thinking. The new company would handle all VW-Porsche marketing, as well as that of Audi in Europe. VG would also look after the 914. American marketing got a complete change; now Porsche and Audi would merge to become a division of VW of America. Meanwhile, Karmann had been taken over and was now part of Volkswagen. Karmann was to build complete 914s equipped with VW's 102.3 cid (1697 cc) four-cylinder engine. Porsche was not entirely happy with

this arrangement, but consented, consoled that at least US cars would bear the Porsche emblem alone even if European versions carried a VW-Porsche badge.

It was not an attractive car. Launched at the 1969 Frankfurt Show as the 912's replacement, the 914 stirred controversy. Porsche purists were disappointed for the 914/4 had too much VW trim – then there was its engine. Styling was different, certainly, and its front and rear suspension came from the 911 but had new coil springs.

The 914 was produced as a two-passenger Targa model with a lift off roof that was attached to the C-pillars which acted as a "basket handle" roll bar. The 96.4-inch wheelbase set the wheels at all front corners – overhanging was a thing of the past with the 914. Its basic shape was devoid of any bumps or bulges and a short-sighted person might have found difficulty distinguishing front from rear, if viewed in profile. Although two years ahead of it, the 914 does not look unlike Fiat's Bertone-styled X19 mid-engined sporty car.

Displacement of 1983-1989 Type 911 Carrera models jumped from the previous 164 cubic inches to 193. Horsepower was 200 (SAE net). The "whale tail" effect was inspired by the successful slope nose 935 racing car.

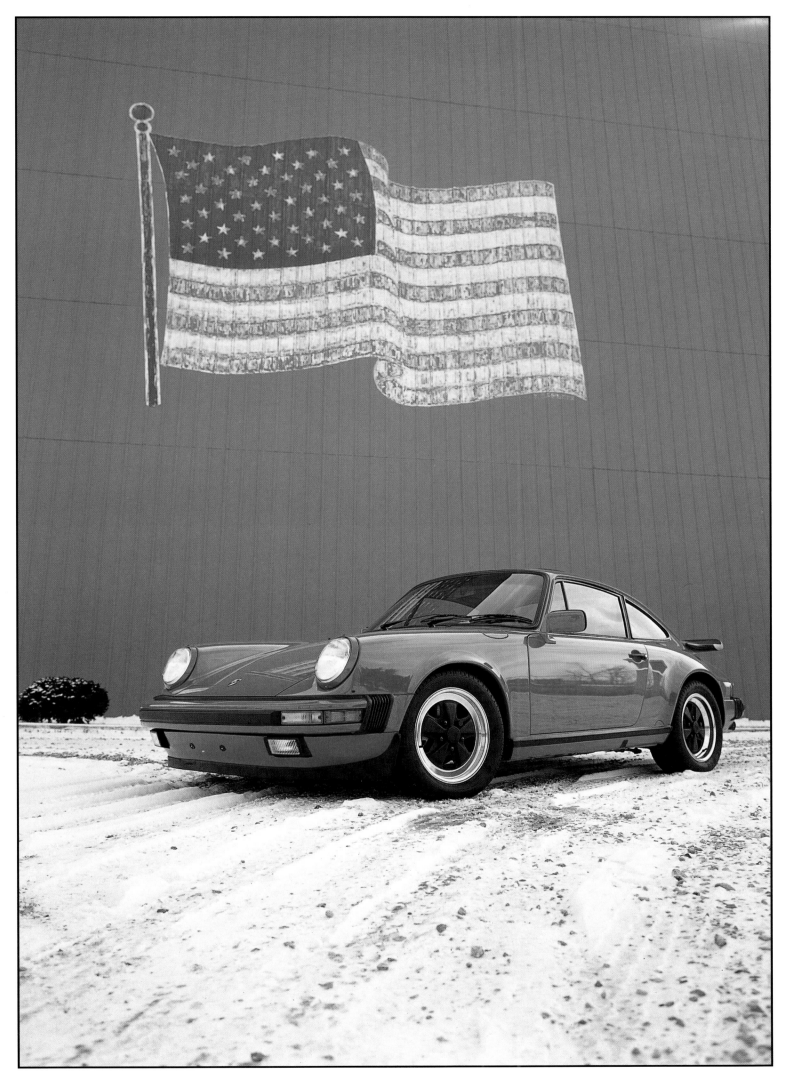

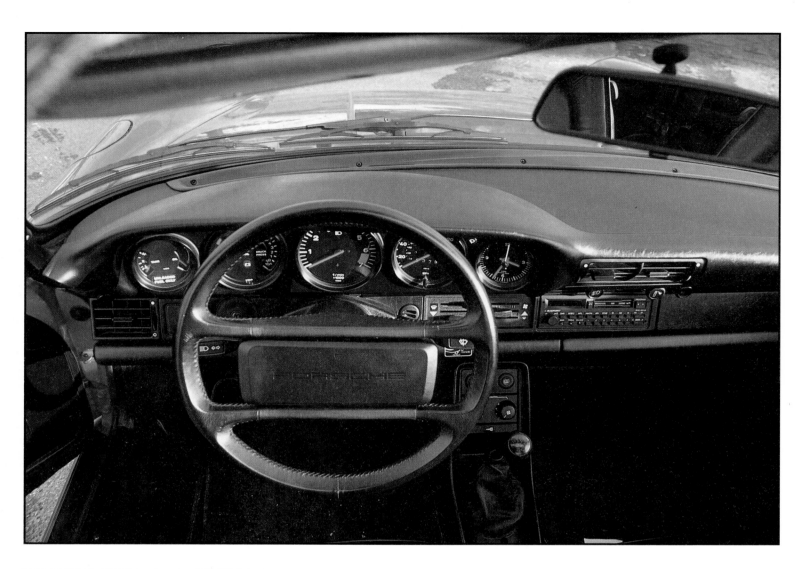

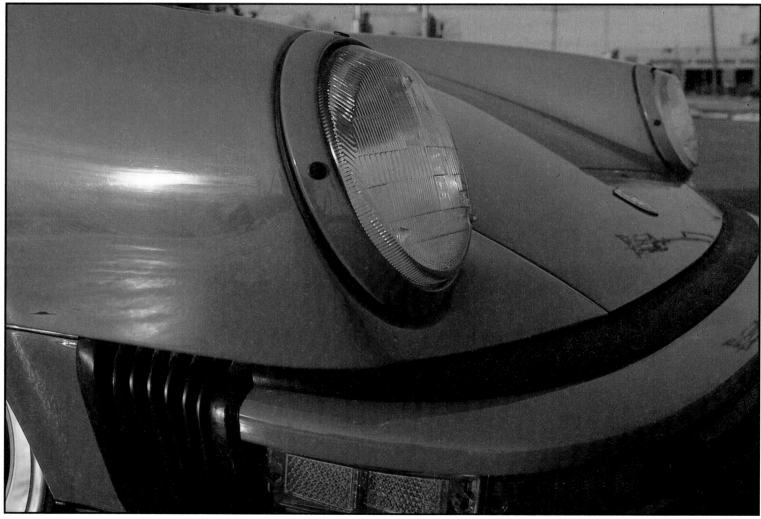

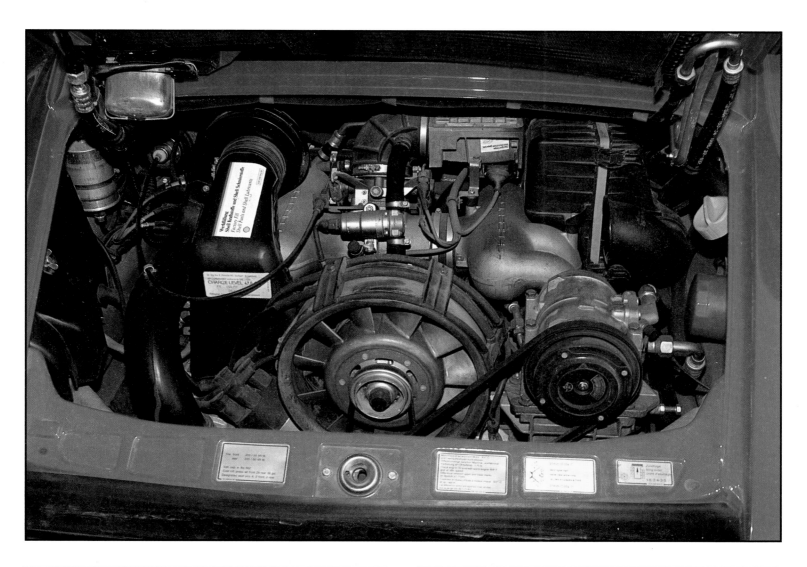

The Carrera's well laid out dash (facing page top) reveals the sort of attention to detail that is a Porsche hallmark. In the engine compartment (top) things have become even more crowded, although accessibility is still reasonable. Painted headlight rims (facing page bottom) have supplanted the original chrome of earlier years. The "whale tail," edged in rubber for pedestrian protection, assumes gargantuan proportions when viewed from this angle (above right).

SPECIFICATIONS
1983-88 TYPE 911 CARRERA

Engine: As per 1964-68 Type 911 except Bore and Stroke: 95 x 74.4mm. Displacement: 3164cc (193 cid). Bhp (SAE net): 200 at 5900 rpm (1983-86), 214 at 5900 rpm (1987-88). Torque (lbs/ft SAE): 185 at 4900 rpm (1982-86), 195 at 4900 rpm (1987-88). Compression ratio: 9.5:1. Bosch Digital Motor Electronics (DME) injection/ignition control.
Chassis: As per 1964-68 type 911 except Final drive ratio: 3.87:1 (1984-86), 3.44:1 (1987-88).
Measurements: As per 1978-83 Type 911SC except Curb weight (lbs): 2740-2750. Tire size: 195/65VR-15 front, 215/60VR-15 rear (205/55VR-16 front, 245/55VR-16 rear optional).

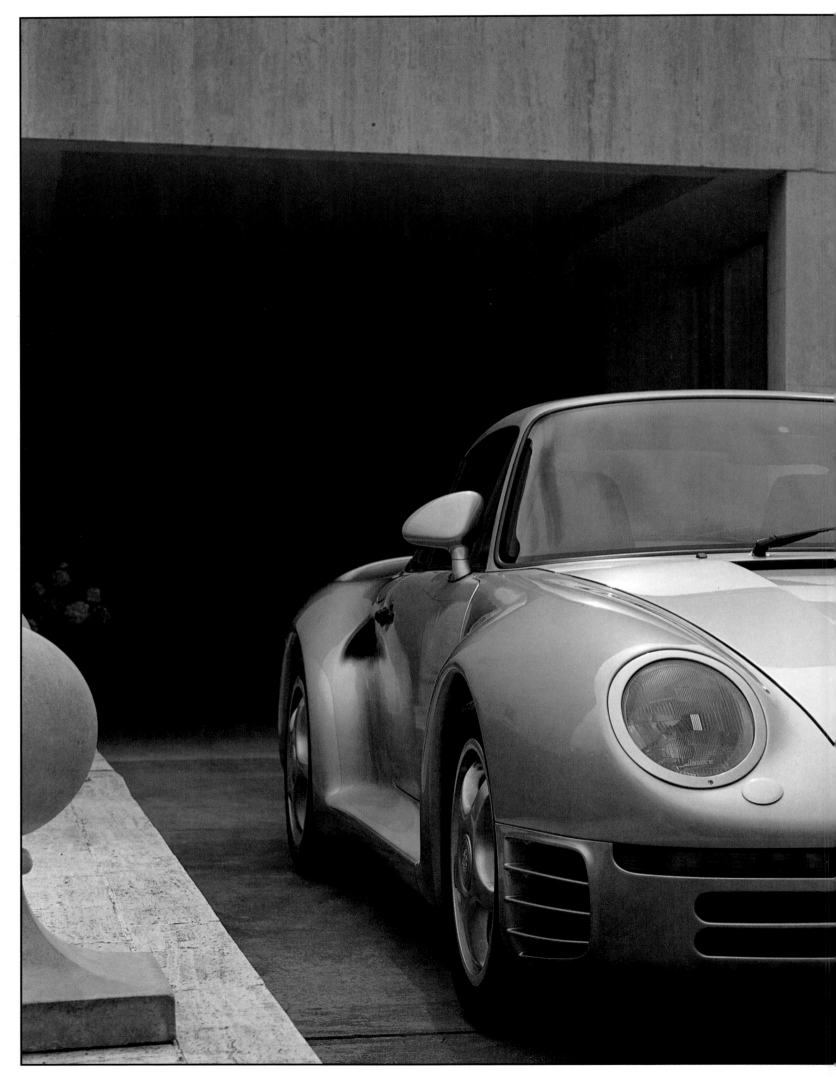

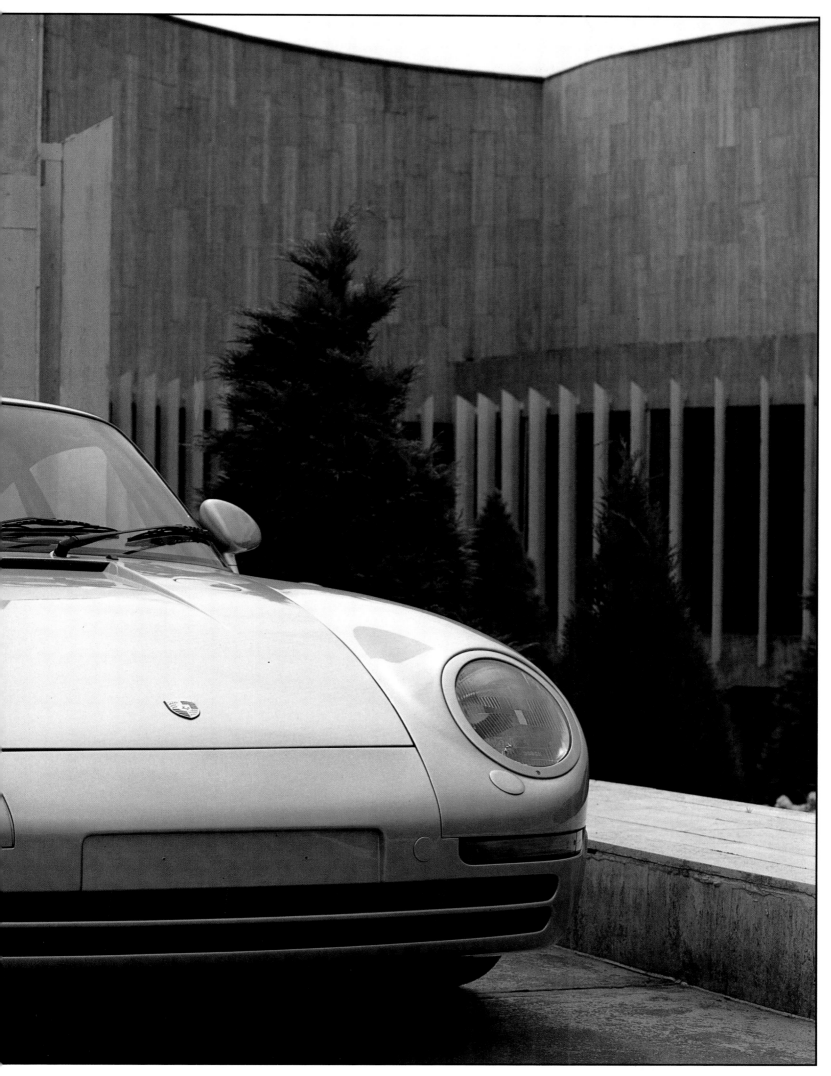

SPECIFICATIONS
1987-88 TYPE 959

Engine: Six-cylinder, flat-opposed, air-cooled. Bore and Stroke: 95.0 x 67.0mm. Displacement: 2849cc (173.8 cid). Bhp (DIN): 450 at 6500 rpm. Torque (lb/ft DIN): 369 at 5500 rpm. Compression ratio: 8.3:1. Dual overhead camshafts, 4 valves per cylinder, aluminium block and water-cooled heads, Bosch Digital Motor Electronics injection/ignition control, dual sequential turbochargers.
Chassis: Independent front and rear suspension with upper and lower A-arms, coil springs, anti-roll bar, and twin shock absorbers; power-assisted rack-and-pinion steering; ventilated cross-drilled four-wheel disc brakes; computer-controlled variable-torque-split four-wheel drive via six-speed manual rear transaxle and integrated differential/multi-plate clutch. Final drive ratio: 4.12:1.
Measurements: Curb weight (lbs): 2977/3197 (Sport/Touring versions). Tire size: 235/45VR-17 front, 255/40VR-17 rear. Track: 59.2" front/61.0" rear. Wheelbase: 89.4". Overall length: 167.7". Overall width: 72.4". Overall height: 50.4".

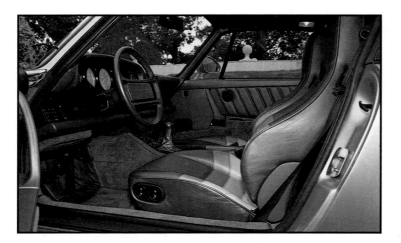

Perhaps the most exciting Porsche to date, the 959 was first unveiled in prototype form as early as September 1983 and exhibited at various motor shows the following year. Its raison d'être was the Group B rally class, a new and spectacular form of competition that permitted four wheel drive and turbocharging. To homologate the cars for racing, 200 production versions had to be built. Then came the bombshell: Group B competition was cancelled by the world motorsport's ruling body as being too dangerous after spectators and drivers had been killed in terrible accidents. That the 959 is related to the 911 is evident from the interior photographs (above and facing page top), with dash, seating and panels virtually the same.

Unfortunately the 914/4 was not a market success. People did not want it because it had a VW engine and the mild price tag of $3,495 did not encourage buyers.

Unhappy with the way things were going, Porsche determined to make the car a "real" Porsche again. Appearing in late 1970 the 914/6 featured Porsche's SOHC flat six displacing 121,5 cubic inches (1991 cc) and developed 110 bhp. The 911 S type alloy wheels with the Porsche crest replaced the VW Beetle hubcaps, and the car received improved 911-type instrumentation.

Nobody could argue the 914/6 was not a Porsche – it was even built entirely at Porsche's Zuffenhausen factory. But the price of $5,595 was more than most were willing to pay and the VW stigma was hard to shake off. Nobody liked what was considered a hybrid; purists turned their backs on the cars and the press didn't care for it.

Two years after its launch the 914/6 was quietly dropped, and early in 1976 the 914/4 was retired.

In a sense the 914/4 and 914/6 were VW-Porsche's Edsel, and like the Edsel had controversial styling the public would not accept. Yet now, as with Edsel, the 914 is undergoing a renaissance as collectors look for them, and those that have them are finding the 914 series ideal for weekend club racing.

A couple of firsts – a water-cooled front engine and a transaxle – heralded Porsche's all-new 924. It was also the product of yet another complicated set of maneuvers by VW-Porsche.

Launched in the autumn of 1975 as a 1976 model, the 924's gestation went back to 1970, a year of change at Wolfsburg. The unpopular Kurt Lotz had gone – during his short stay he had created much controversy. Lotz was replaced by Rudolf Leiding, a man with an eye on the finances, yet an advocate of the sports car and racing as well. His arrival brought the hope that his financial brain would help save VW from the doldrums it now found itself in, compounded by the trouble with the 914, the even worse VW's 411/412 series, and the Audi/NSU buyout from Daimler-Benz. All this was proving much too costly for Volkswagen, and realizing the 914/4 was not going to live up to expectations, management planned a new car to be designed by Porsche. This time the new car would be sold by the VG marketing outlet as a VW-Audi.

Among the guidelines laid down were decent trunk space, roomier and more comfortable interior than in the 914, conventional front-engine rear drive arrangement, and as many VW components from the parts bin as could be crammed into the new car.

Suddenly, in 1973, VG was closed down. At the same time VW took control of the 924 code-named EA425. Considering VW had so far financed the project to the tune of $70 million, it seemed only fair that it should have control.

As with the 914, Porsche's version would be labelled with its own name. Leiding, however, had other ideas. EA425, he said, would only be sold as a VW or Audi, not as a Porsche in the US.

At the time Porsche was working on a 912 stop-gap until the 924 went into production. There was also the larger 928 to consider. None the less, Porsche was cut to the quick by Leiding's decision, and it appeared that Volkswagen was in desperate straits and resorting to anything that might help clear the air – even if it meant damaging relationships. Then, in 1974, Rudolf Leiding suddenly left and his replacement, Tony Schmucker, mindful of the OPEC-inspired oil crises, announced that the EA425 project was cancelled. Porsche thought the 924 worth saving and bought the production rights from VW for $60 million.

It was, however, $10 million short of what VW had already

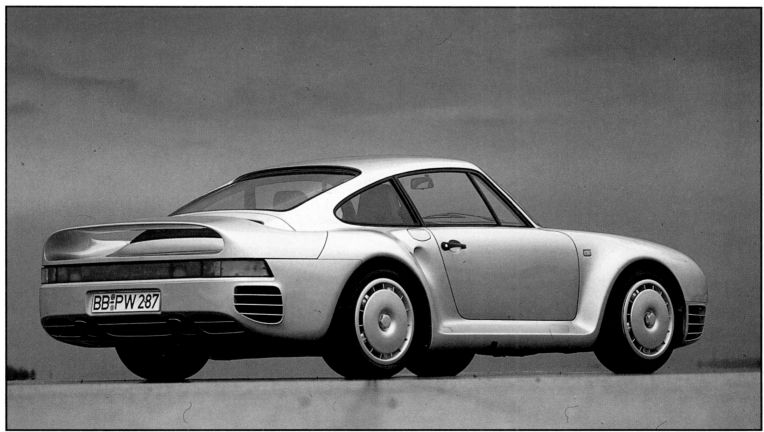

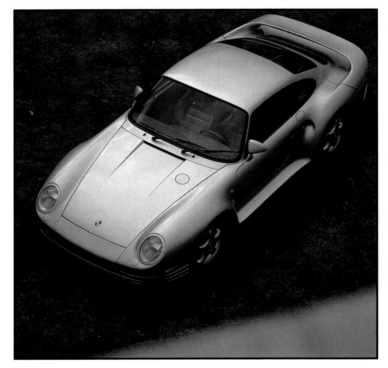

Even though group B racing was cancelled, interest in the Type 959 was so great that Porsche went ahead and built 200 examples. The cost of each unit ran to $250,000, but Americans needn't have worried as the 959 didn't meet Federal safety or emission standards to allow it to be sold in the U.S. Testers found cornering and handling phenomenal, and the 911 parentage can be seen from the above picture. The crowded engine bay (right) reveals a 174 cid DOHC six with four valves per cylinder, twin KKK turbochargers and Motronic fuel injection. Horsepower was a claimed 450 at 6500 rpm.

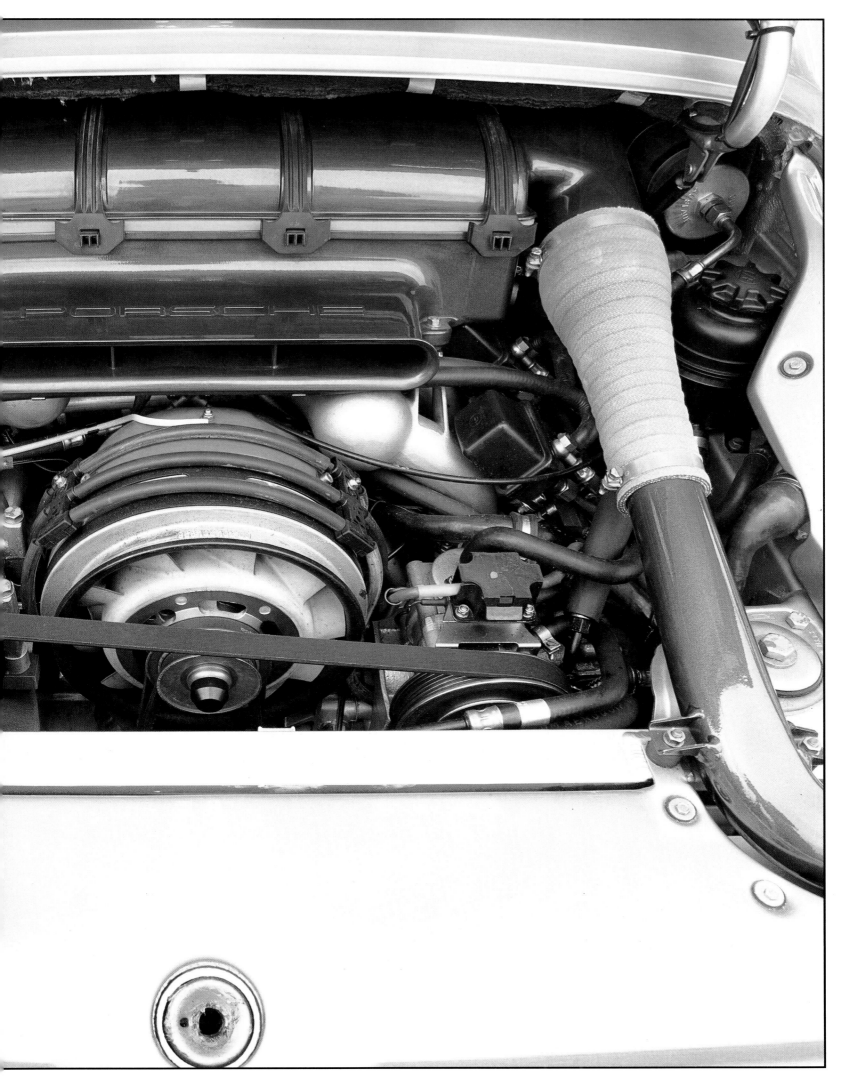

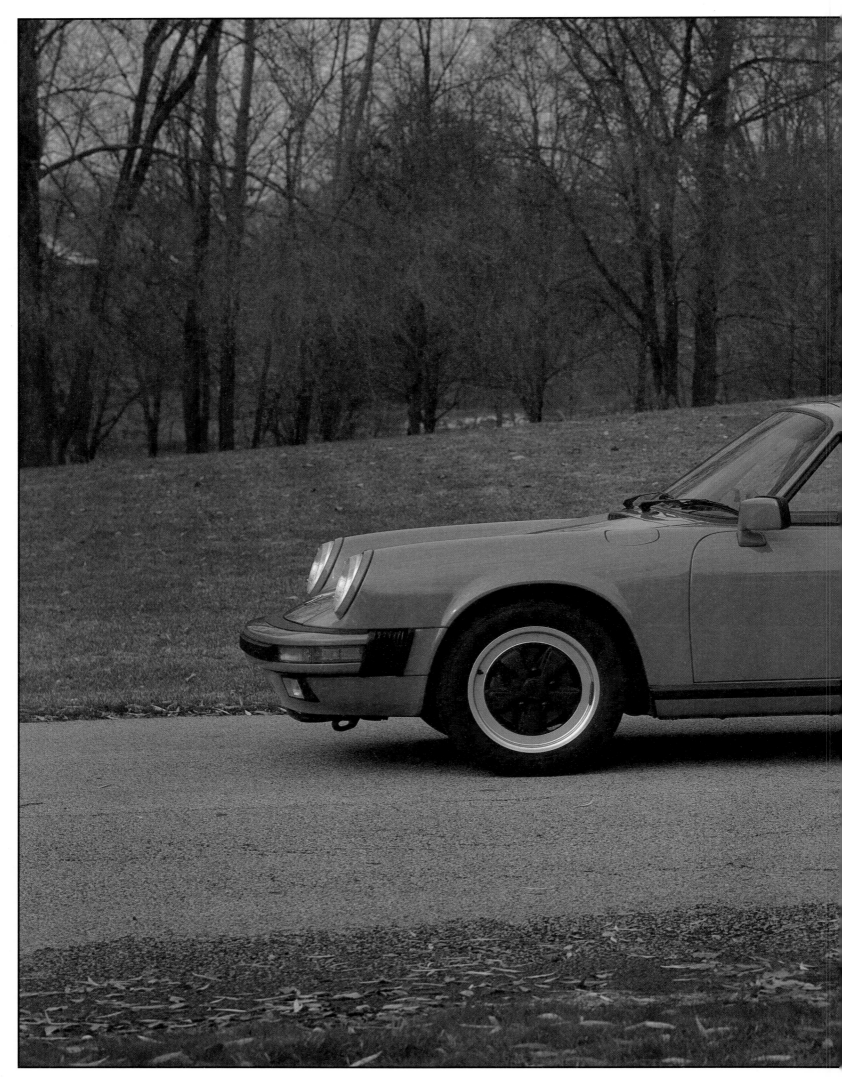

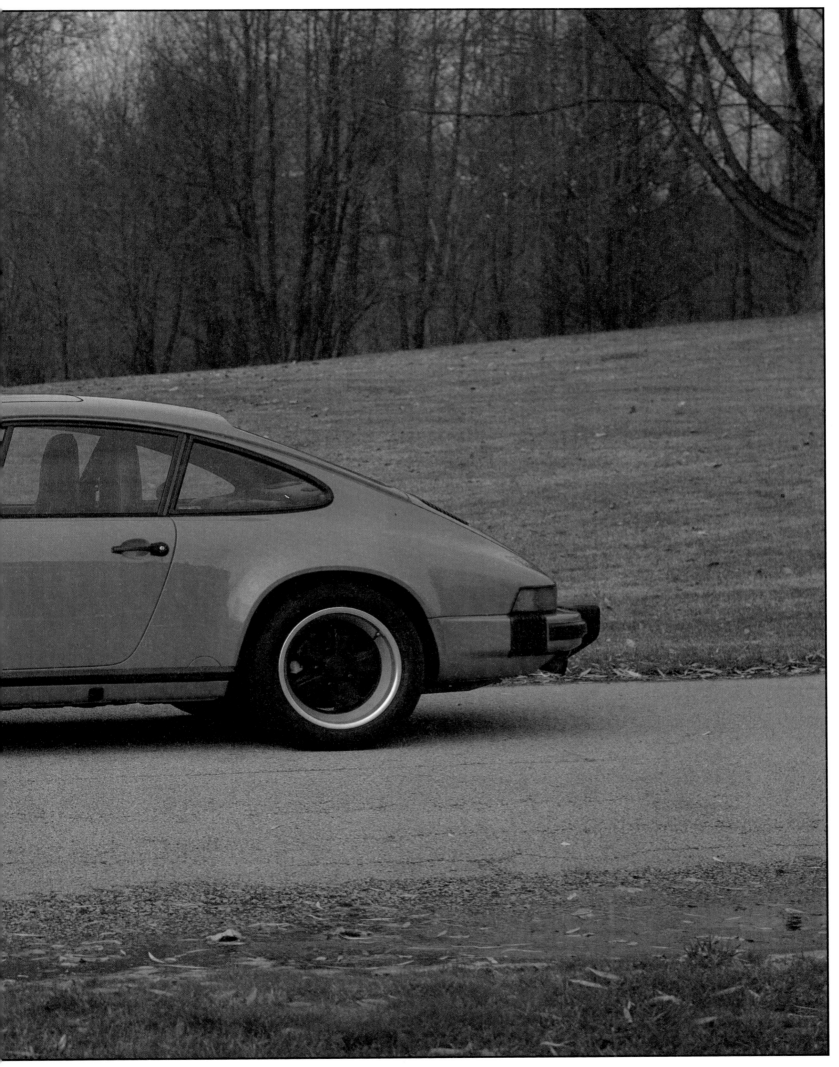

spent. To make up the difference, Porsche agreed to let the car be built at Audi-NSU's factory at Neckarsulm, not far from Stuttgart. Naturally, the 924 would rely on many VW components, including the Audi-built engine, which was actually a Volkswagen design.

Eventually the 924 went into production in November 1975 as a 1976 model for Europe only (US versions were scheduled for delivery in April 1976 but were classed as 1977 models).

For Porsche followers the 924 was the most unusual of the marque yet to be seen. For one thing its engine was up front – the VW designed, Audi-built water-cooled SOHC four-cylinder displacing 121.1 cubic inches (1985 cc) and developing 125 bhp (DIN) in Europe, 95-100 bhp (SAE net) for American editions.

A rear trans-axle, independent suspension, a four speed manual transmission (later a three speed automatic and five speed manual were offered), front discs, rear drums for braking and a plump, rounded body style made up the $9,385 car. Compared to over $15,000 for a 911, the 924 was a bargain.

Like the 914, the 924 was hampered in the beginning by its Volkswagen ties. Critics thought it a better car than the 914 but expressed doubt as to its authenticity. How could the 924 be a genuine Porsche when its engine came from VW and the car was built at an Audi plant?

After winning the 1976 World Championship of Makes and Sports Cars, Porsche in 1977 issued a self-congratulatory "Championship Edition" of the 924. Built as a limited production run of 2,000, the Championship Edition featured a red and black interior augmented by blue pinstriping, and a special world championship plaque on the console. Wheels were painted white instead of the normal silver, and the whole bodywork was set off with red, blue and black striping echoing the interior colors. Mechanically the car was like any other 924 even down to the engine, which developed the same horsepower figures. Porsche claimed a handling package but owners of the Championship model say this is not so. None the less, it was an attractive version of the original design of Porsche designer Harry Lagaay and American born design boss, Tony Lapine.

Mid-1977 saw the US 924s receive a welcome horsepower boost to 110 (SAE net). Audi's three speed automatic also became an available option and a five speed manual came on tap in 1978. The big news was in 1979 when Porsche introduced a turbo-charged 924 built at Zuffenhausen.

The engine block was still VW/Audi but there the connection ended. Atop the block was a newly designed head made by Porsche. It featured hemispherical combustion chambers and the spark plugs moved from the exhaust intake side of the engine. To mount the German KKK – (Kuhnle, Kopp and Kausch) – turbo-charger on the exhaust side required moving the starter to the left.

America got the turbo charged 924 in 1980, which boosted the horsepower to 143 (SAE net), 0-60 came up in 7-8 seconds, a vast improvement over the standard 924 and top speed wavered around 135 mph. As with everything to do with Porsche, the Turbo 924 received chassis and suspension modification to deal with the extra power.

This 1989 911 Carrera (these and previous pages) has changed little over the years. The 3.2 liter six had a horsepower boost to 214 in 1987 and in 1990 a new flat six of 3.6 liters and 247 bhp was introduced, the early engine being dropped.

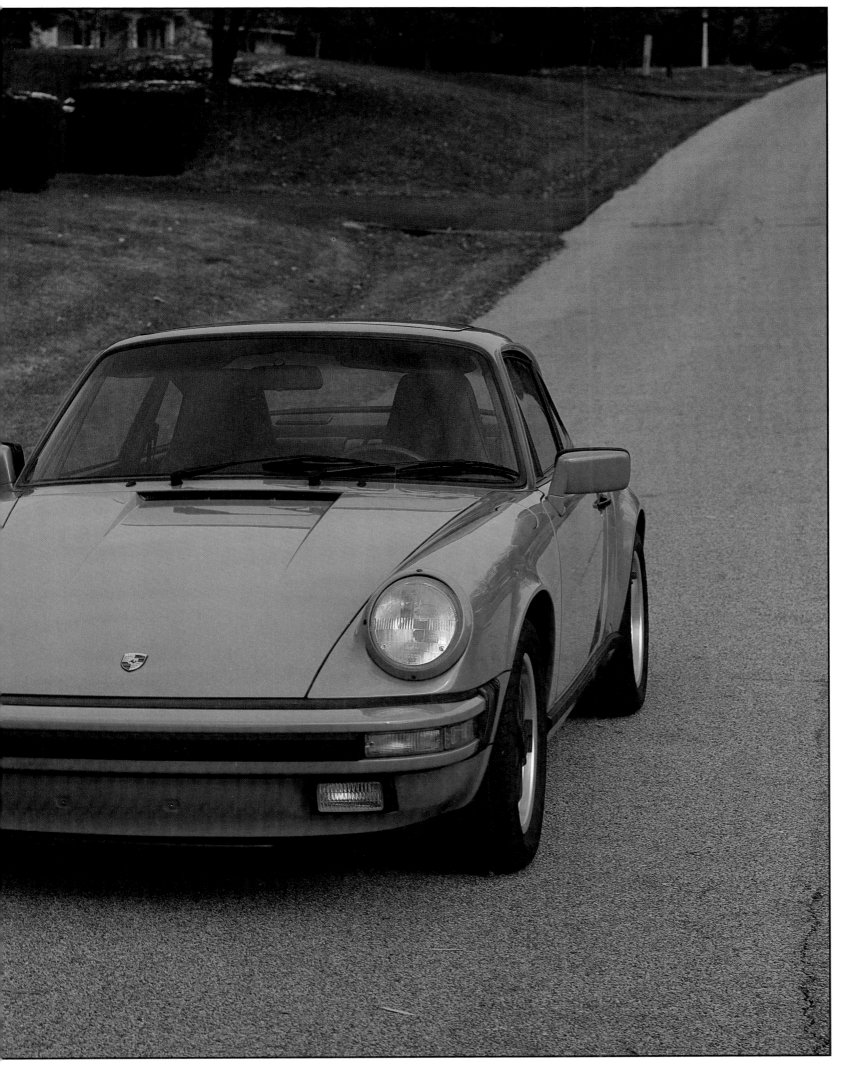

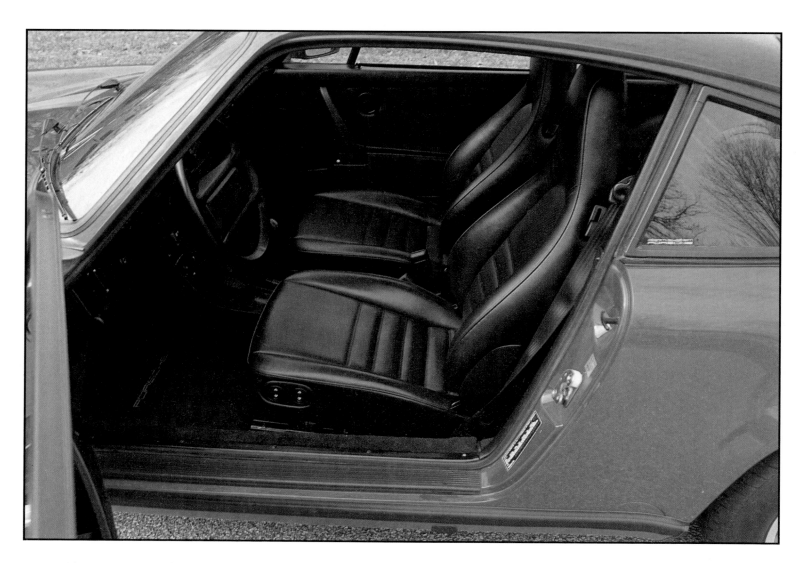

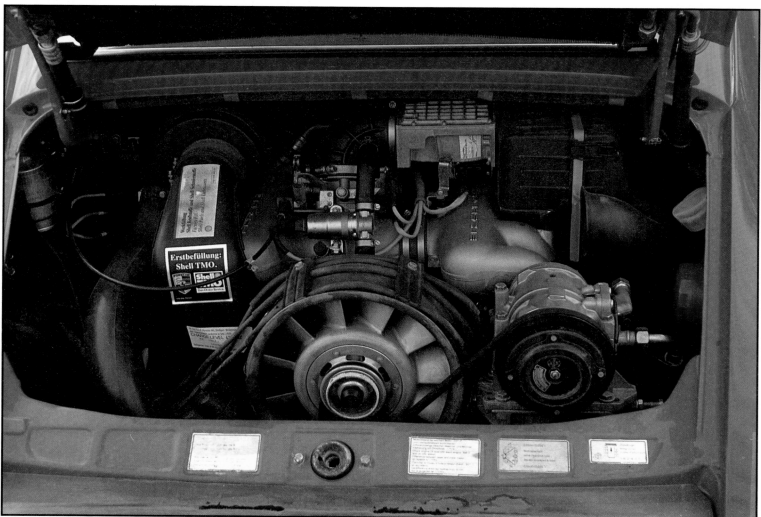

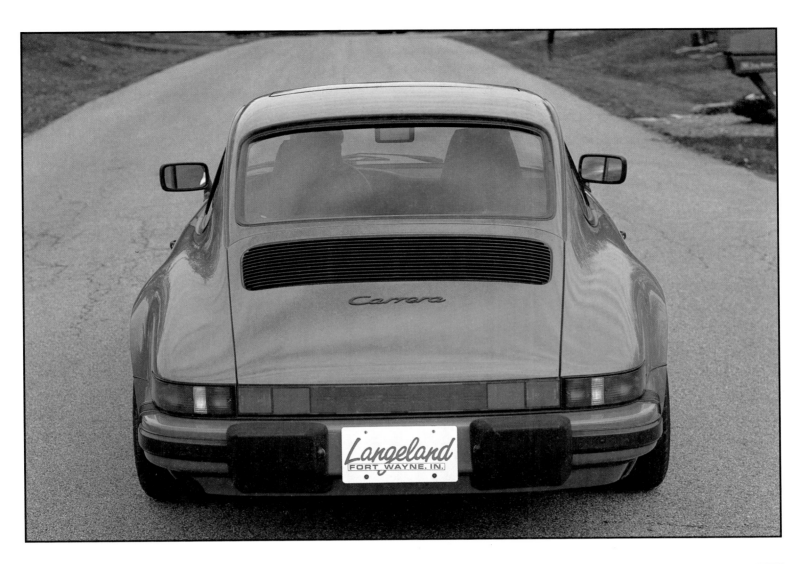

The 1989 911 Carrera's interior is as for the 1987 model, with form-fitting high-back bucket, while the engine (facing page bottom) was in its final year in its existing form. The absence of the optional "whale tail" on this car shows the classic lines of the 911 to best advantage. Black-spoked wheels and the front were identical to those on the earlier car.

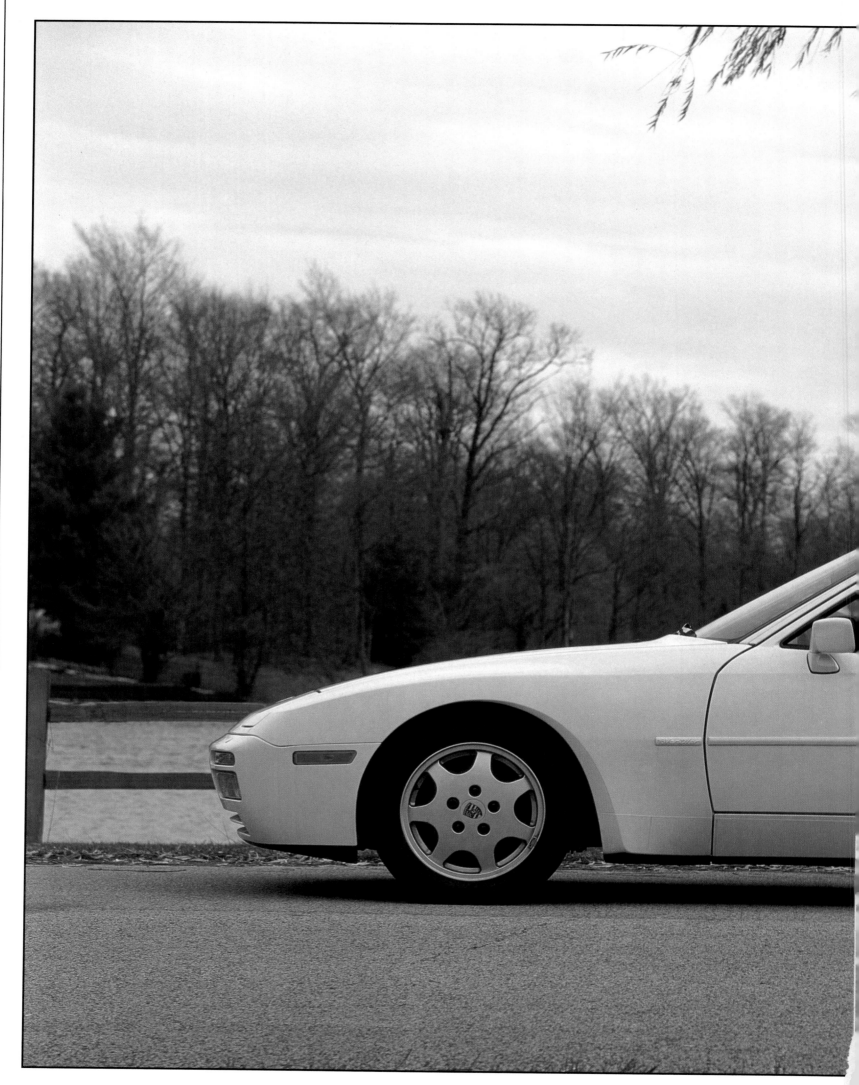

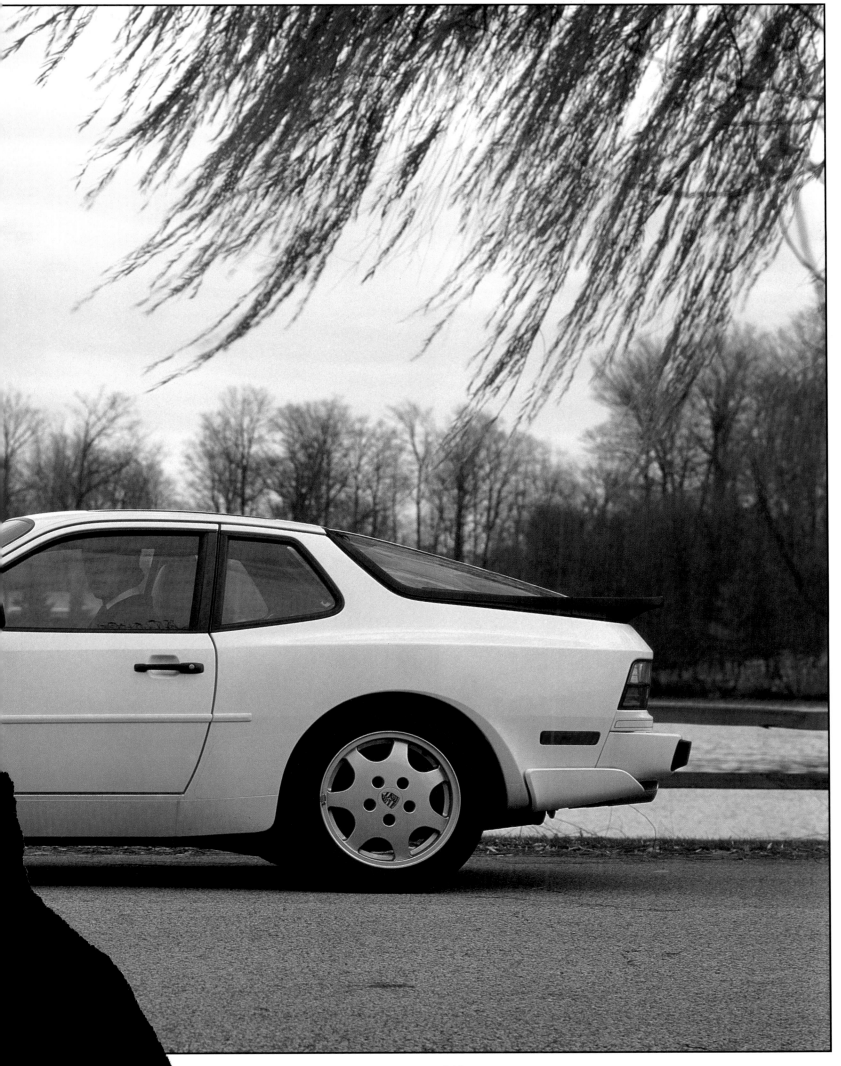

Rear disc brakes made a belated arrival in 1981 as did rear seat belts, but in 1982 standard and turbo 924s disappeared from the US market. They had been replaced by the new 944. However, Europe was blessed with both 924s and 944s and it was not until 1987 that America again was treated to a much improved 924, this time the 924S. Outwardly the only difference was the new alloy wheels but under the hood the 924 inherited the 944's smoother eight valve engine pumping out 147 bhp. Both the 924 and 944 were alike as two peas in the pod by 1988 when American editions got the 2.5 litre eight valve four and 11 extra horsepower.

By 1989 the 924S was gone; the 944 finally engulfed its almost twin brother. On the market since 1981 when it was first shown at Frankfurt, the 944 looked like the 924 – sharp observers would spot the slightly different bumpers though – but was driven by an all Porsche designed engine. But it goes back further than that – to 1978, when the car supposed to succeed the indestructible 911, the V8 powered 928, made its appearance. Ernest Fuhrmann, Porsche's gifted chairman, thought the time had come to prepare for the worst; the day the ever-popular 911 would stop selling. To counter this eventuality, Fuhrmann, his engineers and designers readied the 911's replacement for swift introduction should the need arise. Obviously the car would have to meet the increasingly stringent US and European emissions and safety standards. It was then, with an eye on Mercedes and BMW markets, that the idea of a bigger luxury orientated grand tourer came into being.

All-independent suspension, a front water-cooled V8 engine, rear trans-axle and disc brakes were called for the new model, thought of even in 1973 as the 911 replacement. Design chief Anatole "Tony" Lapine put together a futuristic albeit radical design for the car and one that would not date too readily.

The 928, 175.7 inches long and riding on a 98.4-inch wheelbase was first shown in March 1977 at Geneva instead of Frankfurt. The reasons were simple: Porsche wanted the cars shipped to the US in time for 1978 and as the first 356 had been shown in Geneva, it seemed fitting to display this all-important new model there.

Styling shared a family resemblance with the later 924/944 models but was more sharply defined. There was more overhang at the front than at the rear, which to a prejudiced eye looked like a dog with its tail between its legs or possibly a crouching baboon.

Its engine was a departure; the first V8 for a production Porsche. Displacing 273 cubic inches (4.5 liters), this 90 degree, SOHC V8 developed 219 bhp (SAE net; US versions only). An over-square unit, the bore and stroke measured 95 x 78.9 mm and the pistons were iron clad aluminum alloy, the bores electronically etched to provide a hardened silicon-crystal surface. A Bosch K-Jetronic injection system took care of the engine's fuel needs. Low profile 225/50VR-16 Pirelli P7 tires on cast alloy wheels reminiscent of the old fashioned circular telephone dial took care of the road and 0-60 was reached in an energetic 7 seconds.

Although good, the 924 was not perceived by enthusiasts as being entirely Porsche since it shared much of its technology with VW. To redress the balance, Porsche introduced the 944 in 1983. Unlike the 924, its engine was strictly Porsche, a 151 cid unit with a single overhead cam, Bosch's new Digital Motor Electronics fuel injection system and electronic ignition. Like on the 924, the engine, derived from the 928's V8, was mounted up front. Styling, as seen on previous pages and right, was very close to that of the 924.

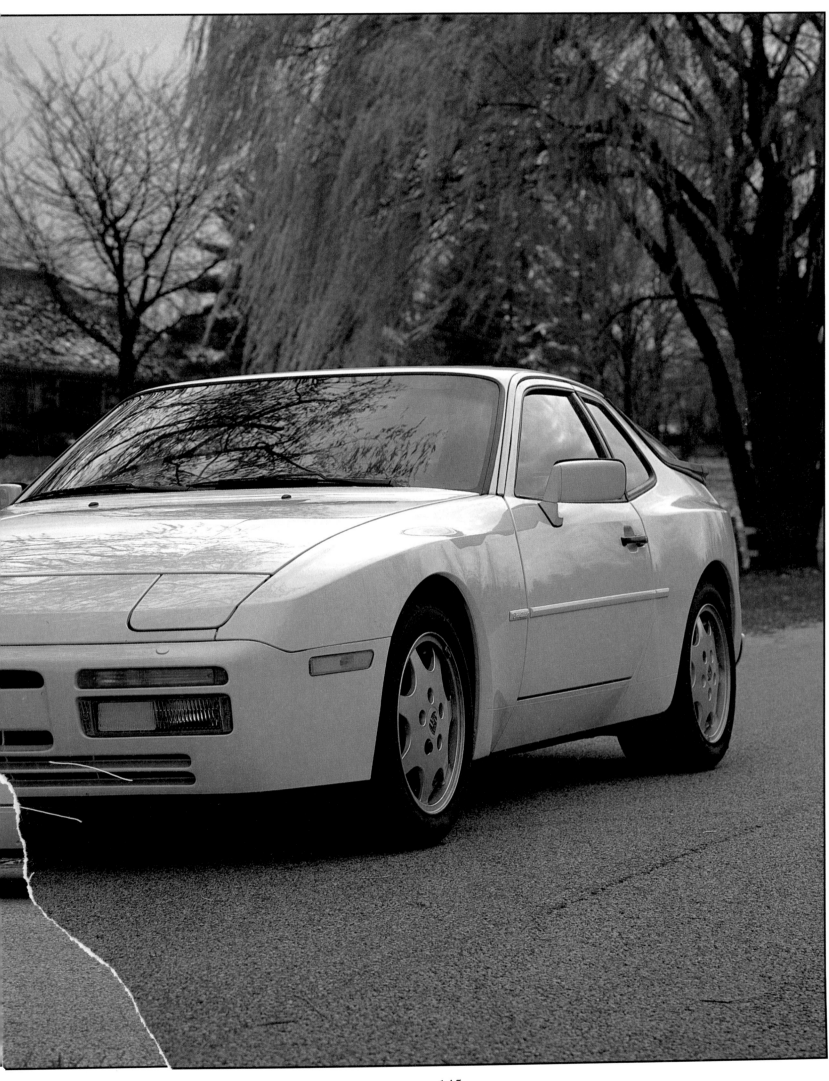

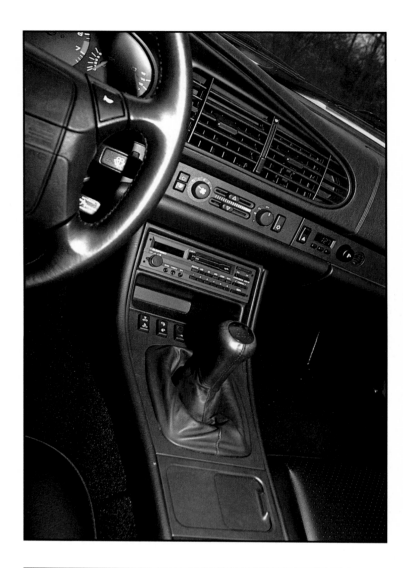

The short gear shift (top) on the 944 is a joy to use, while the large glass hatch (above) offers excellent rear visibility and doubles as a trunk lid. Horsepower was up to 158 by 1988. Right: fenders of the 944 are slightly flared in comparison with the 924, otherwise body differences are minimal.

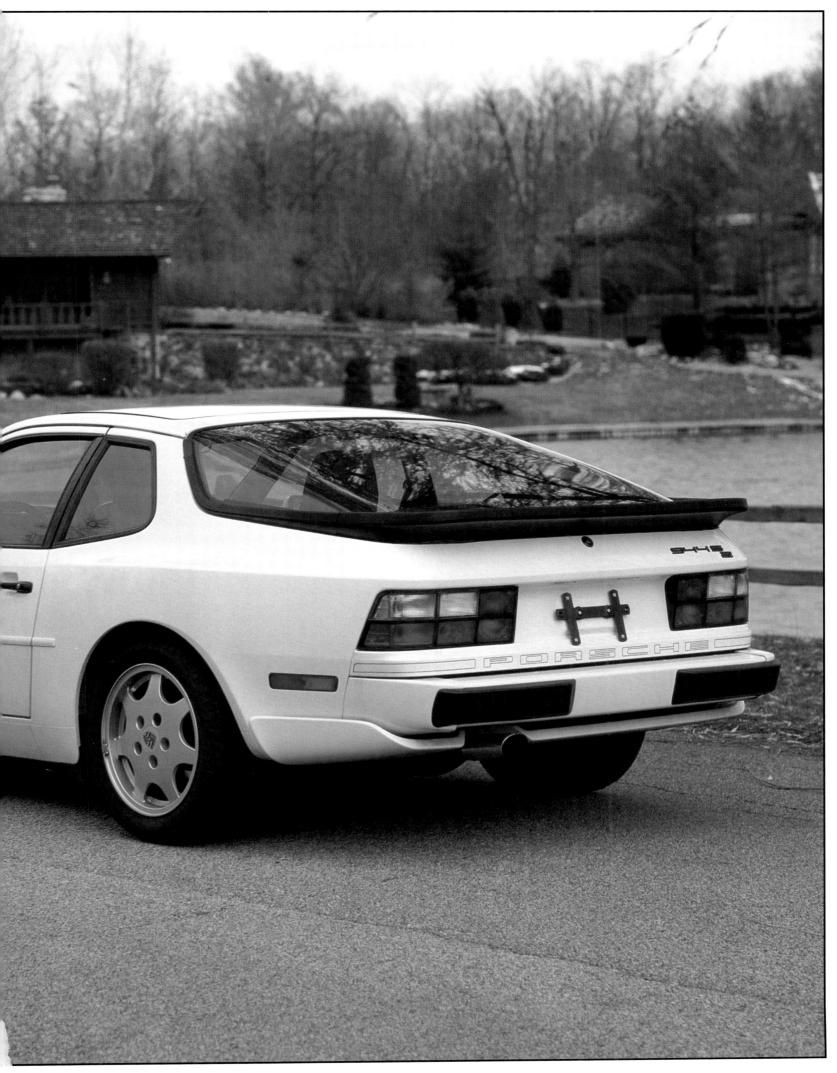

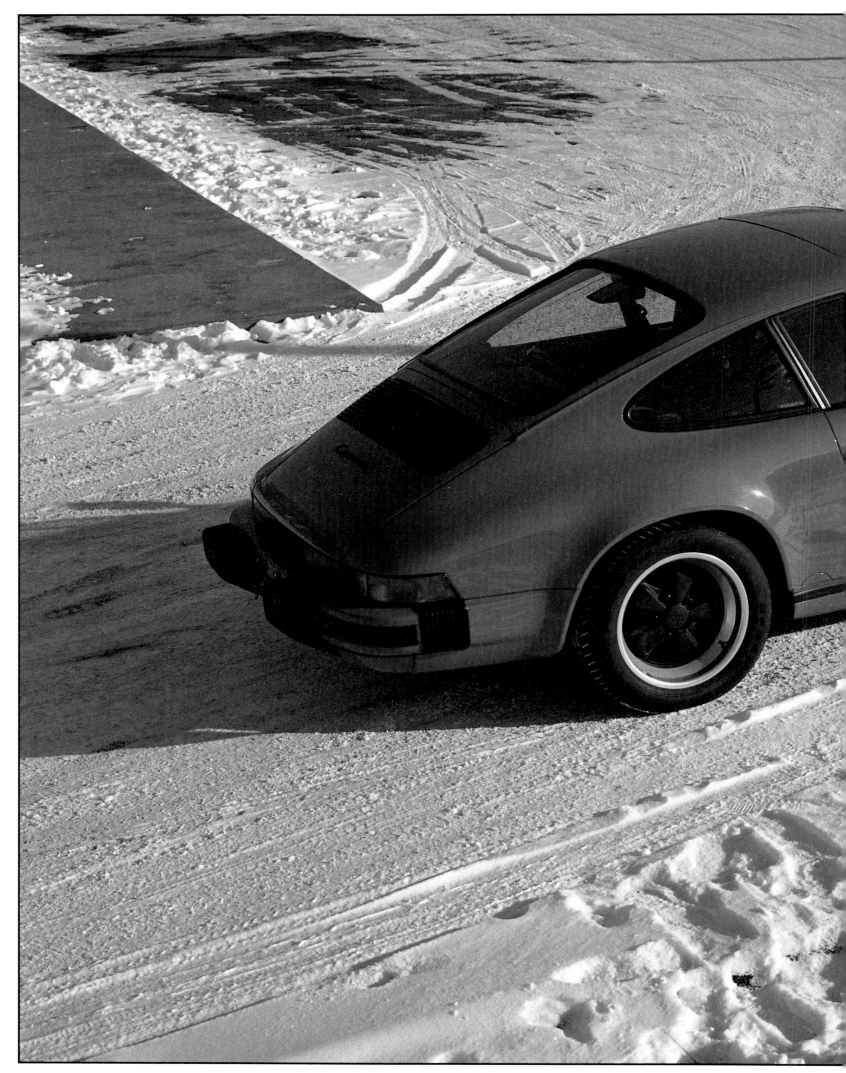

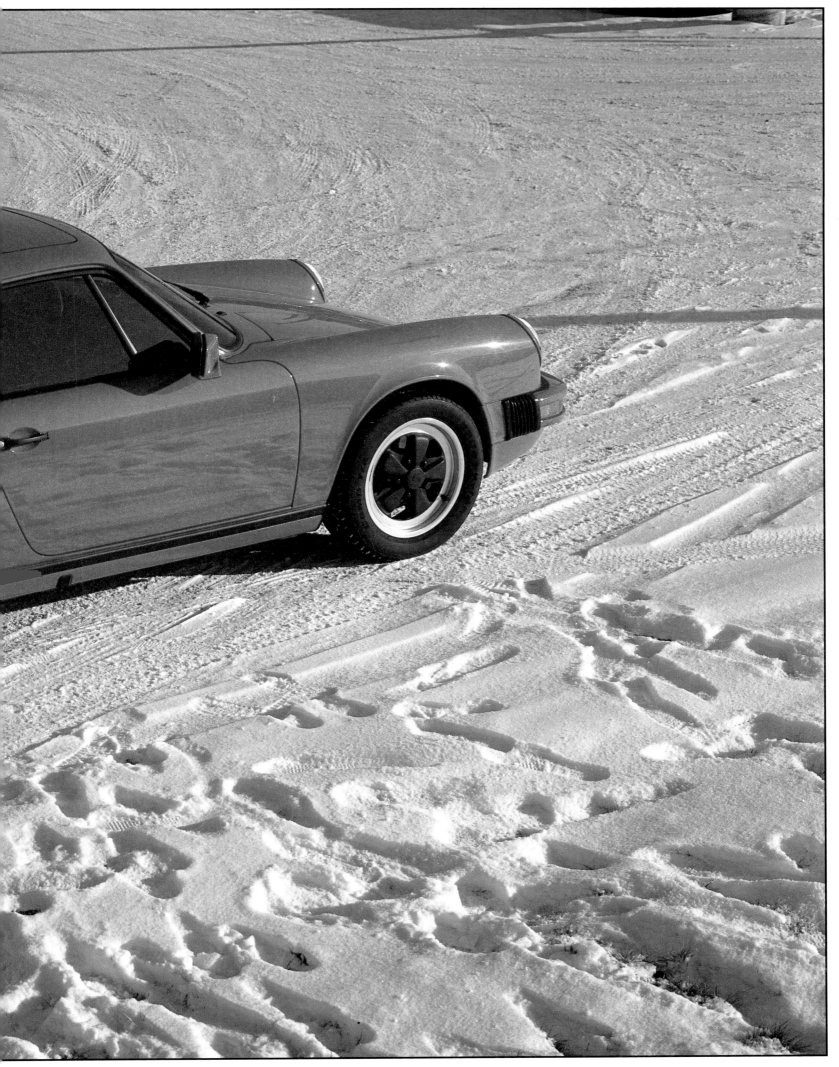

Interior was pure luxury even if the original dogs tooth seat decor was a bit flash. Tilt steering moved the instruments as well, thus ensuring correct visibility at all times (most tilts cover portions of the instruments, which can be annoying if the cruise control is not set). Air conditioning, power windows, in fact all the accoutrements to match the image of the young macho driver.

On the exterior the stout B-pillar was sharply raked back a la Chevrolet's 1955-57 Nomad, and the pop up lights laid dormant, staring skyward until called into action. With the windshield raked back the car was certainly at the forefront of aerodynamics in 1978.

Of course the 928 did not replace the 911 – it joined it. Today both cars continue side by side in production. As with the 911, the 928 has undergone continuous improvement and produced a new model, the 928 S4. Pricewise it is almost beyond any self-respecting yuppie's budget, at a staggering $74,595! For that money one gets a 5.0 liter, 32 valve PF1 V8, 4 wheel disc brakes, ABS braking, automatic climate control, leather power seats, driver's seat memory, power steering, power windows and locks, driver information and diagnostic system, AM/FM stereo ET cassette, power gate lift, and cruise control.

Porsche says the 928 will still be with us as we enter the 21st century. So will the 911 in all probability, and for good reason. Both cars are perennial good sellers, and an unparalleled success in the sports-car field.

Another good car, of course, is the 944. It arrived four years after the 928 and unlike its near twin, the 924, it had a Porsche designed SOHC in-line four cylinder engine. This engine in fact was, to put it crudely, the V8 chopped in half. It had a silicon-aluminum block and crossflow aluminum head, just like the V8. Bore was increased slightly but stroke was the same. And there the similarities ended; no parts were interchangeable and it used Bosch's new Digital Motor Electronics system instead of the Jetronic fuel injection.

Today the 944 includes a convertible, introduced in 1989, as well as the so-called three-door hatchback. Length is 168.9 inches and wheelbase remains at 94.5 inches. Another addition to the 944's list is the turbo, which has the turbo-charged, intercooled SOHC 2.7 liter PF1 four, rated at 247 bhp. Another model, the 944 S2 shares all the spoiler extravagance of the turbo but goes one better with the 16 valve 3.0 liter four, rated at 208 horsepower.

One of the reasons for Porsche's fine engineering in road cars is the company's dedication to motor sport, be it rally, road or track. From Porsche's earliest beginnings there have been competition cars so good that their invincibility more than rivals Ferrari. Though this book cannot even begin to chronicle Porsche's racing history and its endless string of successes, it pays homage to those great racing cars whose technology has found its way into the production vehicles.

The first 550 RS prototypes sped their way to success in 1953 in their class Carrera Pan-Americana (Mexican Road Race). They finished first and second in their class and repeated the performance in 1954. The 550 is regarded highly by racing historians, but it had four overhead camshafts (two per bank) and twin ignition.

One hundred 550s were made and sold to customers, mostly in the U.S., where they were referred to as 550 Spyders. They were delightfully attractive cars, indestructible on the race track. In 1965 Porsche brought out the improved 550 A RS Spyder with a 1500-cc four cam engine developing 135 bhp (DIN). Nicknamed "Giant Killer" because of its unbreakable little engine, the 550 RS would keep going as all others broke. A long string of successes followed the plucky 550 into retirement when it was replaced by the

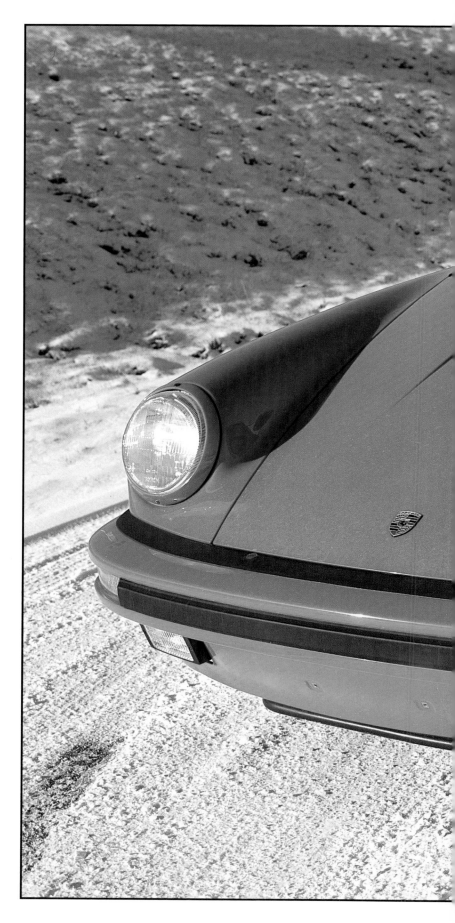

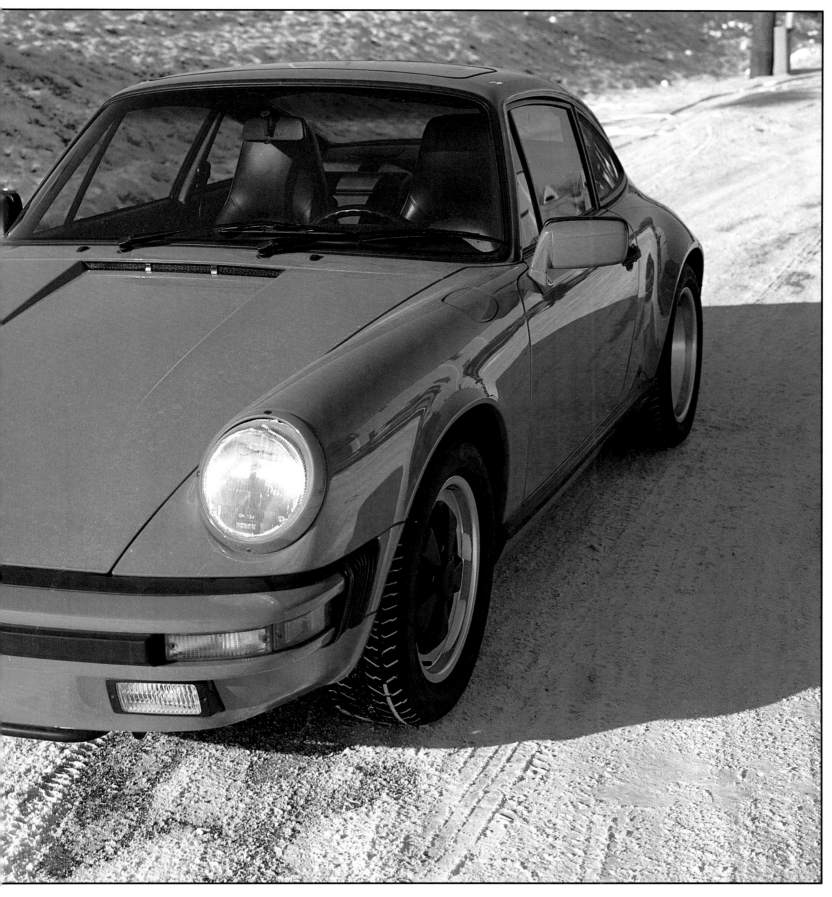

No turbocharged 911 for 1990, the car returning instead as an all-wheel-drive Carrera 4 in 1991. Promised for the Carrera 4 is permanent four-wheel-drive, with 69% of the power going to the rear wheels; should slippage occur, extra power is automatically transmitted to the offending wheel to compensate. Anti-lock brakes and driver/passenger airbags are standard on all models. Although one of the world's most popular sports cars since its inception in 1964, the 911 is not without its faults. Due to the car's rear weight bias occasioned by the location of the engine, there is a tendency for the back to break away if the brakes are hit hard during cornering. In the hands of the inexperienced, this can be a situation that is difficult to control.

151

The shield and wheel design (top), low impact bumpers, headlight treatment and nose profile on the 911 Carrera are classics of Porsche design that have stood the test of time. Criticism, however, is sometimes aimed at the use of red rather than amber turn signal lenses on the rear of U.S. models.

type 718 in 1958. Also known as the RSK 718/1500, this official nomenclature was changed to RS 60 in 1960, the 60 denoting the year. A 1600 cc engine replaced the 1500 unit in 1959 but in 1961 two versions, 1500 and 1600, of the 718 RS G1 were used.

The 917 Group 4 racer was one of Porsche's great cars. Its 5 liter air-cooled flat 12 took the beautifully shaped car to victory time after time. In 1970, 917s won the Manufacturers' Championship. Still the 917 posed a serious threat to most other competitors, its reliability a factor no other make could count on with the confidence Porsche teams could.

All types of competition fell victim to Porsche. Hill climbing, long distance, 24-hour racing, rallying, IMSA, SCCA Group 3 – you name it, Porsche was there with various engines, from four cylinders, six, eight, and twelve, to suit. The four cylinder 904 of 1964-66; the 906, 907, 908, 909s from 1966 to 1968; the legendary 917 series; the 910s, the later 936 cars and the 962 of 1988, all winners in their respective classes and events. Only Formula One does Porsche leave alone, perhaps regarding this form of racing best left alone to companies who do nothing else but build competition cars for that one class, Ferrari, Lotus, and Renault excepted.

Finally Porsche has its share of breaking records as well. It first came in 1951 at Montlhéry Track. On the night of 29 September 1951, three records were broken by Porsches with 1.1 liters, 1.5 liters and a sports racing two-seater. The 500 miles, 1000 kilometers and six hour records stood at 98.16 mph. Porsche swept the board at 100.03 mph, 101.4 mph and 101.1 mph.

The next day a Porsche 1500 cc car attempted the world's 72-hour endurance record, held at 80.71 mph by a Citroen since 1935. It goes without saying Porsche broke it, travelling at over 85 mph. Porsche well deserved this record because there was much tension caused by quite a few problems the car developed during the run. But it succeeded in completing the 72 hours, and broke the record.

Other records fell, other races were won, but the list would fill a book. Recently, the firm's sales have been severely affected, especially in the US, partly through currency problems, partly because of over-extending itself during the days of Peter Schultz' regime.

But with an enviable tradition built over many decades, and a record of great cars and uncompromising engineering, Porsche approaches confidently the threshold of another century in the Motoring Hall of Fame.

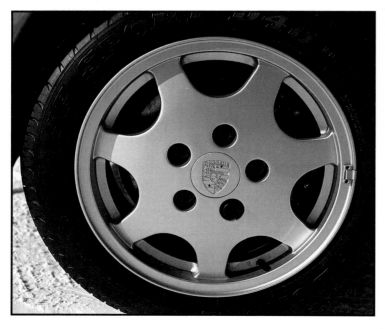

Introduced in Europe in 1989, the svelte 944 Cabrio (previous pages and above) made it to America for 1990. Priced at £38,395 in the UK or $52,650 in the U.S., buyers are assured of a fairly exclusive car on their street. The state-of-the-art four-cylinder in-line water-cooled SOHC engine had leapt from 151 cid (2.5 liters) to 182 cubic inches (3.0 liters) and now developed 208 bhp compared to 155 of old. A five-speed manual transmission and anti-lock brakes are part of the standard package, as is the manually operated top, though a power top is an option.

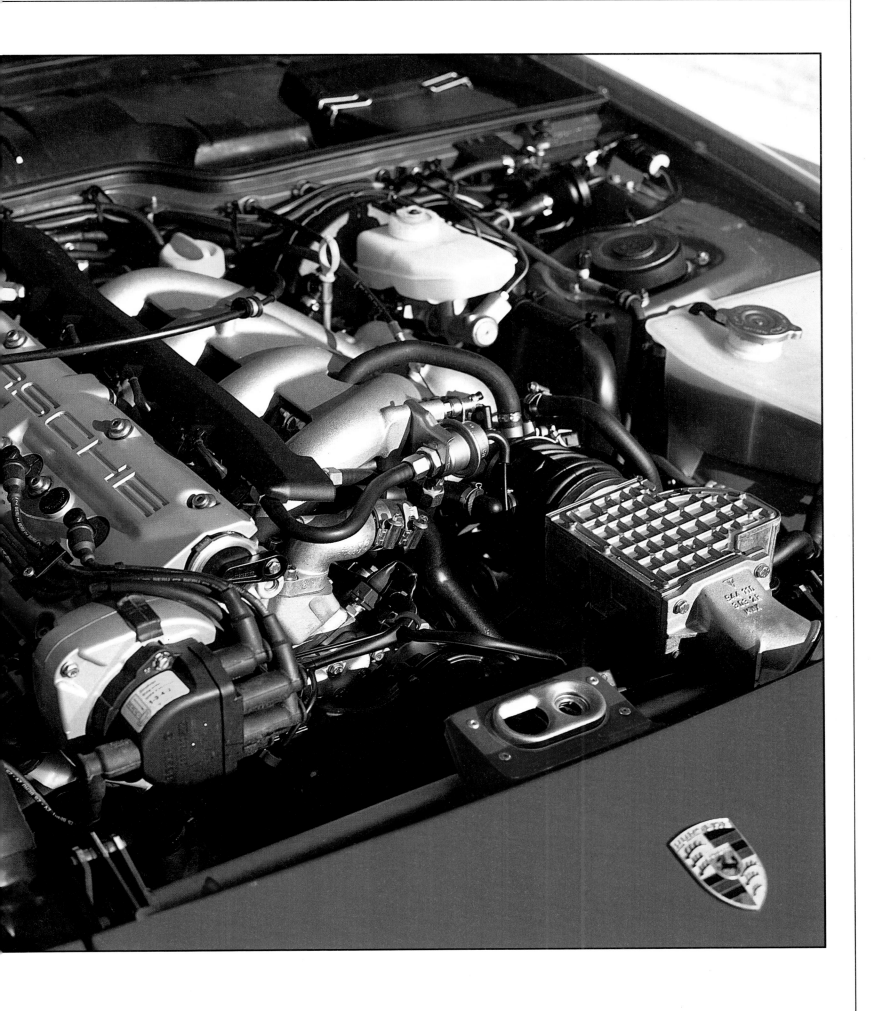

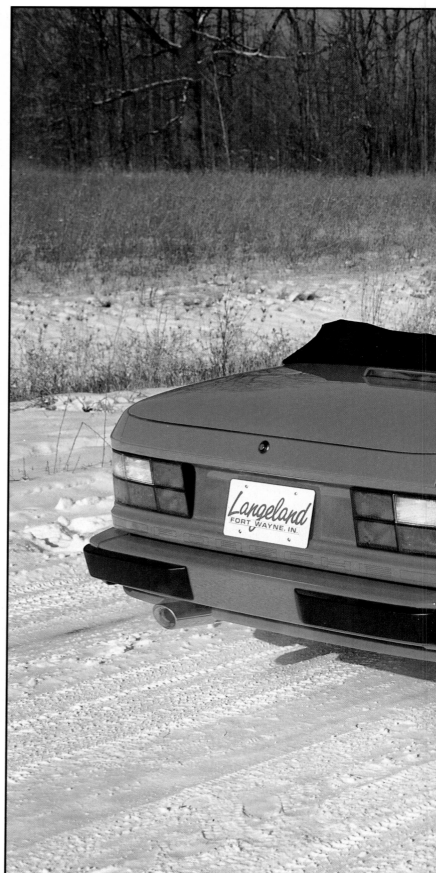

Top and center: pop up headlights have been a standard feature on the 924 and 944 from the beginning, giving the cars a sleek, clean profile when retracted. Whatever angle it is viewed from, the topless 944 Cabrio has rakish lines. The turbo and base 944 are gone; at the moment only the $41,900 S2 coupé and the S2 Cabrio are available, but an interesting prototype that resembles a 944 with new styling has been spied at Porsche's proving grounds. Porsche calls the prototype the 944 Aero II and claims that the car is simply for testing aerodynamics. The truth will become clear in the not-too-distant future.

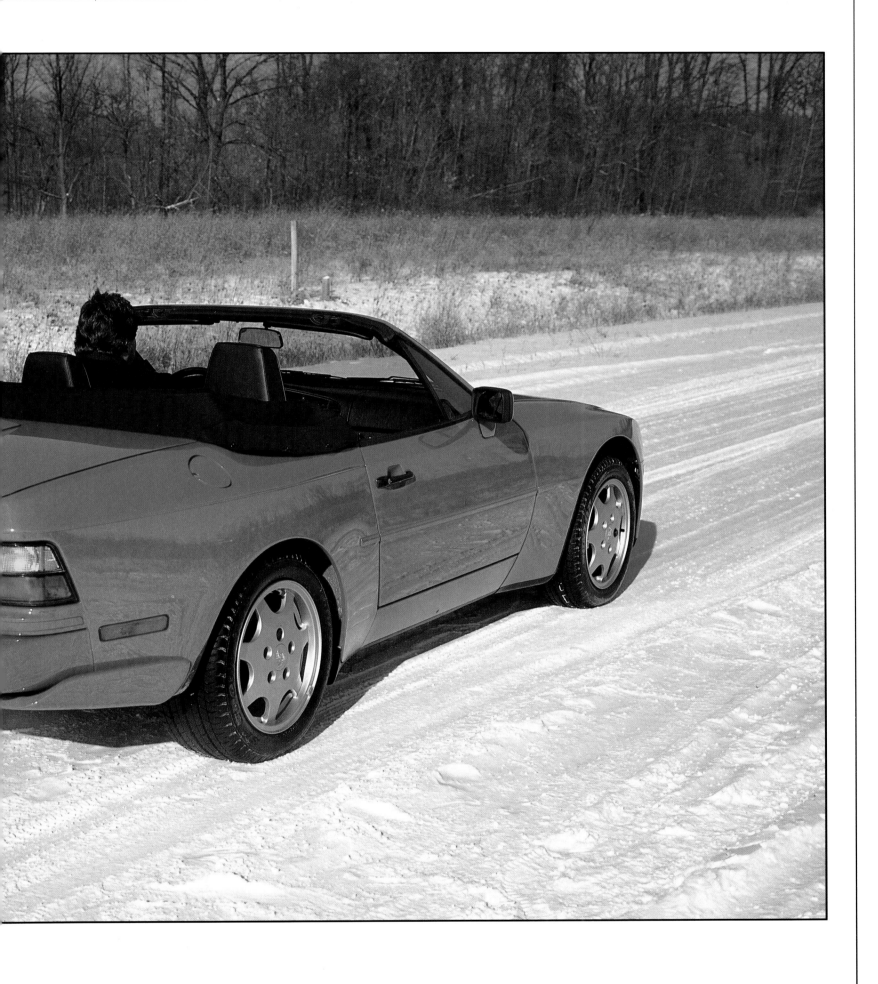

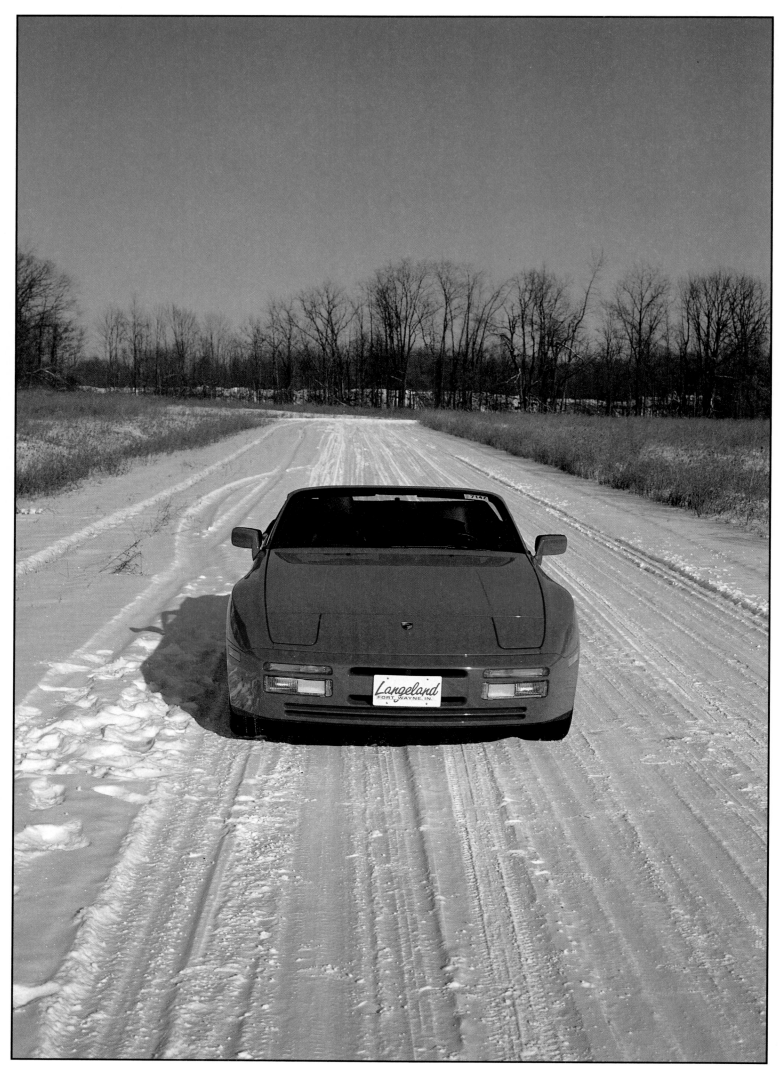

1990 PORSCHE 944 S2 CABRIO